Objects of Desire

Victorian Art

at the Art Institute of Chicago

THE ART INSTITUTE OF CHICAGO

ISSN 0069–3235

ISBN 0-300-11341-2

Executive Director of Publications: Susan F. Rossen; Editor of *Museum Studies*: Gregory Nosan; Designer: Jeffrey D. Wonderland; Production: Amanda W. Freymann; Subscription and Circulation Manager: Bryan D. Miller.

This publication was typeset in Stempel Garamond; color separations were made by Professional Graphics, Inc., Rockford, Illinois. Printed by Meridian Printing, East Greenwich, Rhode Island.

Front cover: *The Festival* (p. 77, cat. 10, detail).
Opposite: *Purple Bird* (cat. 18, detail).
Back cover: *Pitcher* (cat. 15, detail); *Julia Jackson* (cat. 6, detail).

Distributed by Yale University Press, New Haven and London.

This publication is volume 31, number 1 of *Museum Studies*, which is published semiannually by the Art Institute of Chicago Publications Department, 111 South Michigan Avenue, Chicago, Illinois 60603-6110.

For information on subscriptions and back issues, consult www.artic.edu/aic/books/msbooks, or contact (312) 443-3786 or pubsmus@artic.edu. Wholesale orders for *Objects of Desire* should be directed to Yale University Press at (203) 432-0966.

Ongoing support for *Museum Studies* has been provided by a grant for scholarly catalogues and publications from The Andrew W. Mellon Foundation.

Contents

Acknowledgments

Objects of Desire: Victorian Art at the Art Institute of Chicago has allowed us to bring together a group of gifted curators and scholars from both within and beyond the Art Institute, giving them the chance to write essays on objects in the museum that were already of particular interest to them. These full-length articles, together with the equally fascinating catalogue entries that follow, represent the latest installment in Museum Studies's ongoing project of publishing new research on the Art Institute's permanent collection in an accessible, attractive format.

At the Art Institute, many people helped create this publication in ways both large and small. Thanks are due to editors Katie Reilly, Susan F. Rossen, and Ginny Voedisch for reading and refining the manuscript, which was much improved by their efforts. Shaun Manning edited the photographs included here; Amanda Freymann oversaw the issue's production with patience and an expert eye; and Jeff Wonderland brought to the design his unerring sense of elegance. The images themselves were produced by the skilled staff of the Department of Graphic Design, Photographic, and Communication Services, including Chris Gallagher, Bob Hashimoto, Robert Lifson, and Caroline Nutley.

Elsewhere in the museum, Jessica Batty, Salvador Cruz, Lyn DelliQuadri, Pamela Ellsworth, Sarah E. Kelly, Denise Mahoney, Brandon Ruud, and Doug Severson generously offered their advice and expertise. The greatest debt of gratitude, however, is owed to the superb group of authors listed at left, without whose hard work this issue would never have been possible. Chief among these is Martha Tedeschi, whose guidance has helped us—if we have done our job properly—make this publication an object of intellectual and aesthetic desire in its own right.

Gregory Nosan
Editor, *Museum Studies*

List of Contributors

Authors who have written catalogue entries (pp. 68–88) are further identified by the initials following their names.

Judith A. Barter, *Field-McCormick Curator of American Art*

Emily Heye, *Assistant Conservator of Objects*

Laura Lean, *Research Volunteer, Department of Prints and Drawings* (L.L.)

Debra N. Mancoff, *School of the Art Institute of Chicago* (D.N.M.)

Douglas R. Nickel, *Director, Center for Creative Photography, University of Arizona*

Ellen E. Roberts, *Assistant Curator of American Art* (E.E.R.)

Elizabeth Siegel, *Assistant Curator of Photography* (E.S.)

Martha Tedeschi, *Curator in the Department of Prints and Drawings*

Ghenete Zelleke, *Samuel and M. Patricia Grober Curator of European Decorative Arts* (G.Z.)

Introduction

This issue of *Museum Studies* is titled *Objects of Desire: Victorian Art at the Art Institute of Chicago* in order to suggest one of the most compelling characteristics of the Victorian period—that the desire to own luxury goods, including works of art, had never before been more widespread or, in fact, as readily achievable as it was to the middle class, whose ranks expanded dramatically in the nineteenth century. At the same time, however, this publication explores how "Victorian art" in fact encompasses an unexpected diversity of styles and aesthetic impulses, constituting a rich, nuanced visual culture that defies any easy characterization. This collection of essays and catalogue entries illuminates a range of choice "objects of desire" from the Art Institute's collection, seeking to suggest the shape of a complex age and to explore a variety of its artistic movements, including classical and medieval revivalism, Pre-Raphaelitism, Aestheticism, and the Arts and Crafts Movement.

Alexandrina Victoria (1819–1901) began her sixty-three-year reign as Queen of England and Ireland, and Empress of India, upon the death of William IV in 1837. Strictly speaking, the term "Victorian" describes the historical period coinciding with her long and influential rule. However, what we have come to think of as Victorian has less to do with chronology than it does with a system of ambitions, beliefs, sentiments, and tastes. In our time, it is not unusual to hear the word *Victorian* used to connote moral conservatism, piety, sentimentalism, or a preference for cluttered, overstuffed interiors.

Yet while subsequent generations may have characterized the Victorians as a society of fanatical prudes who required even the legs of the piano to be modestly draped, in fact the era's surface obsession with respectability reflects the enormous social, technological, and economic changes through which Victorians lived. Their reality, not unlike ours, was defined both by a breathless race toward "progress" and by a deep ambivalence toward a constantly transforming modernity. Because Americans and Britons shared many of the same cultural values and societal stressors in this period, this publication explores Victorian art from both sides of the Atlantic.

The first half of Victoria's reign was marked by the rapid growth of industry, a massive increase in population, political reform, and a rise to power of the industrial middle class. In this roughly thirty-year period, England enjoyed unprecedented material prosperity and technological innovation, including the invention of photography. Prince Albert, whom Victoria married in 1840, urged that England's achievements be actively compared to those of other countries around the world. To this end, he promoted the Great Exhibition of the Works and Industries of all Nations, which drew an astounding six million visitors when it was shown in London's Crystal Palace in 1851. There, a dazzling array of objects were assembled, classified, and displayed for potential consumption, feeding the cultural fantasies of those who made them as well as those who wished to own them.

The final thirty years of Victoria's rule saw the climate of optimism that had engendered the Great Exhibition eroded by continuous strife between the middle and working classes, a declining birth rate, the looming threat of economic crisis and unemployment, and the challenge offered to traditional moral values by the new science, epitomized by Charles Darwin's *Origin of Species* (1859) and Thomas Huxley's *Man's Place in Nature* (1863). Bitter class conflict and the plight of the poor inspired Charles Dickens to pen social critiques in the form of novels such as *Hard Times* (1854). Oxford professor and art critic John Ruskin lamented the ugliness of the industrial age in his writings, including *Sesame and Lilies* (1865), giving impetus to the medieval revivalism of architects and artists—including the Pre-Raphaelite painters—who sought a return to a purer, more graceful world. As the British Empire struggled to maintain dominance over its far-flung colonies, at home late Victorians indulged in escapism by reading the

adventure fantasies of Rudyard Kipling and Robert Louis Stevenson or losing themselves in the classical utopias depicted by artists such as Edward Burne-Jones, Albert Moore, and Edward Poynter.

In the essays and object entries that follow, authors examine a range of choice Victorian works of art for what they tell us about both their makers and their owners. Taken together, these studies provide a sense of how the Victorians employed their "objects of desire" to fashion their own identities—negotiating questions of family life, money, nationalism, politics, sexuality, social standing, and spirituality—in an age of tremendous change and cultural ferment. In the first essay, Martha Tedeschi, Curator in the Department of Prints and Drawings, discusses the boom market in Victorian England for engravings that reproduced the most popular modern paintings. She describes the ways in which industry and new technologies produced a means of making printed reproductions cheaply, helping to establish an art-buying public within the middle class. Victorians desired these skillfully produced images for a variety of reasons, ranging from the desire to possess the very latest fashions to the need to establish a tone of moral respectability in the home. By looking at the status of prints within the art market as a whole, Tedeschi explicates Victorian attitudes toward mass production and mass ownership, arguing that for much of the Victorian period we see a cultural willingness to accept beautiful reproductions in the place of originals. Finally, she explores the enormous impact of photography on the Victorian art market and on the psyche of art consumers, suggesting why printmaking assumed new roles in the last decades of the nineteenth century.

As the nineteenth-century art market expanded to include mass-produced objects for the middle class, it also encouraged the production of unabashedly luxurious, handmade works, created for the private enjoyment of the very few. The second essay, by Ghenete Zelleke, Samuel and M. Patricia Grober Curator of European Decorative Arts, takes as its subject the painted sideboard and wine cabinet designed by artist-architect William Burges, a fervent champion of the Gothic Revival in mid-Victorian England. This essay is complemented by Art Institute conservator Emily Heye's account of her examination and painstaking conservation of this piece of functional furniture. Through the lens of the Burges cabinet, we gain perspective on the question of why the Victorians found the medieval world so alluring. With its painted narrative panels arranged to suggest stained-glass windows, this secular object suggests an admiration and even nostalgia for a time when piety and manual labor were the stuff of a simpler existence. Leading voices for reform in the visual arts—including William Morris, Augustus Welby Northmore Pugin, and John Ruskin—seized on medieval style, methods of production, literature, and belief systems as a kind of discipline that they believed could be used to reign in the tasteless excesses of industrial modernity. In the catalogue section of this volume, discussions of William Morris's textile works and of medievalizing drawings by Pre-Raphaelite artist John Everett Millias provide additional examples of this cultural phenomenon.

While Victorians loved to acquire actual decorative objects, their desire for possessions also extended to representations of "objects of desire," images that took on added meanings of their own. In the third essay in this volume, Judith A. Barter, Field-McCormick Curator of American Art, examines a revealing selection of American still-life paintings in the Art Institute's collection. As she demonstrates, still lifes provided their owners with a way to celebrate the solidity and significance of their possessions within the security of the domestic sphere. However, as the nineteenth century wore on, the genre of trompe-l'oeil still life, very much the creation of the public sphere of popular culture, seemingly acknowledged the unreliability and evanescence of material things. Modern public life and the private sphere of the home were both subjects of sharp debate in the Victorian world, and visual culture, like literature of the period, often mirrored the efforts of the middle class to establish order and identity in these two realms.

In the next essay, art historian Debra N. Mancoff focuses on the private world of the late-Victorian artist Edward Burne-Jones, who found escape from the glare of public life in the pages of his sketchbooks and the realm of his imagination. The exquisitely rendered graphite drawings on the pages of a sketchbook in the

Art Institute offer the opportunity to examine the unique importance that the classical world, in contrast to the medieval one, played within the Victorian imagination. On the one hand, the graceful proportions and serene beauty of classical art were seen by artists of the Aesthetic Movement as an antidote to the vulgarity of mass-produced manufacture and modern urban life. Interestingly, however, classicism also permitted the enjoyment of another kind of "object of desire." Offering a striking alternative to the cliché about Victorian prudery, the figure drawings of Burne-Jones suggest an unexpected fascination with the sensuality and beauty of the human body.

Perhaps the most revolutionary innovation to shape nineteenth-century visual culture was the invention of photography in 1839. In the last essay, Douglas Nickel, Director of the Center for Creative Photography at the University of Arizona, investigates the wide-ranging group of Victorian photographs assembled in the Art Institute's George Cowper Album, an intriguing record of a medium in transition. As in the case of the Victorian print market, the new photographic technologies radically changed the possibilities of image making. In the case of photography, however, the story is not so much about the expansion of patronage from the aristocracy to the middle class, but rather about the shift of artistic agency and control from a small group of gentleman-amateurs to the enterprising middle orders. The subject matter of the Cowper photographs also suggests the wider ways in which Victorian society was in transition, documenting new attitudes toward social reform (e.g. sanitation, the poor, the mentally ill) that we recognize as modern and progressive. Entries in the catalogue section at the end of this volume present photographs by Julia Margaret Cameron and Lewis Carroll as well as the genre of photographic collage, elucidating the ways in which photography was adopted and manipulated by artists during the first fifty years of its existence.

The essays in this volume use choice works of art, and sometimes groups of objects, as points of departure for the consideration of larger issues in Victorian culture. Complementing these in-depth studies, the shorter entries that conclude this issue offer a catalogue of individual objects from the museum's collections, ranging from the Gothic Revival–inspired images by John Everett Millais and Benjamin Brecknell Turner to the classically inflected works of Albert Moore and Edward John Poynter; from the Japanese-influenced Aesthetic Movement decorative arts of the Herter Brothers and Tiffany and Company to the modernistic Arts and Crafts furniture of Charles Rennie Mackintosh and Mackay Hugh Baillie Scott. Together, these objects, and this issue's authors, challenge us to explore the Art Institute's collections from a new angle and, at the same time, to look afresh at Victorian life and art.

Martha Tedeschi and Gregory Nosan

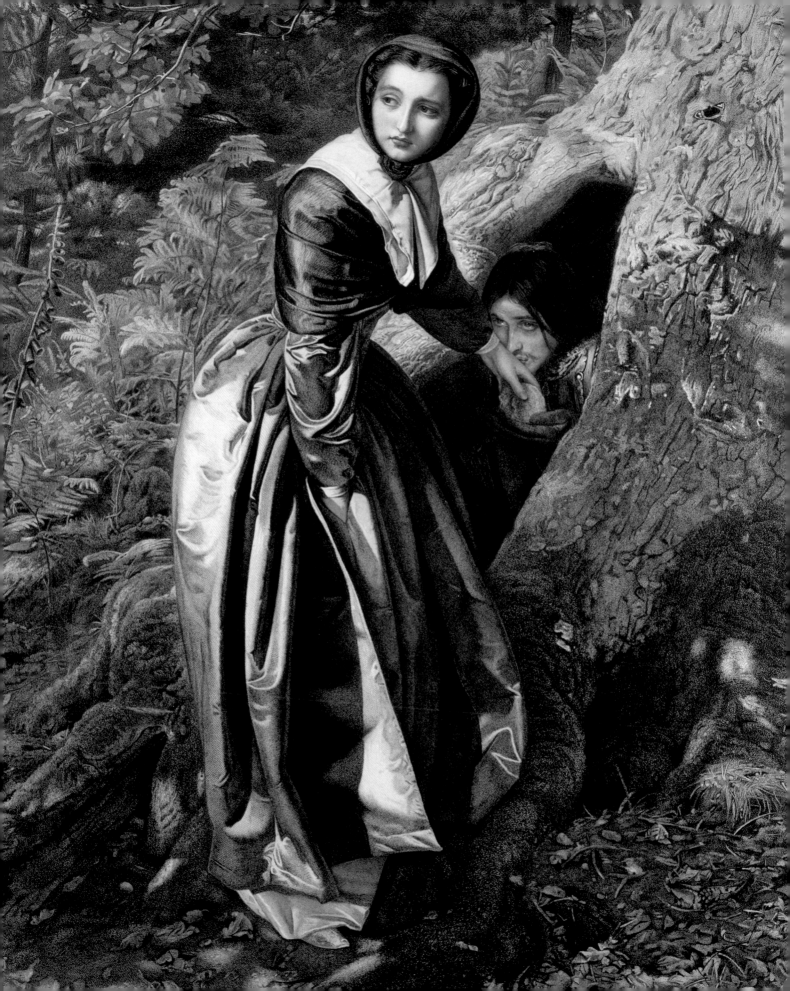

"Where the Picture Cannot Go, the Engravings Penetrate": Prints and the Victorian Art Market

Martha Tedeschi

Curator in the Department of Prints and Drawings

Possibly during no previous period of similar duration have such marked changes been observable as those which properly belong to that time of peace, the Victorian Era.[1]

It is significant that this statement, penned in 1887 by a writer for the *Art Journal*, was made as part of a survey of developments in printmaking. Indeed, the art world of nineteenth-century England was reshaped by an unprecedented boom in the print market, which reached its apex in the 1840s and 1850s.[2] This explosion of interest was the direct result of the profound social and cultural transformations already under way. While the economic engine of the Industrial Revolution produced the surplus capital required to establish a broad market for luxury goods, it also fostered the rise of a literate, newly wealthy middle class that came into its own with the Reform Bill of 1832, gaining greater social recognition, electoral power, and political status.[3] Middle-class confidence expressed itself in a burgeoning consumer demand for objects—including works of fine art—that were once associated only with the gentry and nobility.

These new collectors, however, possessed a different sensibility than their aristocratic counterparts. Never cultivating a taste for the distant and the exotic, and wary of the large numbers of forged Old Master paintings that were appearing on the English market each year, they preferred pictures of familiar subjects by living artists who were able to vouch for their works' value and authenticity.[4] This new audience for contemporary art reconfigured the established art market in a way that, at first, puzzled even the artists who stood to gain the most. In 1851, for example, the painter Charles Robert Leslie wrote: "The increase in private patronage of Art in this country is surprising. Almost everyday I hear of some man of fortune, whose name is unknown to me, who is forming a collection of the works of living painters."[5]

This picture of growth is particularly remarkable in light of the unstable economic climate of the 1840s, a decade in which blight struck the Irish potato crop and England suffered years of poor harvests.[6] W. MacDuff's painting *Lost and Found* and the famous engraving that reproduces it (fig. 2) juxtapose the plight of the lower classes with the flourishing trade in prints. Here two orphans pause in their work shining shoes to admire the engravings in the shop window of legendary printseller Henry Graves. The centerpiece is a portrait of the prominent

FIGURE 1, William Henry Simmons (English, 1811–1882). *The Proscribed Royalist* (after John Everett Millais) (detail), 1858. Mixed method engraving on ivory chine mounted on off-white plate paper; image 45 x 63.8 cm (17 ¾ x 25 ⅛ in.), sheet 60 x 82 cm (23 ⅝ x 32 ¼ in.). William McCallin McKee and Joseph Brooks Fair endowments, 1996.49.

reformer Anthony Ashley Cooper, 7th Earl of Shaftsbury, who in 1844 established the London Ragged School Union to educate destitute children. The work's symbolic implication seems to be that the boys, themselves among the lost, are "found" through their exposure to prints, which are valuable tools for the education and elevation of even the lowest classes of society.

While few individuals could afford to build a collection of oil paintings, many were able to acquire the prints that reproduced them, which ranged from six-penny sheets hawked on the streets to expensively framed engravings sold in elegant shops. By the 1850s, many middle-class parlors boasted dense displays of framed best-sellers such as William Holman Hunt's *Light of the World* (fig. 3) or John Everett Millais's *Proscribed Royalist* (fig. 1), which reflected the religious, sentimental imagery and iconography of Victorian painting. In 1853 the *Art Journal* reported "there is still a large picture-buying public—never so large a one as at present—and a still more numerous body of the community not possessing the means to purchase the original works of our painters, but who are able to acquire, and do acquire, the next best substitutes—engravings, and imitation drawings or chromolithographs."[7]

FIGURE 2. James Scott (English, 1809–1889). *Lost and Found* (after W. MacDuff), 1864. Engraving on paper; 47.6 x 39.1 cm (18 3/4 x 15 3/8 in.). Courtesy of the Old Print Shop, New York.

That the enthusiasm for reproductive prints extended to the upper classes was exemplified by Queen Victoria, herself a collector of engravings, who in July 1842 had a printing press brought to Buckingham Palace so that she and Prince Albert could watch the printing of a plate after a work by the popular animal painter Edwin Landseer.[8] Nevertheless, the print trade was fueled largely by the expanding ranks of the middle class, and those involved in producing and promoting prints recognized the potential for profit that a more democratic patronage of art might bring. The journal *Art Union*, a steadfast supporter of the print professions, became the loudest voice in defense of art's new mass audience: "Art should not be content to minister to the tastes of the few alone, to whom the possession of its best labours is a luxury; but its healthy influence should be felt among *the million*."[9]

While it is unsurprising that the subject matter of prints was virtually identical to that of paintings, the print trade actually had a profound, reverse effect on what artists chose to paint in the first place. In this heyday of the printed reproduction, the popularity of a particular print had a significant impact on its artist's future bargaining power with dealers. While many artists had mixed feelings toward the largely unsophisticated art-buying public, they all experienced extreme pressure to produce subjects with immediate popular appeal.[10]

Themes drawn from contemporary life reigned supreme. The members of the emerging mass market had no classical education and little interest in aesthetic issues. Instead, they were exceedingly attracted to narrative elements and didactic, moralizing content. The art historian Dianne Macleod has argued that these middle-class collectors wished to locate pictorial equivalents to their deeply held beliefs in moral virtue, respectability, and a necessary degree of social conformity, thus "encoding the myth of middle-class stability in the midst of unruly lower orders."[11] Their preferences were recognized and encouraged by a parliamentary committee in 1845, which praised "the more homely scenes of common life," explaining that "they are oftentimes the only intelligible mode in which Art can speak to a large portion of the community."[12]

Some of these popular prints were used to propagate socially useful attitudes and were remarkably effective in bringing about conformity in public opinion. Illustrations of domestic virtue or the beauties of the

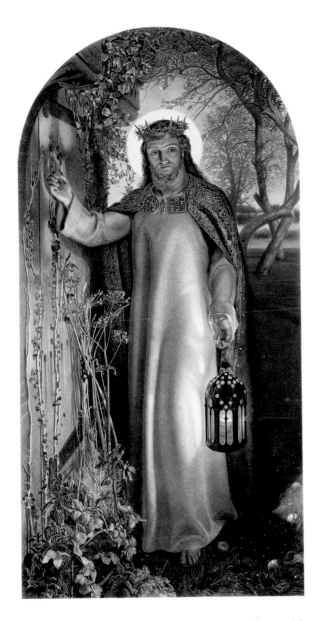

FIGURE 3. William Henry Simmons (English, 1811–1882). *The Light of the World* (after William Holman Hunt), 1860. Line and stipple engraving on ivory chine mounted on off-white plate paper; image 90.1 x 51.2 cm (35 ½ x 20 ⅛ in.), sheet 102 x 63.5 cm (40 ⅛ x 25 in.). Sara R. Shorey Endowment, 1997.658.

English countryside, for instance, reinforced and refined national values. In other works, consumer demand was successfully harnessed to various agendas for reform. The critic F. G. Stephens echoed reformers of the two preceding decades when he wrote in 1860, "Indeed a national service is rendered by the publication of really noble transcripts from noble pictures like these. Where the picture cannot go, the engravings penetrate."[13] Often, heightened emotional content served both to attract patrons and shape their thinking about current issues. Frank Short's *Sorrowing Angel* (fig. 4) is a late example of this trend; reproducing an oil painting by George Frederick Watts, the large mezzotint was published in 1901 to raise funds for the movement opposing the use of bird feathers for fashion and household ornament.

Genre scenes, despite their association with low-brow taste and their traditionally lower status in the hierarchy of artistic subject matter, were considered capable of bearing the same moral weight in this new social climate as history painting had traditionally done under aristocratic patronage. Such a purpose in turn had an effect on style, since detail, high finish, and extreme literalism were considered necessary to convey a subject's full didactic meaning. A rustic cottage interior, for instance, could suggest humble piety, hard work, and loving family values through an easily read iconography of elements such as its tidiness, an open Bible next to a half-burnt candle, or a carefully mended garment hanging on a peg. Such is the case with one of the most familiar images of the period, Henry Wallis's painting *Chatterton* (1855/56; Tate Britain, London), which depicts the poignant death in a garret of Thomas Chatterton, a brilliant poet and forger who, when found out, poisoned himself with arsenic at the age of seventeen.[14] Wallis's almost photographic technique invites viewers to linger on every meaningful detail. Thomas Barlow's mixed method engraving *The Death of Chatterton* (fig. 5) translates the picture's mesmerizing, funereal aura into black and white, and similarly invites a careful contemplation of each and every symbolic component, including the purloined verses, rejected and torn to shreds, which have fallen from the dead poet's hand.

Biblical imagery was another staple of the print market. It must be remembered that Victorian family life revolved around religion, and many painters were themselves deeply pious, as evidenced by the moralizing subjects they often selected for their own private printmaking activities as members of the London Etching Club.[15] Millais, for example, favored scenes of feminine virtue, sometimes combining them with a religious theme, as he did in *Saint Agnes of Intercession* (fig. 6). Holman Hunt, too, elected to etch scenes of quiet familial harmony such

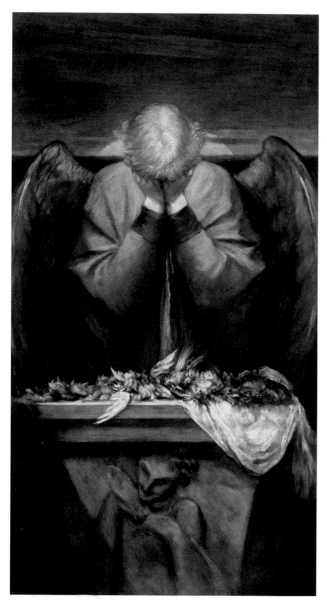

FIGURE 4. Frank Short (English, 1847–1945). *The Sorrowing Angel* (after George Frederick Watts), 1901. Mezzotint, heightened with blue chalk on cream wove paper; image 58.7 x 31 cm (23 $\frac{1}{8}$ x 12 $\frac{3}{16}$ in.), sheet 65.6 x 34.4 cm (25 $\frac{7}{8}$ x 13 $\frac{1}{2}$ in.). Gift of Dorothy Braude Edinburg to the Harry B. and Bessie K. Braude Memorial Collection, 1991.622.

tual fervor, his paintings translated well into black and white (see fig. 3). The artist himself seems to have been intensely interested in transmitting his message through the print medium, going so far as to design a massive gold frame that could be purchased with Frederick Stacpoole's large engraving (fig. 8) of *The Shadow of Death* (1869/73; Manchester City Art Galleries). Decorated with a large cartouche of a cross and crown of thorns, this frame drove home the picture's prophecy of the crucifixion.[16]

The flourishing print trade was responsible for the emergence of numerous new institutions that radically transformed the traditional topography of the London art world. Established in 1847, the Printsellers Association responded to the need for trade regulation when the market became flooded by mediocre impressions published in unlimited editions; new periodicals, the foremost being the *Illustrated London News*, depicted events of the day with wood engravings that could be removed and collected. Under increasing pressure from all sides, the august Royal Academy had to reconsider its longstanding refusal to admit engravers as full members. The first such honor was bestowed in 1855 on Samuel Cousins, who was justly celebrated for his ability to translate the velvety textures, soft flesh tones, and rich chiaroscuro of oil paintings into print. His mezzotints after portraits by Thomas Lawrence, including *Miss Julia MacDonald* (fig. 9), exemplify the skill and intuition with which he turned a reproduction into a ravishing work in its own right.

As more and more hopes—ranging from the improvement of British industrial design to the moral reform of the working classes—were pinned to the print trade, it gained political, as well as artistic and commercial, clout. Members of Parliament such as Thomas Wyse actively campaigned for the dissemination of fine art in affordable forms.[17] Numerous parliamentary select committees were established to examine and debate various aspects of the print market and its value to society, including art unions, copyright violation, professional recognition of engravers, and the print's impact on art education.

Throughout most of the Victorian period, painters had the right to sell their canvases and the corresponding copyrights as separate entities.[18] Publishers, who were often picture dealers, printsellers, or both, mediated between artists and the public. It was not unusual for them to commission pictures specifically for reproduction, and if a painting did not prove a critical and popular

as *The Father's Leave-Taking* (fig. 7). In this work, a portrait of his wife and son, the artist elevated the theme of maternal love and duty by giving the figures the monumental presence of classical statuary. Reproductive prints after Holman Hunt were particularly in demand; chock-full of sacred symbolism and glowing with spiri-

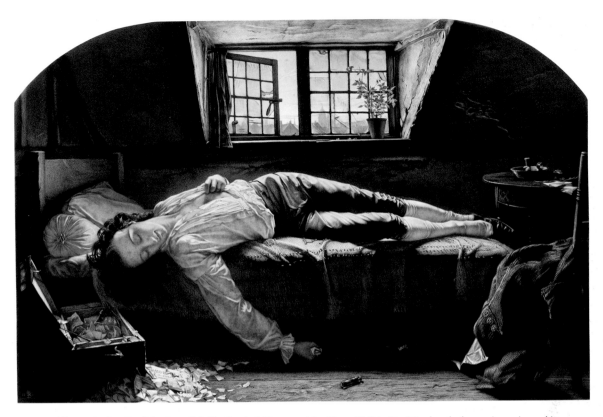

FIGURE 5. Thomas Barlow (English, 1824–1889). *The Death of Chatterton* (after Henry Wallis), 1860. Mixed method engraving on ivory chine mounted on off-white plate paper; image 60 x 82.7 cm (23 ⅝ x 32 ½ in.), sheet 80.5 x 106.6 cm (31 ¾ x 42 in.). Sara R. Shorey Endowment, 1997.659.

success there would be little demand for its prints. To minimize their risks, publishers tended to favor a small handful of highly fashionable artists—Holman Hunt, Landseer, and Millais most prominently—whose works would be assured a profitable reception by the art buying public. This practice in turn fostered a kind of monopoly over the print market and, by extension, over the art market in general.

The demand for prints of popular modern subjects was so great that publishers were encouraged to pay astounding fees for engraving rights. Possibly the highest of these was the £10,500 that Thomas Agnew paid Holman Hunt in 1874 for *The Shadow of Death* and its copyright, which led to the massive success of Stacpoole's engraving (fig. 8). Proceeds from the sale of its proofs alone came to more than £20,000.[19] Such transactions netted fortunes for successful publishers, who became known as the "princes" of the art world. By providing an incentive to pay generously for paintings and their copyrights, the avid demand for prints drove the prices of modern British art increasingly higher, reinforcing its status as an economic investment.

Salable copyright also influenced the art trade in other ways. Careers could be made or destroyed according to a painter's success on the reproduction market. Millais, one of the most frequently engraved artists of the Victorian period, owed his lavish annual income of £25,000 to £40,000 mainly to copyright sales. It was in part the economics of the popular print market, coupled with critical hostility, that persuaded him to abandon his early attempts at artistic reform in favor of giving the public what it wanted.[20] *The Proscribed Royalist*, published in 1858 as a stunning mixed method engraving (fig. 1), was one of a series of paintings of star-crossed lovers that Millais painted and released in printed form between 1857 and 1864.[21] The arrival of each new work in this series was an event, with customers scrambling to obtain the latest one. The theme of staunch love and loyalty in the face of the wrenching demands of war and politics was exactly the kind of uplifting, sentimental message the government promoted and the public hungrily pursued.

British artists could exercise a great deal of control over their reputations, as well as the view posterity would take of them, by deciding themselves which of their paintings would be engraved and which would not. Indeed, most of their continental admirers would have known their works almost exclusively through the circulation of reproductive prints. If a painter and his patron or publisher determined early on to have a work engraved, this inevitably affected both the choice of subject matter and how to treat it. Artists often altered a work's style when they were midway through a canvas, when it was specified which reproductive medium would be used and who the engraver would be. For instance, the choice of William Henry Simmons to engrave *The Proscribed Royalist* was a carefully considered one; his varied and flexible style of mixed method engraving was perfectly matched to Millais's painting, which plays the rich, satiny fabrics of the young woman's dress off against the tangled undergrowth of the forest where her lover is hiding.

Throughout most of the nineteenth century, reproductions—whether engravings, mezzotints, or plaster casts—were prized for their ability to convey both the form and the content of their originals. The medium of translation seems to have been virtually transparent to most mid-Victorian viewers and the unique facture of the original of minor significance. "The print indeed exhibits all the characteristics of the painter," was the type of approving comment generally made by reviewers of newly published prints.[22]

The prevailing intaglio techniques of mezzotint, stipple, mixed method, and pure line engraving each possessed strengths and limitations that made them suitable for translating different kinds of pictures. The

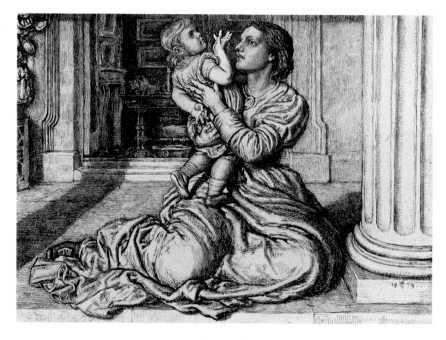

FIGURE 6. John Everett Millais (English, 1829–1896). *Saint Agnes of Intercession*, 1850. Etching on cream laid paper; image 11.6 x 18.6 cm (4 9/16 x 7 5/16 in.), sheet 22.7 x 29.7 cm (8 15/16 x 11 11/16 in.). Promised gift of Dorothy Braude Edinburg to the Harry B. and Bessie K. Braude Memorial Collection, 160.1992.

FIGURE 7. William Holman Hunt (English, 1827–1910). *The Father's Leave-Taking*, 1879. Etching on ivory laid paper; image 18.7 x 25 cm (7 3/8 x 9 7/8 in.), sheet 33.1 x 47.6 cm (13 x 18 3/4 in.). Promised gift of Dorothy Braude Edinburg to the Harry B. and Bessie K. Braude Memorial Collection, 127.1992.

desire for heightened cheapness, novelty, and speed produced an unprecedented fever of innovation in the middle decades of the century. By 1859 the printer W. J. Stannard could list 156 different reproductive techniques in his book *Art Exemplar*.[23] Despite this welter of new processes, intaglio techniques such as engraving and mezzotint, in which lines and marks are incised with various tools into a metal plate, remained paramount for the reproduction of original paintings throughout most of the Victorian era. Pure line engraving, in which variations in tone could only be achieved by painstakingly varying the intervals between lines, was traditional during the eighteenth century but was tremendously time consuming: ten large works could employ one artist for thirty years. Although esteemed as the highest form of printmaking, this approach was competing with quicker intaglio methods by the mid-Victorian period, with mixed method engraving and mixed mezzotint emerging as the dominant processes.[24]

A mixed method engraving could be produced in less than a year because it employed as many as five different intaglio techniques on a single plate. Artists could suggest tonal gradations by using aquatint, etching, mezzotint, or stipple, while rendering elements of the composition in line engraving, which gave the much-prized appearance of a high finish. Engravers also used mechanical devices such as the ruling machine, particularly for filling in large background areas with monotonous but regular patterns of lines and dots. Publishers and engravers particularly favored the combination of line engraving and stipple (or "dotting"), since they were able to hire unskilled workers to do the stippling cheaply.[25] In the hands of a master like Simmons, the stipple technique could be exploited to achieve extraordinary atmospheric effects, such as the rays of the lantern in *The Light of the World* (fig. 3).

Mezzotint, which involved rocking the entire surface of the plate until it would print a deep, rich black and then burnishing back the light areas, was much faster than engraving in part because assistants could prepare

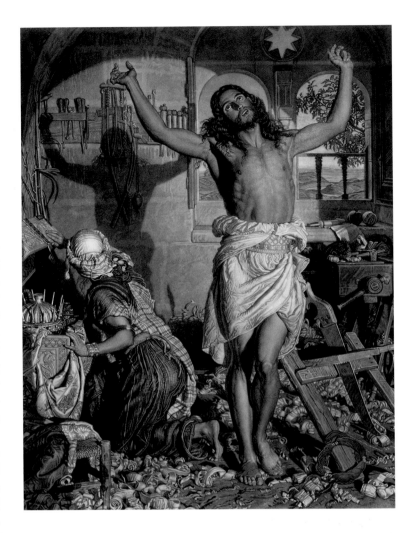

FIGURE 8. Frederick Stacpoole (English, 1813–1907). *The Shadow of Death* (after William Holman Hunt), 1878. Mixed method engraving on ivory chine mounted on off-white plate paper; image 102.3 x 79 cm (40 ¼ x 31 ⅛ in.), sheet 130 x 100 cm (51 ⅛ x 39 ⅜ in.). Sara R. Shorey Endowment, 1997.657.

the plate. Due to its potential for velvety blacks, luminous highlights, and a wide range of intermediate tones, it was especially well suited to reproducing oil paintings, particularly nocturnal images of subjects in which light effects played a critical role (for example, figs. 4, 10). Practical and popular during the eighteenth century, mezzotint remained in use throughout the Victorian era thanks to the introduction of steel plates, which could yield as many as 20,000 to 30,000 impressions.[26] This innovation was generally praised for its democratizing effect, since refined images could now be achieved by

means of mass production. The *Art Journal* of 1850, for instance, credited the steel plate with "improving the taste, and cultivating a love for the beautiful in Art and Nature" among "the great masses of society" who once could afford only "objects that ministered to a depraved taste."[27]

Despite the popularity of mezzotints and engravings, print production during the first half of the 1800s was marked by the engravers' constant struggle for professional recognition.[28] Oddly enough, it seems to have been the very laboriousness of their work that contributed to the relatively low regard in which they were long held. As late as 1853, John Ruskin reinforced the view of the engraver as humble artisan and slavish copyist:

When you spend a guinea upon an engraving, what have you done? You have paid a man for a certain number of hours to sit at a dirty table in a dirty room, inhaling the fumes of nitric acid, stooping over the steel plate, on which,

by the help of a magnifying glass, he is, one by one laboriously cutting out certain notches and scratches of which the effect is to be the copy of another man's work. You cannot suppose you have done a very charitable thing in this![29]

While the engravers saw themselves as artists specializing in interpreting pictures and translating them into other media, the public was clearly only interested in their ability to replicate the original exactly. Reviewers for the *Art Union* praised them only when they succeeded in hiding the signs of their own labor, awarding compliments such as this: "His manner is forcible and spirited, as well as accurate: he aims to show the painter rather than himself; and the productions of his burin are always singularly true to the originals he copies."[30] Ironically, by the time engravers achieved higher status at mid-century, their livelihood was within a generation of extinction, as handwork became rapidly replaced by mechanical and photomechanical methods for fine-art reproduction.

Of course, the positive side of the gigantic demand for engravings was that there was plenty of work to go around, a major change from the situation at the turn of the nineteenth century, when the book trade provided the only regular employment. By the 1850s Holman Hunt himself was lamenting the difficulty of "obtaining a first-rate engraver who is disengaged."[31] Artists recognized the importance of securing the services of the best engravers, and just as most painters became associated with a specific reproductive medium that suited the translation of their style, many formed associations with a particular engraver; for example, Simmons, one of the period's most sought-after line and stipple engravers, was considered ideal for transforming Millais's and Holman Hunt's painted images into print (see figs. 1, 3).

If engravers labored in obscurity, publishers and printsellers became the acknowledged governors of the English art world, enjoying profits that brought them respect for their business acumen and allowed some to establish themselves in high society. Indeed, by the 1840s the average annual income of the top twenty publisher-printsellers in London was calculated at £16,000.[32] This is a huge sum in view of the fact that an annual living of £250 could support an entire family as late as 1860 and that between

FIGURE 9. Samuel Cousins (English, 1801–1887). *Miss Julia MacDonald* (after Thomas Lawrence), 1830/31. Mezzotint on ivory wove paper; image 23.1 x 19.2 cm (9 1/8 x 7 9/16 in.), sheet 51.4 x 42 cm (20 1/4 x 16 1/2 in.). Gift of Walter S. Brewster, 1928.772.

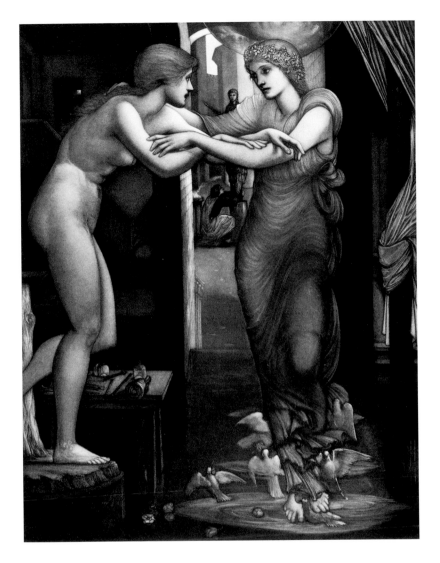

FIGURE 10. Charles William Campbell (English, 1855–1887). *The Birth of Galatea* (after Edward Burne-Jones), 1885. Mezzotint on buff ivory chine mounted on off-white plate paper; image 34.1 x 45 cm (13 3/8 x 17 3/4 in.), sheet 40.9 x 41.5 cm (16 1/8 x 16 3/8 in.). Robert Chase, Hannan, and Prints and Drawings Purchase endowments, 1996.50.

each of these would have been used to make thousands of impressions—sometimes as many as 30,000—driving the total number of legally circulated copies well into the millions.[34]

In this period, a complex pricing structure came to be widely and systematically adopted by dealers of reproductive prints. This system was designed to convince consumers that the more they were willing to pay for an engraving, the more rare the work, and the better their investment. In actuality, virtually all such works were mass-produced, so claims regarding the uniqueness and impression quality of "proofs" remained largely a marketing device with little basis in fact. For example, in 1860 the powerful publisher Ernst Gambart recorded his plans for an engraving of Holman Hunt's *Christ in the Temple*: "I propose to Print from 1000 to 2000 artist's proofs at 15 G[uinea]s, 1000 Before letters Proofs at 12 Gs, 1000 Proofs at 8 Gs, & I hope 10,000 Prints at 5 Gs."[35] By positioning prints as scarce, valuable commodities in this way, entrepreneurs such as Gambart were able to simultaneously stimulate and satisfy a huge volume of demand.

The dealer system, however, was only one means by which prints were distributed. Another was the Art Union of London, founded in 1837 with the goal of "extending the love of the Arts of Design throughout the United Kingdom" and giving "encouragement to artists beyond that afforded by the patronage of individuals."[36] One of many similar societies that sprang up in the Victorian climate of social reform, the Art Union attempted to integrate art education and support by making "cheap art good and good art universal."[37] It also, however, embraced new mechanical technologies such as steelfacing and electrotype and established a distribution network of unprecedented scope, thereby achieving its democratic mandate of expanding the art-buying public.[38] From the outset, the organization embraced the broadest possible audience, directing its attentions as

£800 and £1,000 allowed one to live in "good society."[33]

The emergence of printselling and publishing as sound, highly respected businesses was accompanied by significant growth in the profession and, inevitably, by increased competition. In William Hogarth's time, twelve printselling shops conducted business in London. By 1839 there were recorded seventy-two printsellers and publishers in operation, a number that had grown by the 1880s to approximately 125. Between 1847 and 1894, 4,823 plates were registered with the Printsellers Association;

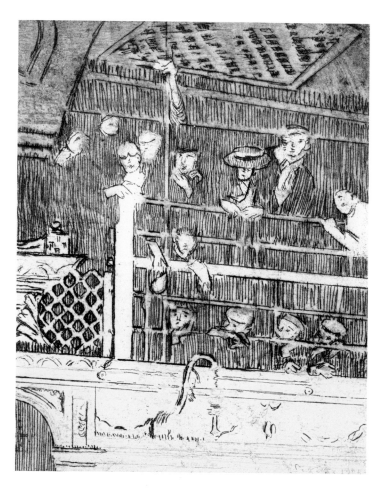

FIGURE 11. Walter Sickert (English, born Germany, 1860–1942). *The Old Mogul Tavern, Drury Lane*, 1908. Etching on cream laid paper; image 20.5 x 15.5 cm (8 1/16 x 6 1/8 in.), sheet 31.4 x 26.2 cm (12 3/8 x 10 5/16 in.). Promised gift of Dorothy Braude Edinburg to the Harry B. and Bessie K. Braude Memorial Collection, 234.1992.

much to the provinces and colonies as to the capital. Ironically, even though the art unions disseminated impressions of low quality they did encourage a more realistic, appropriate understanding of their value. Unlike the printsellers, whose trumped-up hierarchy of "proofs" was designed to obscure the mass-produced nature of their offerings, the art unions had no such pretensions. They published and marketed their prints according to a different criterion: affordability. Subscribers paid one guinea for their prints, knowing full well that they received the same work as thousands of others across the vast British Empire.

In the second half of the century, the growing use of photomechanical techniques for reproduction dramati-

cally undercut the print's status in British culture. Inexpensive and quick to publish, this new breed of image began to erode the established engraving trade after 1860, helping to bring about the end of an era. At the same time, creators of photographically produced copies were able to stake a new claim to objectivity, making hand-engraved reproductions suddenly suspect as works of subjective interpretation.

The repercussions of this sea change were enormous. By the end of Queen Victoria's reign in 1901, the engraver's profession had all but died out. Many artists no longer wanted an engraver mediating and translating their work for the public; likewise, many collectors were no longer satisfied with the large, highly finished prints produced by professional engravers, preferring instead the intimacy of original drawings or prints that revealed the unique touch of the artist's own hand. At the same time, a new curiosity about and hunger for a closer look at originals, piqued by photographic reproductions, helped to stimulate revivals of original printmaking by painters—especially among the avant-garde—in the decades after 1860. These artistic movements, which were paralleled by similar developments on the Continent, were influential in bringing about modernist definitions of art. As the golden age of the reproductive engraving waned, the modern print became a nondidactic, individually produced object, the result of creative genius freely exercised.

In England, painter-printmakers active in the late Victorian period included Walter Sickert and Theodore Roussel. Both students of James McNeill Whistler, they adopted the American master's unorthodox approach, opposing the highly finished look, moralistic subjects, and techniques of mass distribution that the engraving trade traditionally supported. Sickert, for example, used a lively, idiosyncratic etching style to capture the vivacity of a London dance hall in *The Old Mogul Tavern, Drury Lane* (fig. 11). Roussel's *The Agony of Flowers* (fig. 12) is the result of the artist's highly experimental approach to printmaking. He created both color and black-and-white versions of the subject, searching for the perfect means for expressing the melancholy mood evoked by a vase of dying flowers. Such prints were

never intended to please the crowd or convey moral lessons. Instead, they responded to a new breed of connoisseurs who wished to distinguish themselves from the masses by demonstrating their preference for a few suggestive strokes of genius over the hard labor of reproductive engravers.

Today, despite the adoption of replication and appropriation strategies by some Postmodern artists, reproductions and copies remain largely devalued. As we have seen, however, the marketing and acceptance of reproductive engravings as works of fine art—and the important role accorded to copies, reproductions, and versions in the Victorian art world in general—point to that culture's quite different willingness to value translations in place of the real thing. At their best, these reproductive prints are sensuously beautiful objects. Created by professional engravers who were gifted artists in their own right, they helped transform Victorian consumers into an engaged, art-collecting public.

FIGURE 12. Theodore Roussel (English, born France, 1855–1926). *The Agony of Flowers*, 1890/95. Etching, soft-ground, and aquatint on cream wove paper; 45 x 34.9 cm (17 ¾ x 13 ¾ in.). John H. Wrenn Memorial Endowment, 1997.426.

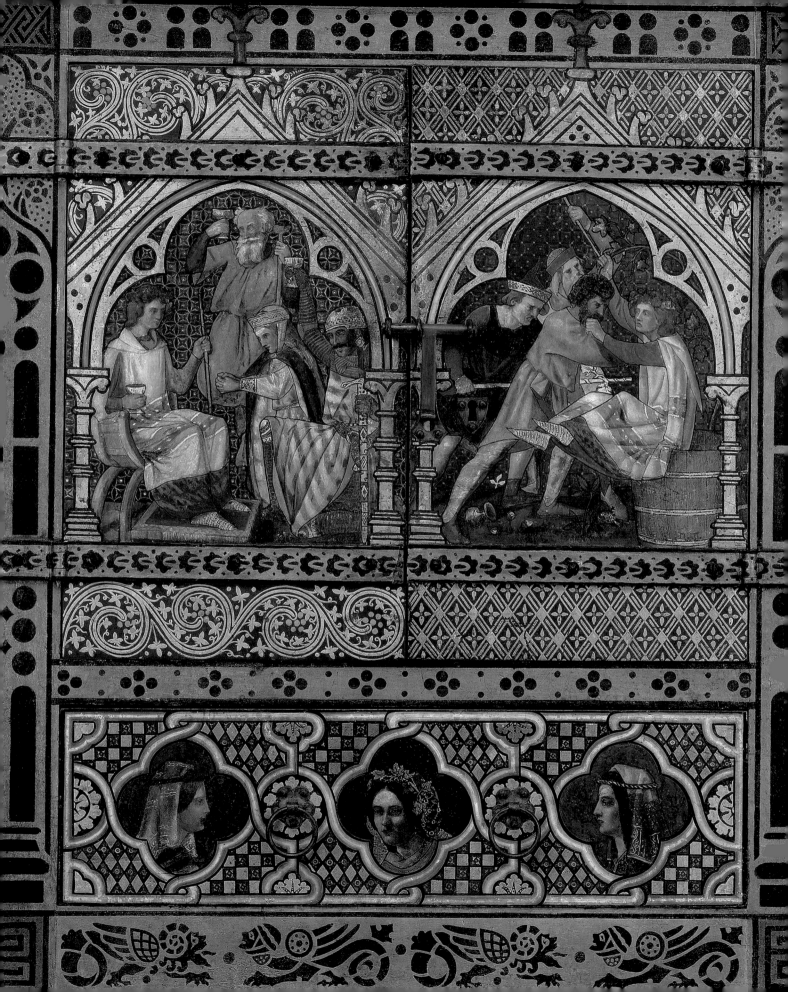

Telling Stories in the Gothic Vein:
William Burges and the Art of Painted Furniture

Ghenete Zelleke

Samuel and M. Patricia Grober Curator of European Decorative Arts

I was brought up in the thirteenth-century belief and in that belief I intend to die.

William Burges, 1876[1]

In 1999 the Art Institute of Chicago acquired a sideboard and wine cabinet richly painted and gilded with narrative scenes, allegorical portraits, and ornament (fig. 2). Last seen in public at the 1862 International Exhibition in London (fig. 3), it was designed by the artist-architect William Burges and painted by Nathaniel Hubert John Westlake, and is the most complex of several related pieces that Burges conceived and exhibited in the years between 1858 and 1862 (see figs. 9–11).

Burges was born in 1827, the son of a successful civil engineer, and studied at Kings College School, London, before being apprenticed to Edward Blore, Surveyor of Westminster Abbey, and later to Matthew Digby Wyatt, special commissioner to the Great Exhibition of 1851.[2] He subsequently partnered with the architect Henry Clutton, with whom he entered and won the 1855 competition for Lille Cathedral.[3] Independence rather than partnership seemed to suit Burges best, however; the freedom that his private income provided allowed him to strike out on his own in 1856 and pursue his passion for re-creating a world of Gothic fantasy in his architectural, interior design, and applied arts projects.

Burges was deeply versed in history, philosophy, and sacred as well as secular literature, and intimately familiar with the allegories, fables, and myths that he used to give life to his architecture and furniture. A prolific lecturer and writer, he published numerous exhibition reviews and a volume of lectures under the title *Art Applied to Industry* (1865). In that work, he discussed the origins and development of various branches of the decorative arts, including furniture, glass, metalwork, pottery, and textiles.

Burges's education was also stimulated by extensive travel: between 1853 and 1854, he toured more than forty towns and cities in France and Italy on what he called his "long journey."[4] He indulged this enthusiasm in succeeding years, returning often to France and Italy and occasionally exploring parts of Greece, Ireland, Switzerland, and Turkey. He ranged constantly within England and Wales, visiting cathedral towns and the homes of friends and clients, including John Patrick Crichton-Stuart, 3rd Marquess of Bute, whose Cardiff Castle in Wales was a main focus of his creative efforts from 1865 onward.[5]

FIGURE 1. Detail of the central bay of William Burges's *Sideboard and Wine Cabinet* (fig. 2), showing the second and third episodes in the painted narrative of Saint Bacchus's "martyrdom." Visible below are "portraits" of Sherry, Claret, and Port.

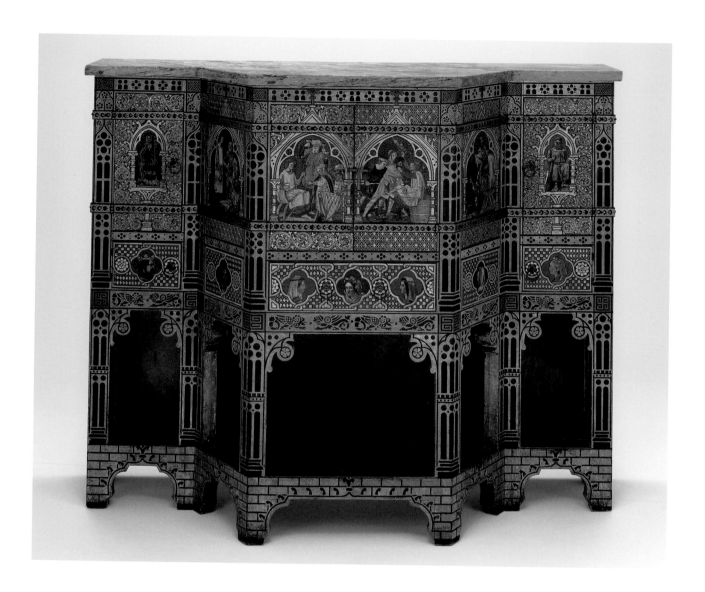

FIGURE 2. William Burges, designer (English, 1827–1881). Nathaniel Hubert John Westlake (English, 1833–1921), painter. Harland and Fisher, London, manufacturer. *Sideboard and Wine Cabinet*, 1859. Pine and mahogany, painted and gilt, iron straps, metal mounts, marble; h. 126.5 x 157 x 58 cm (49 ¾ x 61 ¾ x 22 ¾ in.). Restricted gifts of the James McClintock Snitzler Fund through the Antiquarian Society, Mrs. DeWitt W. Buchanan, Jr., Mr. and Mrs. Henry M. Buchbinder, Mr. and Mrs. Stanford D. Marks, Mrs. Eric Oldberg, Harry A. Root, and the Woman's Board in honor of Mrs. Gloria Gottlieb; Harry and Maribel G. Blum Foundation, Richard T. Crane, Ada Turnbull Hertle, Mr. and Mrs. Fred A. Krehbiel, Florence L. Notter, Mr. and Mrs. Joseph R. Varley, and European Decorative Arts Purchase endowments; through prior acquisitions of Robert Allerton, the Antiquarian Society, Mr. and Mrs. James W. Alsdorf, Helen Bibas, Mrs. E. Crane Chadbourne, Mr. and Mrs. Richard T. Crane, Jr., The R. T. Crane, Jr., Memorial Fund, H. M. Gillen, George F. Harding Collection, Mrs. John Hooker, and the Kenilworth Garden Club, 1999.262.

Burges (fig. 4) emerged as one of the most important and colorful champions of the Gothic Revival in mid-nineteenth-century Britain. A generation younger than the architect and designer Augustus Welby Northmore Pugin, who had advocated a return to the Gothic as the only true Christian architecture for England, Burges also promoted the close study of Gothic structures and furnishings, writing that "we may learn very nearly all we want to learn if we go to the Middle Ages."[6] Of medieval interiors in particular, he claimed, "the great feature . . . is the furniture; this, in a rich apartment, would be covered with paintings, both ornaments and subjects; it not only did its duty as furniture, but spoke and told a story."[7] At the same time, he admitted that,

because so little survived, it was "almost impossible for us . . . to conceive the effect of a first-class piece of mediaeval sacred furniture, covered with burnished gilding engraved and punched into patterns, enriched with paintings by an artist like Giotto, and glittering with mosaics of gilt and coloured glass."[8]

Burges did, however, identify some models, using them to re-create modern versions complete with painted narratives. In the 1840s and 1850s there appeared a spate of illustrated volumes—including works by César Daly, Adolphe-Napoléon and Édouard Didron, Eugène-Emmanuel Viollet-le-Duc, and Ludovic Vitet—that illuminated the architecture and furniture of the French Middle Ages, particularly the thirteenth century.[9] These appealed to Burges's taste, since he was of the opinion that "early French art [was] more suited to the requirements of the present day than any other phase of Mediaeval architecture."[10] As a contemporary observed in 1859, he was especially inspired by the painted furniture in these books:

> In following up this peculiar style of painted furniture, Mr. Burges has apparently been guided, in a great measure, by the early examples which have lately attracted the notice of Mediaeval architects and of archaeologists, and which have been illustrated by M. Viollet-le-Duc . . . M. Caesar Daly . . . and M. Didron. . . . We allude especially to the cabinet of the thirteenth century preserved in the cathedral of Bayeux, and that of Noyon, of somewhat later date, composed . . . in the form of a building, and covered externally and internally with paintings on canvas of saintly legends and single figures.[11]

These two cabinets, or armoires, were rare survivors that had retained their painted and gilt religious figures and narrative scenes. While the Bayeux Cabinet was published as early as 1852, it is unclear when Burges actually became aware of it.[12] That question can be answered with confidence for that of Noyon. Burges visited the city on his "long journey" of 1853 and documented the cabinet in the cathedral, where it was housed.[13] In a diary entry of 1856, he referred to "Didron," one of the editors of *Annales archéologiques*, a periodical that published an illustration of the Noyon Cabinet (fig. 5) as early as 1846. Burges also acknowledged the crucial example of the architect and theorist Viollet-le-Duc, whose publica-

FIGURE 3. Stereoscopic view of the Medieval Court in the International Exhibition, London, 1862. Courtesy Victoria and Albert Museum, London.

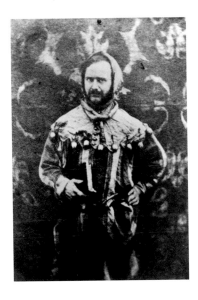

FIGURE 4. William Burges in fancy dress, c. 1860. Courtesy National Portrait Gallery, London.

tions shaped his understanding of French Gothic furniture. It was Viollet-le-Duc who issued the first color image of the Noyon Cabinet in his *Dictionnaire raisonné du mobilier français*, to which Burges paid tribute by admitting: "We all crib from Viollet-le-Duc . . . although probably not one buyer in ten ever reads the text."[14]

These cabinets and the scholars who explored them were not the only influences that Burges brought to bear on his own work, however. He was also familiar with the furniture and painted interiors of the Italian Renaissance, both from his travels[15] and from reading Giorgio Vasari's profile of the painter Dello Delli in his *Lives of the Most*

Eminent Painters, Sculptors, and Architects.[16] In his account, Vasari referred to Delli's specialty decorating *cassoni*, or marriage chests, with "fables taken from Ovid, or other poets; or narratives related by the Greek and Latin historians; but occasionally they were representations of jousts, tournaments, the chase, love-tales, or other similar subjects."[17]

Color was intensely important to Burges, who protested that there was no reason "why we should not have buildings in smoky London glowing with imperishable color."[18] In designing painted furniture and interior decorations, he often combined gilding with intense, heraldic hues reminiscent of those found in medieval manuscripts and stained-glass windows. This brilliant treatment was typically applied to flat surfaces and differed from the monochromatic, heavily carved work of architects such as Pugin. Even William Morris and his circle, when painting furniture in the years up to 1862, generally employed more subdued tones rather than radiant colors.

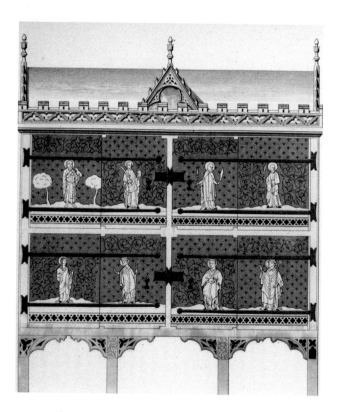

Burges designed the Art Institute's sideboard as a rectangular cupboard that features a projecting central bay and is raised above a lower shelf by eight sturdy legs (see fig. 2). He planned the painted scenes across the front and sides, along with the row of portrait heads below, to be viewed as two stories of stained-glass windows. Burges set these within the framework of a Gothic-inspired building whose vertical and horizontal elements are stenciled with tracery and arcades, the whole supported by a rusticated foundation. The cabinet was first exhibited at London's Ninth Architectural Exhibition in 1859, when it was described variously as a "sideboard and wine cabinet" and a "sideboard and wine cooler," and attributed to S. Fisher of the London cabinetmaker Harland and Fisher.[19] Nathaniel Westlake, who executed the painted decoration, is best known for his later stained-glass designs and would have undertaken this project early in his career.[20]

The four principal panels appear on the central bay, where they illustrate the martyrdom of Saint Bacchus, after a fourteenth-century French poem that was published in an anthology of medieval literature in 1839 and excerpted in the catalogue of the Ninth Architectural Exhibition.[21] While feeding the hungry, healing the sick, and consoling the unfortunate were regarded as saintly attributes, the poet recognized the same virtues in wine. In his verse, he canonized the beverage—not to mention its personification, Bacchus—in a playful hagiography in which he lamented the grape's "martyrdom." The poem's combination of Christian and pagan iconography was particularly alluring to Burges, who repeatedly used such contrasting imagery on his painted furniture. The designer also preferred to ornament these pieces with scenes that suggested their actual function: here, for instance, the story of Bacchus reflects the sideboard's use for serving and storing wines.

Westlake depicted Saint Bacchus in a striped, hooded cassock, with a crown of grapevines adorning his head. In the first two episodes (see figs. 6, 1), the saint offers goblets of wine to his inebriated companions, who toast him in return. These scenes dramatize a moment in the poem which tells how "Saint Bacchus is sought by people from beyond the seas and from every land. . . . He calms the angry, removes the constraints from others and makes them run and play; he strengthens the weak; to the dying he brings life, and a healthy

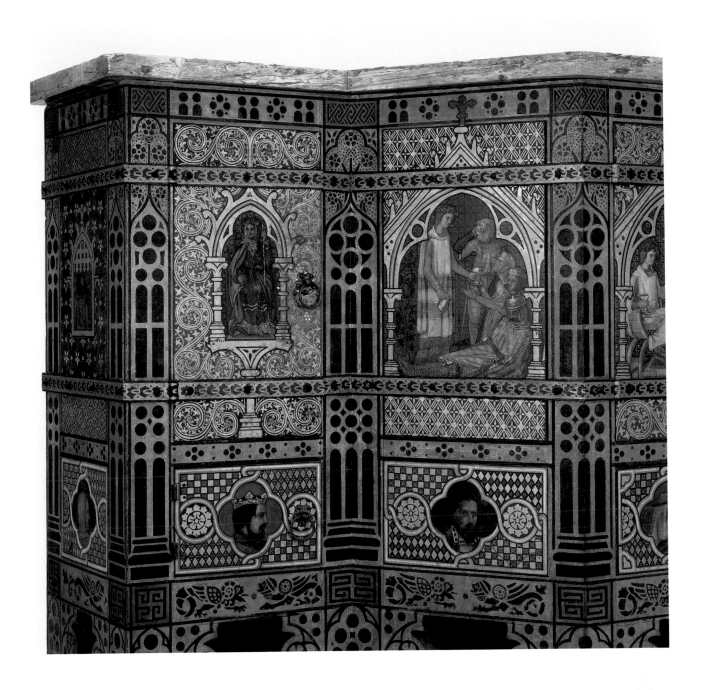

FIGURE 6. Detail of the cabinet's left side, showing (at center right) the first painted episode. Visible below are images of the wines Burgundy and Tent, which are perhaps portraits of Burges's friends.

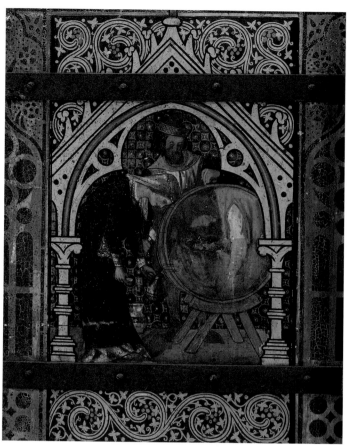

FIGURE 7. Detail of the cabinet's right side, showing its condition before conservation. Visible along the left column is varnish damage caused by dripping liquids; brown flyspecks dot the surface. At the far left of the top strap is a trace of the original painted design. Also visible are the gilding and semitransparent glazes used to define the lower contour of the female figure's robe.

They are, reading from left to right, Rhine, Burgundy, Tent, Sherry, Claret, Port, Madeira, Champagne, and Cyprus (see fig. 2). The three women in the center, emblematic of Sherry, Claret, and Port, are portrayed with increasingly dark hair colors that reflect the potency of the wines they represent (see fig. 1). The profile of Champagne, which appears on the far bottom right of the cabinet front, is especially beautiful, her head garlanded with grapevines bearing fruit (see Heye, fig. 2). One Victorian critic, however, characterized her as "perhaphs too coquettish."[24] It has been suggested that some of these heads may indeed be portraits of Burges's friends, as it was not unusual for him to incorporate their likenesses in other examples of his painted furniture.[25] Might Burgundy (see fig. 6), personified by a dark-haired prince wearing a crown, depict the artist Dante Gabriel Rossetti, or the full-faced, dark-haired and bearded Tent to the right—representative of a deep red Spanish wine— be a picture of the designer Owen Jones? The especially vivid rendering of these faces, along with that of Claret, at center, suggests that they may be actual as well as symbolic portraits.

Burges also showed a selection of drawings at the 1859 exhibition. These detailed a number of designs that had been planned or executed during the previous year, including a pigeonhole cupboard decorated with subjects related to architecture; a bookcase and escritoire depicting the history of Cadmus and various descriptions of writing; a sideboard featuring a dispute between wines and beers; a wardrobe with figures emblematic of flax and wool; and a buffet ornamented with a sculptured figure representing the sun.[26] This was a productive period for Burges, a time in which his painted furniture was executed by a coterie of artists including Thomas Morten and Edward John Poynter (see cats. 4, 9–10), some of whom were associated with the Pre-Raphaelite painters. Burges was also fortunate in his early clients, the most important being the wealthy Herbert George Yatman, for whom he designed his best-known piece of furniture, the monumental cabinet and writing desk, or escritoire, mentioned above, now in the Victoria and Albert Museum, London (see fig. 8).[27]

complexion, and good blood."[22] In the third vignette (see fig. 1), three ruffians push the saint backward into a cask. The final panel (fig. 7) shows the martyred Bacchus imprisoned in an oak barrel from which one of his admirers draws fine wine—his blood. This scene illustrates another verse of the poem: "Then worse is done, for they put this liqueur in prison, sealed and shut, in what is called a barrel."[23] Lest this paean to wine become intoxicating, however, the inside surfaces of the two central doors are painted with heads representing Sobriety and Temperance, reminding the cabinet's owner to be judicious when taking his pleasures.

Across the front and sides of the cabinet Burges rendered "portraits" of nine different wines framed by quatrefoil reserves, identifying each with an inscription.

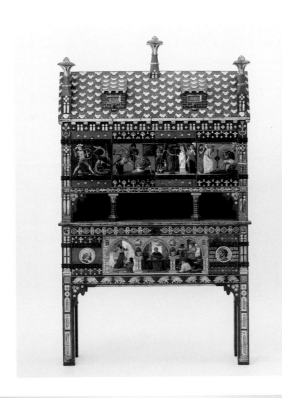

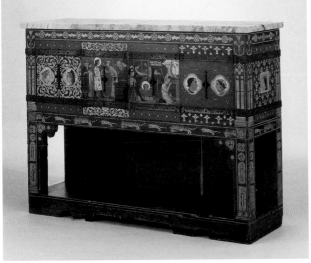

FIGURE 8. William Burges, designer. Edward John Poynter (English, 1836–1919), painter. Harland and Fisher, manufacturer. *Yatman Cabinet*, 1858. Pine and mahogany, painted, stenciled and gilt, with metal leaf, lock and hinges of iron; 236 x 140 x 40.5 cm (92 x 55 x 16 in.). Victoria and Albert Museum, London. Given by Lt. Col. P. H. W. Russell, 217–1961.

FIGURE 9. William Burges, designer. Thomas Morten (English, 1836–1866), painter. Harland and Fisher, manufacturer. *Saint Bacchus Sideboard*, 1858. Stained, painted, and gilt wood with marble and iron; 105.4 x 139.1 x 43.2 cm (41 ½ x 54 ¾ x 17 in.). Detroit Institute of Arts, gift of Mr. and Mrs. E. Cunningham, F82.50.

The Yatman Cabinet, one of Burges's most architectural designs, was inspired by the Noyon armoire in such details as its high, pitched roof, double tiers of imagery, and tall, square-sectioned legs. In keeping with his principle of indicating a piece's function through its painted decoration, Burges adorned it with metaphors for writing. The upper level shows scenes from the life of Cadmus, who is said to have introduced the alphabet to Greece; the lower contains allegories of engraving, printing, and writing, represented by vignettes of an Assyrian engraving a wall, Dante Alighieri writing the *Divine Comedy*, and England's first printer, William Caxton, at his press. Also designed for Yatman was a sideboard or buffet (fig. 9) painted with two figural episodes, one entitled "Saint Bacchus Disputeth with Water" and the other the "Martyrdom of Saint Bacchus." According to one critic, the latter shows "the great martyr tortured in a press" and "his shrine adored by jovial pilgrims, with silver-headed champagne-bottles tied to their staves."[28]

The piece of furniture that most closely parallels the Art Institute's sideboard is the Sun Cabinet of 1859 (fig. 10), now missing its original backboard, which supported a carved figure holding the sun's orb.[29] In form, it echoes the projecting central portion of the Art Institute's example, and its ornament is no less similar. Both works, for instance, possess figural panels that are enclosed by vertical uprights stenciled with Gothic arcades and tracery; horizontal friezes that frame the upper and lower registers of the doors; iron strapwork painted with overlapping flower heads; and repeating, stenciled motifs of winged gargoyles.

The Art Institute's cabinet reappeared three years later at the London International Exhibition of 1862, where it held pride of place in the Medieval Court that Burges designed for the Ecclesiological Society.[30] In stereoscopic views of the installation (see fig. 3), the cabinet appears to have been fitted with a shaped and mirrored backboard, its surfaces laden with a variety of glass and metal vessels. This backboard was not described in an otherwise detailed entry that appeared in the 1859 exhibition catalogue, which implies that it was made later, perhaps specially for the 1862 display.[31]

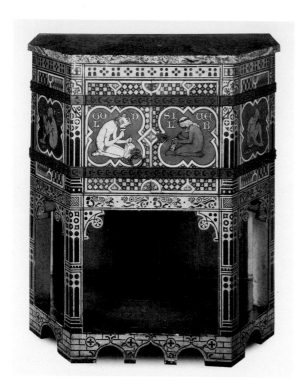

FIGURE 10. William Burges, designer. Attrib. Edward John Poynter, painter. Harland and Fisher, manufacturer. *Sun Cabinet*, 1858/59. Softwood (pine?) painted in oil with marble top and iron straps; 105.5 x 94 x 56.5 cm (41 ½ x 37 ¼ x 32 ¼ in.). Formerly collection of Andrew Lloyd Webber, England.

It was at the latter event that painted furniture was first shown publicly by William Morris and his collaborators Edward Burne-Jones and Dante Gabriel Rossetti. Burges himself celebrated the exhibition as a triumph of painted furniture: "In the Medieval Court there are no less than five exhibitors of furniture, more or less painted. . . . Messrs. Morris, Marshall and Company send six articles, Mr. Burges five." Comparing his creations favorably to those of Morris and Company, he observed, writing in the third person, that "the work of Mr. Burges is equally painted all over, but the tone of colouring is much brighter and the articles are more what would have been found in the houses of the nobility."[32]

Burges flanked the Art Institute's sideboard with the Yatman Cabinet on the right. Others not visible in the stereoscopic view included the so-called Great Bookcase, made for the designer's own use and painted by sixteen different hands.[33] Another piece on display, the Wines and Beers Sideboard (fig. 11), was purchased by London's South Kensington Museum (now the Victoria and

Albert), although that institution's imprimatur did not guarantee the exhibition, or Burges's Medieval Court, uniformly glowing reviews. One critic, for example, dismissed his pieces as "decided nondescripts."[34] Another, more favorable on the subject of painted furniture, presented a rather lyrical description of a future in which, "instead of dull workmen we will employ educated artists and in the place of a bit of polished wood or a coat of flat colour the furniture you buy of us shall be covered with recollections of the stories and poems and histories of the world."[35]

Iconographically sophisticated, highly literate, and rendered in jewel-like tones and gold, the Sideboard and Wine Cabinet in the Art Institute's collection is one of Burges's most accomplished pieces of painted furniture. It vividly conveys the romantic fascination with which Burges and other Victorians looked back upon medieval culture, using and transforming their sacred and secular heritage as a means to reinvigorate the material and artistic aspects of contemporary life.

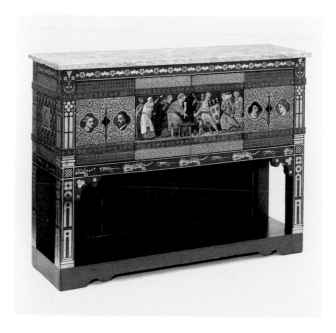

FIGURE 11. William Burges, designer. Edward John Poynter, painter. Harland and Fisher, manufacturer. *Wines and Beers Sideboard*, 1858. Painted and gilded wood with marble top and iron straps; 167.7 x 104.3 x 43.2 cm (66 x 41 x 17 in. Victoria and Albert Museum, London, 8042–186.

Conserving the Art Institute's "Sideboard and Wine Cabinet"

Emily Heye

Assistant Conservator of Objects

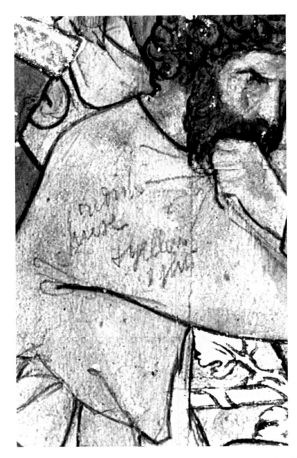

FIGURE 1. This infrared image reveals the color notations on the shoulder of the central ruffian, who appears in the third vignette showing the martyrdom of Saint Bacchus (see Zelleke, fig. 1).

The Art Institute's Sideboard and Wine Cabinet, which clearly had been enjoyed as a piece of functional furniture for many years, presented the museum's conservators with a particularly challenging project. Its doors were dark with handling marks at the upper edges and handles (see Zelleke, fig. 6) and showed evidence of having been forcibly pried open; parts of the lock were missing; rust had pushed the painted design off the iron strapwork; and many surfaces had been compromised by dripping liquids and careless cleaning. From the beginning, our goals were to understand how the work's painter, Nathaniel Westlake, achieved his rich layering of effects, and to mitigate some of the damage in order to recover a sense of the original decorative ensemble.

We were able to determine that Westlake painted the figural panels over several layers of white and colored preparation; he used gilding liberally, shading it with semitransparent glazes on design elements such as armor, crowns, and goblets (see Zelleke, fig. 6). The Gothic arches that frame the painted panels are raised from the surface and are composed of gilding over molded gesso forms. The lower panels, which offer "portraits" of different wines, were painted over a layer of gilding so that Westlake could use the sgraffito technique, in which still-wet paint is pushed aside in decorative patterns, revealing the underlying gold. The fluid, lacy patterns in the scarves of Sherry and Port (see Zelleke, fig. 1) are rendered in this technique. The artist employed metallic tin, ground into a powder, to make the silvery paint on the iron straps.

We examined these paintings using infrared reflectography, a process in which images are made with a camera sensitive to infrared light, which is capable of penetrating through layers of surface paint to reveal features such as preparatory drawings. In this case, the infrared camera captured some of Westlake's written color notations (see fig. 1) and his lively, freehand sketch for the head of Champagne (see fig. 2). The camera's most important contribution, however, was to clarify the decorative scheme on the rusted iron straps (see Zelleke, fig. 1). Infrared light revealed a repeating pattern of black floral shapes on a plain background (see fig. 3), consistent in style with other examples on Burges's furniture (see Zelleke, fig. 10). Working from this infrared image, we constructed a stencil to transfer the pattern onto strips of Japanese tissue and painted them using cues from remaining traces of color. These strips now cover and protect the rusted surfaces, re-creating the original look in a reversible medium. (As is standard in conservation practice, any added materials can be removed with minimal disruption to the original object.)

When the cabinet arrived in Chicago, the two central doors had swelled so much they could not be closed properly. Because the doors are attached to the metal straps rather than hinged to the wood of the cabinet, an elegant solution presented itself: simply by loosening the screws that hold the straps, we were able to pull the right door closer to the right edge of its opening, using a slight gap on this side to relieve pressure on the center edges. We then placed very thin spacer blocks behind the straps on the right side of the projecting bay and retightened the screws to fix the straps in their adjusted position. As a final touch for these doors, the missing lock parts were refabricated, following a model on a similar cabinet in the Victoria and Albert Museum, London (Zelleke, fig. 11).

Beyond this obvious surface and structural damage, though, lay more subtle problems that became apparent as our examination of the gilded surfaces intensified. The gilding itself is covered with a deep yellow varnish with orange added at the corners. Smooth and golden in some areas, this varnish was streaky and very dark brown in others, where it displayed a heavy craquelure, a network of cracks produced by aging. As it was, this darkening effect upset the visual balance between the brightly colored painted panels and their framework of stenciled designs on a gold background. The far right side of the cabinet and the right side of the projecting bay were the most discolored, suggesting that this area had been exposed to the damaging effects of harsh sunlight.

Cleaning tests suggested that the varnish was very tough. When we viewed it under ultraviolet light, it fluoresced a pale yellow-green, a color characteristic of an old drying oil varnish.[1] When a tiny sample was

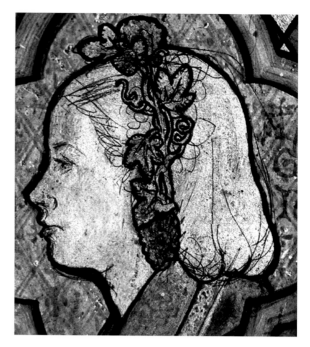

FIGURE 2. The preparatory sketch for the "portrait" head of Champagne, seen at the bottom right of the central bay, as visible in infrared light.

examined with infrared micro-spectrophotometry, a technique used to identify organic coatings, it indeed proved to contain a drying oil such as linseed oil. But the results hinted at a resin component, too degraded to be conclusively identified by this type of analysis. These clues motivated us to make use of a more sensitive technique, pyrolysis gas-chromatography; this process, which breaks molecules into their characteristic fragments, revealed the chemical "fingerprint" of the fossil resin amber.

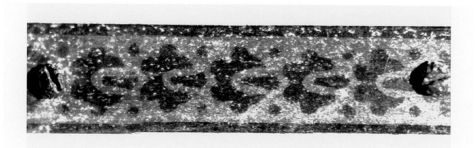

FIGURE 3. Exposing the rusted iron straps to infrared light uncovered the original floral design—stenciled in black onto silvery paint—beneath the surface.

FIGURE 4. A detail of the varnish during cleaning. The upper-right quadrant is uncleaned and shows the darkened, craquelured texture of degraded varnish. Also visible are the tiny losses of yellow varnish caused by flyspecks, which etch into the surface over time.

While recovering this technique probably appealed intellectually to Burges, we believe he also deliberately chose amber varnish for its color, in order to give the gilding an older, more "medieval" character. Cleaning and preserving this coating, therefore, became an extremely important aspect of our efforts to restore the look of the initial decorative scheme. As we began the cleaning process, we chose one stenciled panel as a model because it retained a look that was smooth and uniformly golden in tone. We then applied a gelled solvent to discolored areas, where it slowly turned brown as it worked, indicating the degree to which it was thinning the discolored varnish.[7] After the surface was rinsed carefully, the cleaned areas appeared very much like the model panel (see fig. 4). We then in-painted the areas where gilding was missing and, as a finishing touch, added a stable, non-yellowing varnish where necessary in order to produce a uniform level of gloss. Once we more precisely understood the nature of the damage to the decorative ensemble, both structural and superficial, we were able to design a conservation treatment that would allow the brightly colored central panels to shine out like jewels from a framework of rich and mellow gilding, as the artist clearly intended.

This surprising result suggested that Burges's choice of varnish was largely an aesthetic one, as amber varnishes are always strongly colored.[2] In the early nineteenth century, artists became increasingly interested in exploiting amber's toughness, adapting recipes for varnishes that were traditionally used to protect coachwork.[3] One 1849 treatise, for example, described experiments in adding amber to oil varnishes and directly to oil colors to create especially durable and brilliant coatings.[4] Amber was invariably difficult to dissolve: it was usually ground into a fine powder and then boiled in oils or turpentine for many hours. Otherwise it had to be melted to drive off undesirable components before hot linseed oil was added.[5] While the strength and beauty of the varnish made all this effort worthwhile, researchers also believed they were reviving the lost techniques of their artistic forebears.[6]

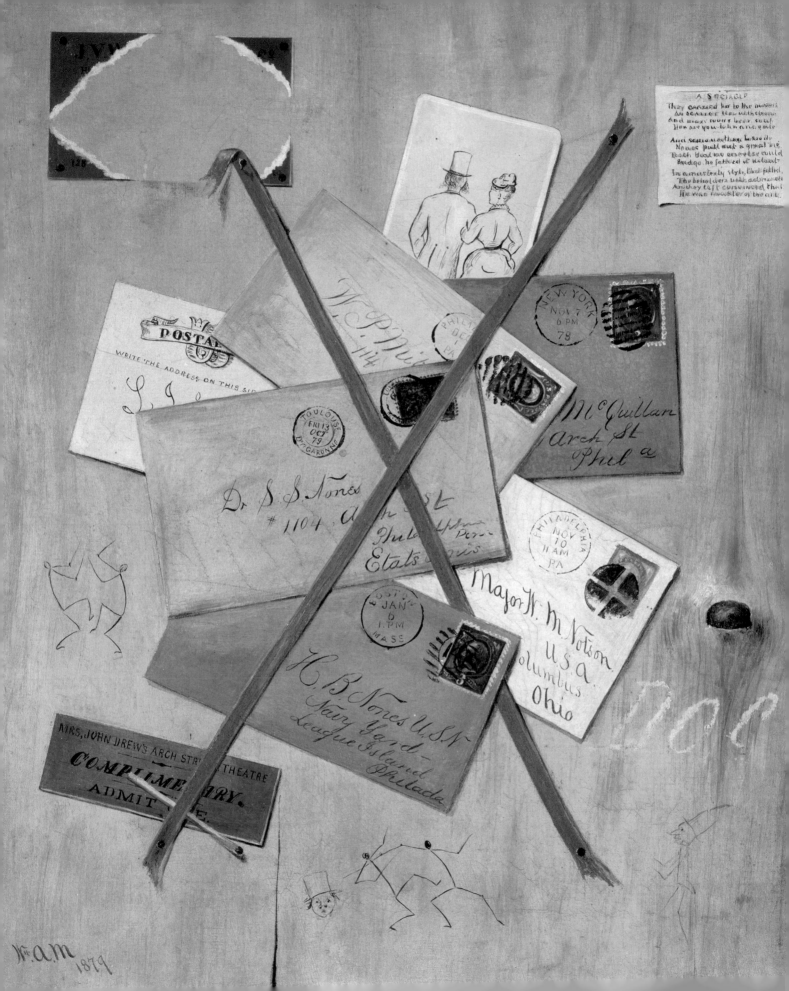

True to the Senses and False in Its Essence:
Still-Life and Trompe l'Oeil Painting in Victorian America

Judith A. Barter

Field-McCormick Curator of American Art

In the Victorian age, and for generations beforehand, still-life paintings were seen to possess little artistic or intellectual merit; in fact, critics regarded them as being unimaginative at best and, at worst, debased. In his famous *Discourses on Art* (1769–90), the influential English portraitist and writer Sir Joshua Reynolds ranked still life a distant fourth in importance behind history painting, biblical subjects, and landscape. According to Reynolds, the genre lacked both the didactic appeal of history painting and grand portraiture and the contemplative, often sublime quality of landscape. Indeed, Reynolds and his nineteenth-century descendents deplored still life in part because of the perceived commonness of both its aesthetics and its audiences. Content to merely imitate ordinary objects, the genre was thought to appeal to unsophisticated, uninitiated viewers. Because of their association with popular rather than polite culture, still-life paintings rarely received the critical attention reserved for higher forms of art. When included in American exhibitions, for example, they were often relegated to corridors or other marginal viewing areas, away from the main focus of attention.

In spite of such neglect, however, the still-life genre—which also included, importantly, trompe l'oeil (literally, fool the eye) works—only increased in appeal during the nineteenth century. In America this attraction may have resulted from the way in which the still life managed to capture the shape of individual and national hope and memory. In the early-to-mid-1800s, still lifes offered their makers and viewers a way to celebrate the abundance and potential of the present and the possibility of the future, both on a personal and a collective level; later on, they served as a means to critique the present and recall and memorialize a lost past. The best American painters, as we shall see, also used the genre as a way to engage with a set of related, broader questions about the uses of memory, nature, science, and the real.

Still-Life Painting, Cultivation, and Gendered Space

In Victorian homes, still-life paintings were used as a main means of displaying stable, easily readable signs of not just their owners' prosperity and social status but their morality and learning as well. Indeed, the genre's popularity was related then, as in earlier times, to contemporary investigations in the natural sciences. Late-eighteenth- and early- nineteenth-century Americans avidly pursued the Enlightenment interest in science, and artists were no excep-

FIGURE 1. American. *Rack Picture for Dr. Nones* (detail), 1879. Oil on canvas; 43.8 x 35.9 cm (17 1/4 x 14 1/8 in.). Frederick G. Wacker Endowment; through prior gift of Mrs. Albert J. Beveridge in memory of Abby Louis Spencer Eddy, 2000.135.

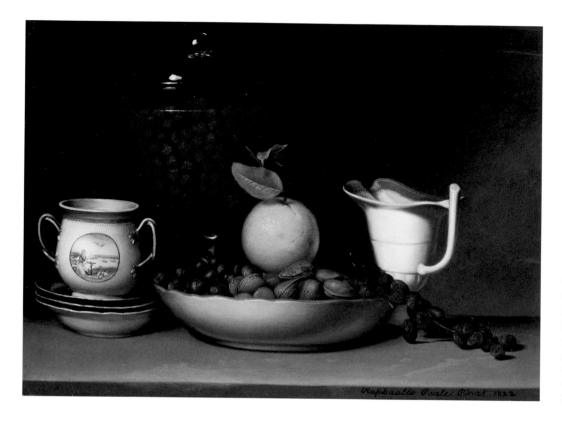

FIGURE 2. Raphaelle Peale (American, 1774–1825). *Strawberries, Nuts, &c.,* c. 1822. Oil on wood panel; 41.1 x 57.8 cm (16 3/8 x 22 3/4 in.). Gift of Jamee J. and Marshall Field, 1991.100.

tion. The Peale family, for instance, lived in and around the sophisticated city of Philadelphia and was deeply involved in botany, horticulture, and taxidermy; the painter and paterfamilias, Charles Willson Peale, eventually retired to his country estate, Belfield, to pursue his botanical interests.[1] However much he may have enjoyed his studies, Peale believed, like Reynolds, that painting ordinary objects was less important, less noble, than executing portraits of people. His eldest son, Raphaelle, was also an artist but an indifferent observer of human beings: his finest portraits were the fruits and flowers he saw around him, and he became recognized, albeit posthumously, as the first American painter to specialize in still life.

The younger Peale's approach to the subject seems to have been inspired by Spanish Baroque paintings by Juan Sánchez Cotán that he saw in an 1816 exhibit at Philadelphia's Pennsylvania Academy of the Fine Arts.[2] Like Peale's paintings, such seventeenth-century works featured objects situated on a ledge and illuminated by a raking light. The use of one-point perspective, perfected during the Renaissance, allowed viewers to experience

the illusion of spatial depth on a flat surface, to enter into the world of the painting as something separate from their own. Like these Spanish examples, Peale's canvasses generally anticipate a meal, showing the elements or ingredients but not the partially consumed leftovers, as Dutch paintings sometimes did.

One of the artist's finest mature works is the Art Institute's *Strawberries, Nuts, &c.* (fig. 2). The painting is a "dessert picture," showing strawberries, soon to be eaten with sugar and cream; filbert hazelnuts and almonds; late-season grapes becoming raisins; and an orange. Even as the painting impresses us with Peale's ability to capture the physical attributes of these things, it also asks us to decode their cultural meanings. The manufactured objects suggest trade and prosperity: the sugar bowl and creamer are Chinese export porcelain, purchased by the wealthy and emblematic of Philadelphia's status as an important trading port.[3] The large glass urn is also a precious item, handblown at the Amelung Works, the first glass house in the United States, founded in Frederick, Maryland, around 1784. The produce tells its own story, since it is an odd assortment that would hardly have been in season at the same time and place:

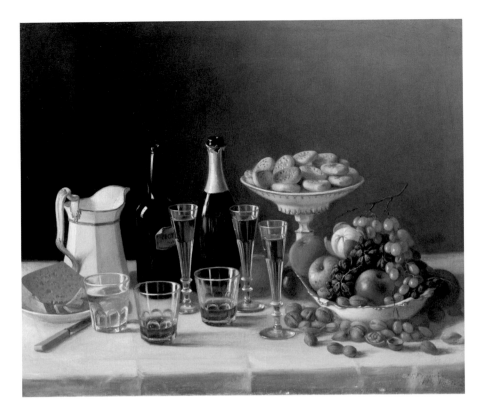

FIGURE 3. John F. Francis (American, 1808–1886). *Wine, Cheese, and Fruit*, 1857. Oil on canvas; 63.5 x 76.2 cm (25 x 30 in.). Restricted gifts of Charles C. Haffner III and Mrs. Herbert Alexander Vance; Wesley M. Dixon, Jr., Fund, 1994.239.

nuts and grapes are fall items, strawberries ripen in early summer, while oranges would not naturally grow in a mid-Atlantic climate at all. Since we know Peale to have valued visual accuracy and to have used models carefully, we can conclude that these items were certainly set before him but only available because of his family's interest in hothouse cultivation at Belfield. The covered glass urn can be seen to symbolize the greenhouse itself.[4]

Strawberries, Nuts, &c., then, even as it decorated its owners' dining room, contains visual elements that represent the wider world of nineteenth-century botany, horticulture, manufacturing, and trade. Taken together, these details signal material and intellectual bounty, suggesting "cultivation" in both the scientific and cultural senses of the word. The painting also continues to evoke the careful balance, proportion, and stillness of the Enlightenment, sitting as it does on the cusp of eighteenth- and nineteenth-century aesthetics. With its balance and quietude, it serves as a model that would be rearranged and reinterpreted just a few decades later by painters such as John F. Francis and Hannah Skeele, who imbued still-life painting with a taut, polished interpretation of nature that spoke to moral issues.

In *Wine, Cheese, and Fruit* (fig. 3), for example, the Philadelphian John F. Francis echoed Peale's use of raking light and his tabletop arrangement but dressed the surface in a crisp, white cloth, quite unlike Peale's muted, neutral, marble ledge. The table area becomes a larger, more important part of the picture, making possible the presentation of strikingly vertical elements that seem almost to stand at attention. This too is a dessert picture, showing the cognac, fortified wine, and assorted delicacies that were served to gentlemen after the main meal was cleared away. But Francis's repeated verticals and additional objects lend the work a cacophony not found in Peale's silent, static painting. Leaving science behind and hinting at the Victorian excesses ahead, Francis was more intrigued with variety than with contemplation. In contrast to their counterparts in straitlaced Philadelphia, New York's contemporary painters, including the German-born Severin Roesen, created full-blown Victorian still-life compositions, seeming to follow the aesthetic mantra that more is better. In *An Abundance of Fruit* (fig. 4), nature itself overcomes any inorganic elements, and one senses that this glorious pile was just delivered fresh from the garden, stems and all, an unorchestrated profusion of plenty.

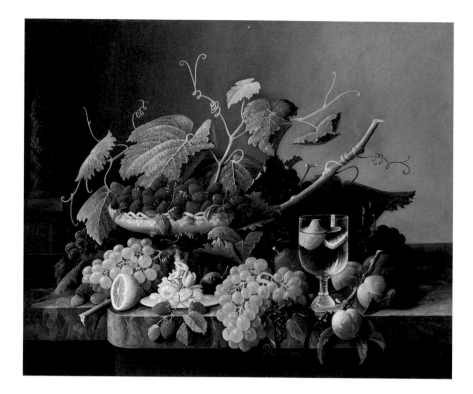

FIGURE 4. Severin Roesen (American, born Germany, 1815/17–1872). *An Abundance of Fruit*, c. 1860. Oil on canvas; 63.5 x 76.2 cm (25 x 30 in.). Americana Fund, 2004.2.

social prestige seem synonymous: champagne and cognac, the drinks on display, would have been understood by contemporary viewers to represent the loftiest, most sophisticated product of the grape. The furnishings are no less refined and include glassware manufactured in Pittsburgh and ceramics that are most likely of European origin. Such objects no doubt appealed to the upper-class buyers who purchased paintings like this one for their dining rooms.

In recent years, historians have come to recognize that Victorians, both in Britain and America, treated certain rooms in their homes as gendered spaces.[8] The parlor, or sitting room, was typically a center of feminine activity in which afternoon visitors were entertained and tea served, and to which ladies retired after dinner. Hannah Brown Skeele's *Fruit Piece* (fig. 5) suggests just such a ritual and would have been an appropriate decoration for a fashionable parlor. Skeele, who may have studied with Raphaelle Peale's cousin Sarah Miriam Peale in St. Louis, achieved a certain simplicity in this composition. She delineated its elements with light, adding embellishments such as the reticulated basket, figured cloth, polished silver, and a filigree bowl containing precious, expensive lumps of sugar.[9] While her subject is also dessert, or possibly a simple tea, it clearly has been assembled for a ladies' gathering, since no alcoholic beverages are present.

Men, on the other hand, remained in the dining room, smoking cigars, drinking brandies or other fortified spirits, and eating biscuits, cheese, fruit, and nuts. Paintings like Francis's, which would have been displayed in a dining room, often signaled an abundant income and celebrated the importance and prowess of the men who earned it. While no longer literally hunting and gathering the meal itself, they did make rich living possible and displayed symbols of their spoils on their household furnishings.

This is especially the case in another sort of dining room still life, a sideboard by the New York cabinetmaker

While the numerous glass vessels in *Wine, Cheese, and Fruit* allowed Francis to show his virtuosity at rendering reflected light, the beverages they contain hint at the sober moral and political message he was attempting to convey. An elusive figure, the artist turned from portraiture to still-life painting around 1850, and his best works date from the decade that followed. Those years were also the peak of agitation for temperance advocates in the northeastern United States; only the growing crisis over slavery was a more politically volatile issue.[5] Although we do not know Francis's views precisely, we do know that he admonished his heirs not to "degrade their manhood by the sin of intemperance."[6] Given such sentiments, it is tempting to question the links between prohibition, Francis's temperance-supporting portrait subjects, and his still-life paintings that treat alcoholic beverages as their primary subject matter.[7]

Here, the presence of food as well as water suggests that we are being instructed in the appropriate use of alcohol, which is present in five of the glasses. Moreover, Francis constructed a scene in which moderation and

Alexander Roux (fig. 6). The piece itself, crafted from rosewood and highly carved, was expensive. But even more fascinating is its subject matter. While most American still lifes of the moment were devoted to flowers or to food not yet eaten, Roux's sideboard recalls the hunting pictures of the seventeenth-century Dutch artist Frans Snyders, who represented a profusion of animals in various stages of unvarnished death.[10] Carved upon its lower surfaces are indigenous fish and wild game, including eel, grouse, lobster, rabbit, and trout, all surveyed by a mounted fox head at the top; also visible are more commonly represented fruits and nuts.

Sideboards such as this one, which sported designs that incorporated both hunter and hunted and evoked the culinary delights of the land, sea, and sky, clearly engaged Victorian diners, who were able to look beyond the implied violence and death laid out before them. Perhaps these objects helped their users reconcile their religious sensibilities with their material wealth, echoing the biblical view that humankind should have dominion "over the fish of the sea, and over the fowl of the air, and over the cattle, and over all the earth, and over every creeping thing that creepeth upon the earth" (Genesis 1:26). While doing so, they would also have celebrated the unlimited consumption of resources practiced by the upper classes while reinforcing the vision of predatory competition that was central to Victorian ideas of both capitalism and masculinity.[11]

Such excessive displays of abundance gave way, in the second half of the nineteenth century, to a relaxed informality and a focus on humbler objects. The theories of the English critic John Ruskin, who argued for even greater naturalism in art, inspired disciples who painted still lifes set outdoors, in nature itself. Languid and casual, Martin Johnson Heade's *Still-Life: Magnolias on Light Blue Velvet* (fig. 7) celebrates the lush, sensory appeal of flowers and fabric. Heade eschewed props, including only one man-made object: the cloth. Unlike the works of Peale, Francis, or Roux, this painting does not concern itself with the display of wealth but is about the purity and fragility of nature and the passage of time. The freshly cut ends of the magnolia branches show us that these magnificent, humid blooms will soon wilt, and the waxy leaves drop. We are drawn into the depth of the picture through the traditional format of the ledge, but also returned to the surface by the amazingly rich tactile quality of flowers and velvet.

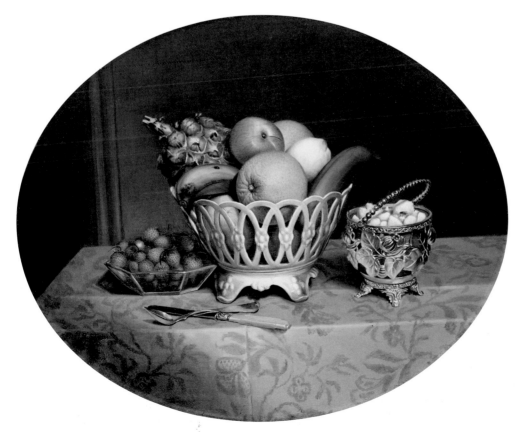

FIGURE 5. Hannah Brown Skeele (American, 1829–1901). *Fruit Piece*, 1860. Oil on canvas; 50.8 x 60.6 cm (20 x 23 7/8 in.). Restricted gifts of Charles C. Haffner III, Mrs. Harold T. Martin, Mrs. Herbert A. Vance, and Mrs. Jill B. Zeno; through prior acquisition of the George F. Harding Collection, 2001.6.

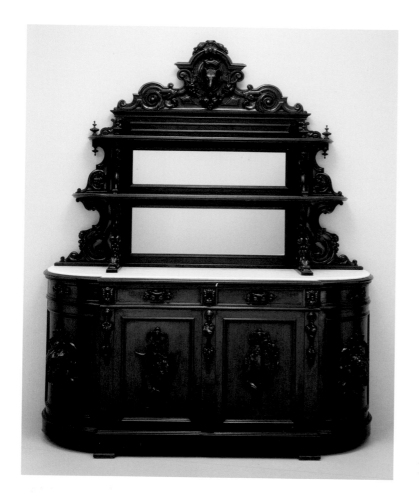

Trompe l'Oeil, Reality, and Humor

This use of objects painted to scale and set close to—or even appearing to move out of—a picture's surface was also the hallmark of trompe l'oeil, a variant of still life that reappeared on the American scene around 1875. Members of the Peale family had executed such paintings many decades before, but the style had lain dormant until the Philadelphia artist William Michael Harnett revived it with *The Artist's Letter Rack* (1879), now in the Metropolitan Museum of Art, New York.[12] Unlike the still lifes we have seen so far, which were hung within the domestic space of polite Victorian homes, trompe l'oeil paintings were fixtures of popular, public culture and would have been found in expositions, fairs, shops, and drug stores, among other venues.[13] The collectors of Harnett's work were usually retail merchants—John Wanamaker, for example, displayed *For Sunday's Dinner* (fig. 9) in his Philadelphia department store. Saloons were particularly apt settings for these paintings, for it was there that other illusions took place—card, die, or shell games that mirrored trompe l'oeil's own brand of visual foolery.

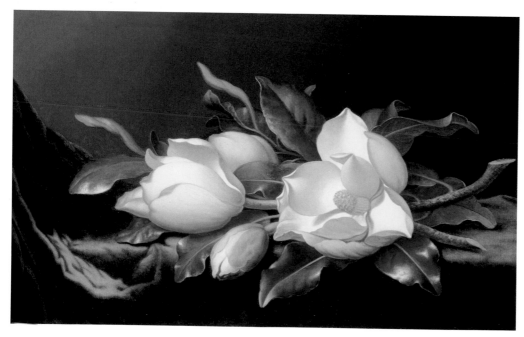

FIGURE 6. Alexander Roux (American, born France, c. 1813–1886). *Sideboard*, 1850/57. Rosewood with walnut, tulip poplar, glass, and marble; 238 x 204.5 x 58.4 cm (93 ¾ x 80 ½ x 23 in.). Gift of the Antiquarian Society, 1995.245.

FIGURE 7. Martin Johnson Heade (American, 1819–1904). *Still-Life: Magnolias on Light Blue Velvet*, 1885/95. Oil on canvas; 38.6 x 61.8 cm (15 ¼ x 24 ⅜ in.). Restricted gift of Gloria and Richard Manney, Harold L. Stewart Endowment, 1983.791.

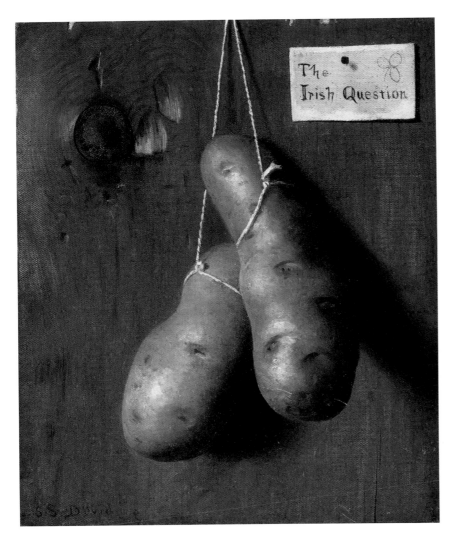

FIGURE 8. DeScott Evans (American, 1847–1898). *The Irish Question*, c. 1880s. Oil on canvas; 30.5 x 25.4 cm (12 x 10 in.). Restricted gift of Carol W. Wardlaw and Mrs. Jill B. Zeno; the Roger and J. Peter McCormick endowments, 2004.3.

If dining-room pictures frequently celebrated the success and cultivation of their well-to-do owners, trompe l'oeil works often turned to the wider, public world, critiquing it with a humor that could be alternately lighthearted and grim. One example of the latter mood is DeScott Evans's *The Irish Question* (fig. 8), which uses trompe l'oeil techniques to startle viewers to attention. At first glance, the picture recalls seventeenth-century paintings by Cotán, in which hanging vegetables and birds appear within in a darkened niche. Here, however, depth is denied: Evans hung his realistic, life-size potatoes against the flattened picture plane, demanding that we

look twice to determine whether these are real vegetables or merely a painted surface. The artist completed the illusion by extending the painted string over the top of the canvas and behind the picture's edge, as if it is attached to the same nail that holds the "board" onto the wall.

By "tacking on" a piece of paper that reads "The Irish Question" and contains the image of a clover leaf, Evans clearly recalled the Potato Famine of the 1840s, when over one million Irish died and more than two million emigrated, chiefly to the United States. (Ireland reasserted itself in the American consciousness throughout the 1870s, as the country struggled against the British for home rule.)[14] But the caption also undoubtedly suggests the anti-Catholicism, labor worries, and other cultural anxieties that accompanied a later wave of Irish settlement in the 1880s. Hanging his potatoes by their "necks," the artist alluded not only to earlier works like Cotán's but also intimated the violence to which many of the urban Irish poor were subjected. Beyond these layers of reference, however, the picture's meanings remain as mysterious as the details of Evans's career.[15]

While this painting uses aesthetic surprise in the service of a political message, many other trompe l'oeil works are infused with a humor that is unmistakably Victorian in its reliance on embarrassment and punning. Harnett's *For Sunday's Dinner* (fig. 9), for instance, is so realistically painted, its impression of reality so complete and complex, that it provokes both wonder and laughter. For trompe l'oeil illusion (and deception) to work, the objects depicted must appear to come out of the picture, must invade our space and seem part of it, so we accept them as real. Harnett's joke is that his perfect illusion cannot be tested or broken unless the viewer touches the picture's surface—an act that the naked, pimply, plucked

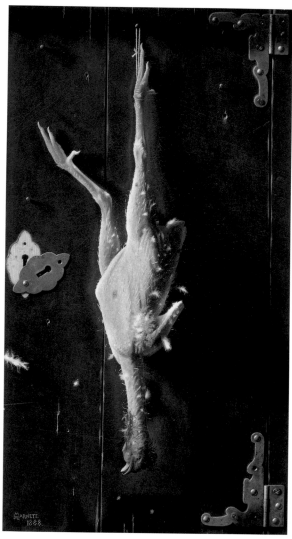

FIGURE 9. William M. Harnett (American, born Ireland, 1848–1892). *For Sunday's Dinner*, 1888. Oil on canvas; 94.3 x 53.6 cm (37 ⅛ x 21 ⅛ in.). Wilson L. Mead Fund, 1958.296.

Often, artists such as Charles Meurer introduced painted newspaper clippings about counterfeiting into their compositions. The text headline in *Still Life with Currency* (fig. 10) reads "Counterfeiters Caught," seeming to compliment Meurer's skill as a visual con man and his own talent at evading capture—at least for the moment. So troubling were such works that federal agents actually considered them a form of counterfeiting, arresting Meurer when he exhibited a painting entitled *My Passport* at the 1893 World's Columbian Exposition in Chicago. Depicting a passport and money, the image was confiscated by the Secret Service until the artist agreed to add red lines of cancellation across the faces of the painted bills.[16]

Money pictures were prevalent in the 1890s when political arguments over "hard" versus "soft" currency became volatile, leading to the formation of the Populist Party, the rancorous Presidential election of 1896, and William Jennings Bryan's famous "Cross of Gold" speech, in which he argued for the abolishment of the gold standard and the devaluation of currency to help the working classes and pull the nation out of a severe depression. Ironic commentaries on this bitter national division, these paintings were also, for Meurer, a way to critique government policy itself as being a kind of counterfeit. While viewers no doubt understood such political allusions, they were also profoundly confused by these works, which successfully questioned the difference between illusion and reality, and also challenged the conventions of nineteenth-century art, in which money was represented through veiled allusions and not literally or crassly depicted.[17]

chicken makes repugnant. The title of a trompe l'oeil picture often reinforced its sense of humor: in this case, the genteel tenor of *For Sunday's Dinner* emphasizes the gulf between the delicious, prepared Sabbath feast and its gruesome beginnings, which the image actually describes.

In its most essential form, humor in trompe l'oeil painting is based upon the idea of being "had," or "conned." The purest examples of this impulse are "money pictures," which not only satirized the direction of contemporary monetary policy but also managed, in the process, to challenge the very nature of the real.

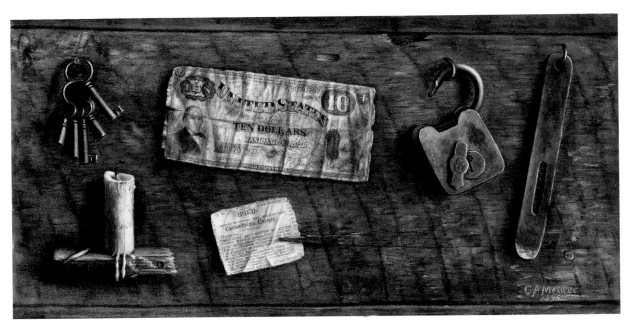

FIGURE 10. Charles Meurer (American, 1865–1955). *Still Life with Currency*, 1895. Oil on canvas; 25.4 x 55.9 cm (10 x 12 in.). Estate of Frederick W. Renshaw, 2001.183.

Illusion, Time, and Memory

Another, equally unsettling variety of trompe l'oeil is the rack picture, originally popular in seventeenth-century Holland and eighteenth-century France. This format takes as its subject a letter rack—a board fitted with ribbons and used to hold notes, mementos, and other items meant to be seen and kept close at hand. The Art Institute holds an early example entitled *Rack Picture for Dr. Nones* (fig. 1), made by a Philadelphia artist signing himself only "Wm. A. M." He executed this painting in 1879, the very year that Harnett painted his first rack picture, and must have known his work. As in most examples of this type, objects are arranged on the flat picture plane. Writing and printing are of great importance, adding textual elements to the profusion of overlapping shapes and images: stick figures seem to dance around a group of newspaper clippings, envelopes, printed stamps, and tickets, forming an ever-widening web of illusion. The deceptions of rack pictures are particularly disarming, however, because the elements they depict are incongruous, seemingly unrelated, and therefore mysterious. These surreal arrangements produce confusion, interpretive curiosity, and the desire to impose narrative logic on random scraps, to discover the story that links them together. They become anomalous pictures, differing from yet another type of trompe l'oeil composition that purposely evokes the passage of time.

Another Philadelphian, George Cope, excelled at this brand of nostalgic painting, which underscores trompe l'oeil's effectiveness at capturing not the optimism of science or the promises of wealth but rather a poignant mood of retrospection. Cope's hyper-illusionistic *Civil War Regalia of Major Levi Gheen McCauley* (fig. 11) was commissioned by McCauley himself, who had served as an officer in the Pennsylvania Seventh Regiment. Adhering to his patron's wishes, Cope painted the remnants of McCauley's military career in a dignified, formal way, arranging the crossed swords under hanging medals and anchoring the composition with a vertical axis formed by cap and canteen. These relics speak of the past, evoking feelings of memory and loss. Contemporary newspaper articles report that Cope's picture hung in McCauley's office and in the Philadelphia jewelry shop of Bailey, Banks, and Biddle for passersby to admire.[18] Masculine and made for a public space, it advertised the major's status as a distinguished veteran and also recalled the war's rupturing of American society and the lost lives of a generation of men. In a wider sense, it spurred memories of an antebellum world that was predominately rural versus the new, postwar society of urbanization, industrialization, and Gilded Age wealth. Indeed, it was around this time that the first Civil War veterans were beginning to die,

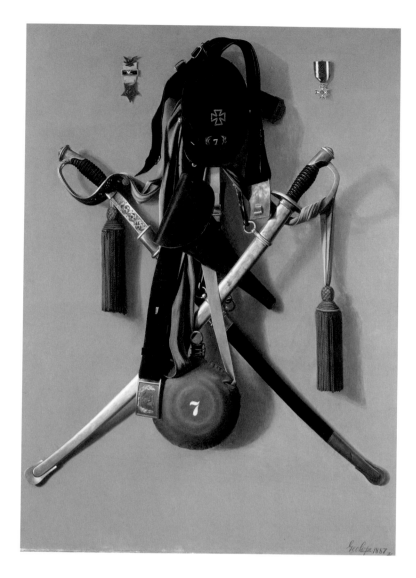

FIGURE 11. George Cope (American, 1855–1929). *Civil War Regalia of Major Levi Gheen McCauley*, 1887. Oil on canvas; 127 x 92.7 cm (50 x 36 ½ in.). Mr. and Mrs. Robert O. Delaney and Chauncey and Marion McCormick funds; Wesley M. Dixon Endowment, 2000.134.

famous painting of 1886.[21] Peto's *Lights of Other Days* (fig. 12) features a similar collection of forgotten relics, stashed on a shelf, stored out of sight and mind. Included are candlesticks, lamps, and lanterns made before the Civil War: among others, an early tin sconce, circa 1810; a "hogscraper" candlestick from the 1830s (tipped forward off the edge of the shelf, on the right); a lantern with an open door and a partially hidden square lantern, both from around 1830.

Peto, like his fellow Victorians, lived in a rapidly changing world. By the time he painted this work in 1906, he had witnessed the advent of gaslight, the kerosene lamp, the arc light, and the electric light bulb. While this canvas is a testament to the Victorians' interest in invention, progress, and technology, Peto was not fascinated by artificial light per se. He painted these dilapidated, tallow-encrusted objects by natural light—also, by that point, rather antique—and used it to carefully pick out the highlights of the metals, the shadows cast. The illumination is soft and diffuse, the palette a muted gray-green, creating a powerful aura of memory and nostalgia. Formally, the complex composition addresses the interplay and combination of color, shape, and texture. Not every object is as important as the next, nor do we sense that illusionism is Peto's final goal. In fact, the sheer number of lamps, not to mention their tangled arrangement, almost demands the sort of leisurely study that complements the picture's retrospective mood.

The punning title, moreover, recalls not only times past, but also the cycles of history and mortality. Indeed, the gaping, dark opening of the conical lantern, a focal point of the composition, suggests shades of the unknown, the coffin, the abyss. Peto painted this picture during his final year. Suffering from a debilitating illness, he likely saw this work as a memento mori, a commentary on how quickly the lights and lives of other days fade. Completed almost ninety years after Peale's *Strawberries, Nuts &c.*, this work addresses some of the same issues but in a strikingly different way. While both Peale and Peto

and this development sparked a wave of new museums and monuments, agitation for commemorative holidays, and other nostalgia-driven efforts.[19]

In the decades after the nation's 1876 centennial celebration, Harnett, Cope, and their friend the artist John F. Peto took to incorporating old, obsolete objects into their pictures.[20] Harnett and Peto posed for a photograph (fig. 13) in Peto's studio with some of these props, which included an earthenware jug, a spinning wheel, and Harnett's old violin, which he incorporated into a

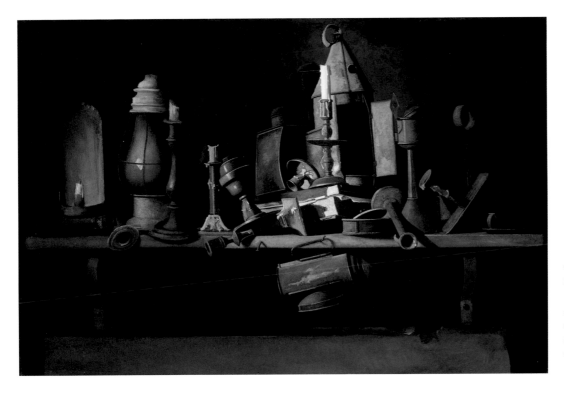

FIGURE 12. John F. Peto (American, 1854–1907). *Lights of Other Days*, 1906. Oil on canvas; 77.5 x 114.9 cm (30 ½ x 45 ¼ in.). Goodman Fund, 1956.125.

painted frozen time, the earlier image is filled with bounteous promise, the later with the quiet contemplation of a lost past. Seen together, the two paintings suggest how the early-nineteenth-century belief in science and progress had given way to a sense that all, in the end, becomes obsolete. They also recall Nathaniel Hawthorne's 1844 short story "Rappaccini's Daughter" and its reminder that even if something be "true to the outward senses, still it may be false in its essence."[22] Hawthorne explored the appearance of nature and the darker, unseen reality underneath visual illusion. The sheer longevity of the Victorian period, which spanned almost a century, assured that the hope and progress of the Enlightenment, followed by the materialism of the mid-nineteenth century, would give way to the doubt, introspection, and cynicism of the modern era.

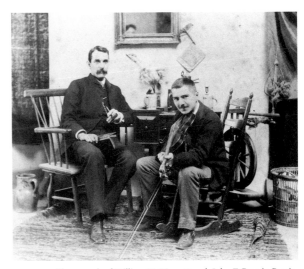

FIGURE 13. Photograph of William M. Harnett and John F. Peto in Peto's Philadelphia studio, c. 1870s. Glass plate; 18.1 x 21.3 cm (7 ⅛ x 8 ⅜ in.).

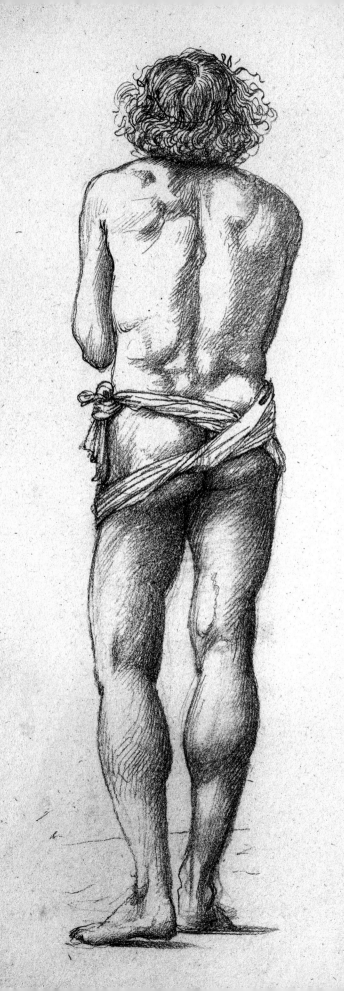

Unpainted Masterpieces:

The Drawings of Edward Burne-Jones

Debra N. Mancoff

School of the Art Institute of Chicago

On an 1869 visit to Edward Burne-Jones's home, the American educator Charles Eliot Norton marveled at the number of unfinished pieces in the artist's studio, noting that the commodious room had "a pleasant look of work about it, and a general air of appropriate disorder."[1] Paintings and sketches were everywhere, perched on easels, leaning against the wall, and stacked in piles across the floor. Always deliberate, Burne-Jones took time with his art, first laying down what he called "the bones of a picture," which he followed by layer after layer of paint.[2] Norton also observed that "Jones's lively imagination is continually designing more than he can execute. His fancy creates a hundred pictures for one that his hand can paint."[3] Some works sat untouched for years before completion. Burne-Jones despaired of his studio habits, complaining that "my rooms are so full of work—too full—and I have begun so much that . . . I shall never complete it." In one caricature (fig. 2), the artist even portrayed himself as a bedraggled figure seated on a crate in front of a forest of canvasses that he described as "unpainted masterpieces."[4]

Among his friends and family, Burne-Jones was known for another type of "unpainted masterpiece." From his youth, he made swift sketches that appeared effortless in contrast to his carefully crafted paintings and allowed him to work out ideas and refine details. But he also drew outside the studio, and his contemporaries remarked at his uncanny ability to do so while fully engaged in other activities. The painter W. Graham Robertson recalled:

> Once, while talking to me, he took up a little pocketbook and sketched absently as he carried on the conversation. As I left him he gave me the book, which contained the careful drawing of a sleeve and falling draperies, a half-fledged bird, a cat with a tail erect stalking the same, a fat baby, and a highly imaginative drawing of Noah's ark with rain and rainbow complete.[5]

To Burne-Jones, these random images reflected his fleeting visual thoughts. Rather than recording what he saw, he sketched whatever came to mind, whether a winsome face, a graceful gesture, or a droll notion. He once compared an artist's sketch to an autobiography, explaining that "you get very close to the personality of a man when you've got a study of his."[6] While

FIGURE 1. Edward Burne-Jones (English, 1833–1898). *Back View of Male Nude* (detail), 1873/74. Graphite on ivory wove paper; 25.3 x 17.8 cm (9 $^{15}/_{16}$ x 7 in.). Ida E. S. Noyes Fund, 1920.1137.

drawing, Burne-Jones felt released both from the demands of his rigorous technique and from critical scrutiny. Putting pencil to paper, he unleashed his most intimate thoughts—his initial ideas, his passion for beauty, his flights of fancy—and inscribed them with fluid confidence.

The Burne-Jones drawings in the Art Institute of Chicago elucidate the mind and method of the artist at a crucial point in his career. Most of these, which include cartoons for stained glass and a sketchbook containing thirty-nine drawings in pencil, date from the 1870s, a decade during which he reformed his aesthetic ideals and began to paint some of his most representative works. Little is known about the sketchbook, which D. Edmund Brooks, a Minneapolis art dealer, purchased from the artist's son Philip in 1913 and sold to the Art Institute six years later.[7] Sixteen of the drawings bear subject inscriptions in Philip's hand, and all but eleven of them can be linked to specific projects. While these works provide valuable insight into Burne-Jones's artistic process, they are equally compelling in the way they confirm his elusive mission to express "a beautiful romantic dream of something that never was, never will be—in a light better than any light ever shone, in a land that no one can define or remember—only desire."[8]

The constant and almost compulsive need to draw can be traced to Burne-Jones's childhood. Within a week of his birth, his mother died, and his father, a Birmingham frame maker, grieved for years. Looking back at his youth, Burne-Jones claimed never to have been disconsolate: "Unmothered, with a sad papa, without sister or brother, always alone, I was never unhappy, because I was always drawing."[9] Although family friends remarked on the boy's precocious talent, and he amazed his schoolmates with the prodigious sketches that covered his exercise books, art lessons played only a minor role in Burne-Jones's early education. He later studied theology at Oxford, where he met his lifelong friend and collaborator William Morris, with whom he pursued a mutual fascination with the essays of John Ruskin, the art of the Pre-Raphaelite Brotherhood, and medieval authors, most notably Geoffrey Chaucer, whose interpretations of classical tales inspired their later interest in the epics of Homer and Greek mythology.

FIGURE 2. Edward Burne-Jones. *Self Caricature: Unpainted Masterpieces*, c. 1890. Pen and ink; 17.6 x 10.7 cm (6 7/8 x 4 1/4 in.). Birmingham Museums and Art Gallery.

Burne-Jones undertook his first professional commission in 1854, producing at least eighty-eight pencil and ink designs for the book *The Fairy Family*.[10] The tight, precisely detailed style of his illustrations reflects his admiration for the Pre-Raphaelite poet-painter Dante Gabriel Rossetti. In 1856 Burne-Jones left Oxford without his degree and headed for London, where Rossetti took him under his wing, helping him secure work designing stained glass. Burne-Jones was slow to take up painting, but his drawing in pen and ink grew increasingly skillful and densely decorative, and Rossetti, pleased with the results, declared them "marvels of finish and imaginative detail, unequalled by anything unless perhaps Albert Dürer's finest works."[11]

By the next decade, Burne-Jones began to follow a more independent path. Two trips to Italy ignited his interest in the lyric potential of color, and upon his return to the studio, painting in watercolor and oil took dominance over drawing in pen and ink. From this point forward he regarded drawing as a preliminary stage of work and adopted his deliberate method of constructing a

painting. He began with a rough sketch of a composition and then refined it through countless pencil drawings, often from models, making minor adjustments to details of posture, gesture, and draperies. These were then enlarged to scale on brown paper, and he executed a preliminary cartoon in pastel or watercolor to test the general effect. When he was satisfied, a studio assistant transferred the design onto canvas, sketching lightly in burnt sienna or raw umber. Then Burne-Jones would begin to paint.[12] Although he attracted little critical attention from the art world during the 1860s, he provided designs for Morris's decorative arts firm and exhibited work at the Old Water-Colour Society, an association that he joined in 1863.[13]

In 1870 public reaction to the male nude in his watercolor *Phyllis and Demophoön* (1870; Birmingham Museums and Art Gallery) prompted the Old Water-Colour Society to ask him to either clothe the figure or remove the painting altogether.[14] Burne-Jones took the work off the wall and, at the close of the exhibition, resigned from the group. For the next seven years, he

FIGURE 3. Edward Burne-Jones. *The Story of Troy*, 1870–98. Oil on canvas; 275 x 298 cm (108 x 117 7/8 in.). Birmingham Museums and Art Gallery.

retreated into the studio and refused invitations to exhibit. While out of the public eye, he lacked neither work nor motivation. He made two more journeys to Italy, enjoyed commissions from sympathetic patrons, and provided Morris's firm with sketches for stained glass, book illuminations, and tapestries, becoming its foremost contributor. Later in life, Burne-Jones described this time of self-imposed isolation from the art world as "the seven blissfullest years of work that I ever had; no fuss, no publicity, no teasing about exhibiting, no getting pictures done against time."[15]

The Art Institute sketchbook offers a glimpse of the artist's creative process, as well as a significant change in his ideal of physical beauty, during these "seven blissfullest years." Although a letter of authenticity written by Philip Burne-Jones dates the drawings between 1873 and 1877, the chronology of his father's studio activity reveals that he executed many of them earlier. Among these are six sketches related to Burne-Jones's unfinished *Story of Troy*, which he began in the summer of 1870, after his resignation from the Old Water-Colour Society.[16] For more than a decade, he and Morris had been intrigued with the saga of the Trojan War. In 1857 Morris outlined a cycle of poems called *Scenes from the Fall of Troy* and a few years later conceived a plan to have Burne-Jones embellish the hall and front staircase of his new home, the Red House, with Trojan-themed murals.[17] Neither project was completed, but the idea of Troy continued to allure the members of the Pre-Raphaelite circle. Burne-Jones's wife, Georgiana, recalled that when Rossetti read his new poem "Troy Town" in 1868, it "sounded like a challenge to the world."[18] Two years later, Burne-Jones took up that challenge in earnest.

The Story of Troy (fig. 3) featured several qualities that would distinguish Burne-Jones's mature and late work. The artist conceived the project as an ensemble of ten separate panels inserted into an elaborate structure patterned after a Renaissance altarpiece. Grand in scale and complexity, it was his most

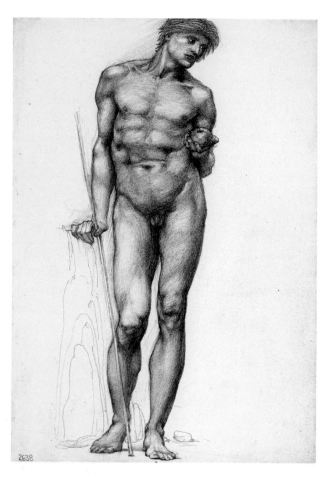

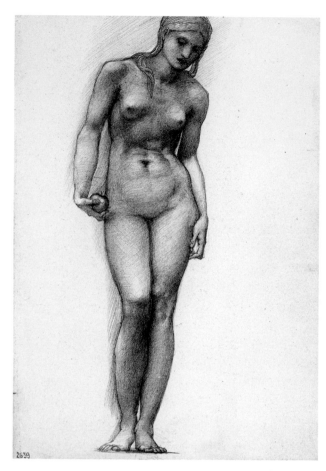

FIGURE 4. Edward Burne-Jones. *Study of a Male Nude for the Central Panel of "The Story of Troy,"* 1871/72. Graphite on ivory wove paper; 25.4 x 17.8 cm (10 x 7 in.). Ida E. S. Noyes Fund, 1920.1168.

FIGURE 5. Edward Burne-Jones. *Study of a Female Nude for the Left Panel of "The Story of Troy,"* 1871/72. Graphite on ivory wove paper; 25.4 x 17.8 cm (10 x 7 in.). Ida E. S. Noyes Fund, 1920.1169.

ambitious plan to date, reflecting his ongoing fascination with extended narrative. Rather than illustrating specific textual sources, Burne-Jones presented a pictorial interpretation of the tragedy, evoking key events such as the Judgment of Paris on the central panel and offering symbolic commentary through images like *Venus Concordia* and *Venus Discordia*, which appear on the predella, or lower structure, of the triptych.[19] The work never advanced beyond a preliminary stage, although Burne-Jones's studio assistant T. M. Rooke carried out the figure outlines on the main panels and, in the winter of 1871–72, painted the *Venus* panels.[20]

Three drawings in the Art Institute sketchbook—all nude studies—can be linked directly to the initial outlines drawn by Rooke and illustrate Burne-Jones's habit of establishing the positions of figures within a complex composition by approaching them one by one, in isolation. These are a sketch of Paris, who holds the golden apple and leans on his shepherd's staff in the left portion of the central panel (fig. 4); one of Venus holding the golden apple while presiding over Helen's abduction in the upper left corner of the left panel (fig. 5); and another of Paris in the lower right corner of the same panel (fig. 6). The physical grandeur of these figures marks the emergence, in Burne-Jones's work, of a new way of representing the human body. On his third trip to Italy, in 1871, the artist visited Rome for the first time. Enthralled with Michelangelo's frescoes on the ceiling of the Sistine Chapel, he purchased a pair of opera glasses and studied the works from a vantage point on the floor, lying on his back on his

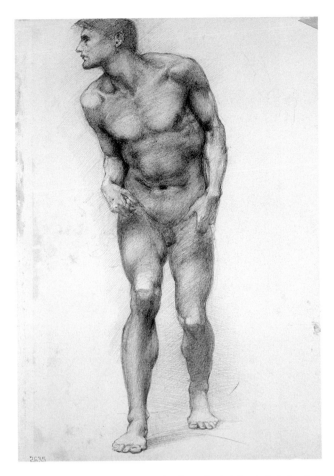

FIGURE 6. Edward Burne-Jones. *Study of a Male Nude for the Left Panel of "The Story of Troy,"* 1871/72. Graphite on ivory wove paper; 25.4 x 17.8 cm (10 x 7 in.). Ida E. S. Noyes Fund, 1920.1165.

railway rug.[21] When he returned to the studio, his drawing reflected what he had seen: once lithe and attenuated, his figures became weighty and muscular, with an expressive force of gesture that echos the monumental quality of Michelangelo's examples. In line with Burne-Jones's studio practice, Rooke would have made his delineations from highly developed sketches, suggesting that Burne-Jones produced these early drawings after returning from Italy at the end of September 1871 and before Rooke completed his outline work in 1872.

The two male nudes display the massive proportions—broad torso, heavy shoulders, thickly sculpted arms—that became characteristic of Burne-Jones's depiction of the male form from this time forward. He enjoyed modeling these powerful figures, telling Rooke, "A woman's shape is best in repose, but the fine thing about a man is that he is such a splendid machine, so you can put him in motion, and make as many knobs and joints and muscles about him as you can."[22] Although the first figure of Paris (fig. 4) is still, the forward thrust of the head and the muscular twist of the torso, which are forced by an exaggerated shift of posture, evoke the coiled energy of suppressed motion. There is a tense beauty in this form, but the second study of Paris (fig. 6) is heavy and lumbering. Its posture was transferred to the canvas without adjustment, suggesting that Burne-Jones wanted to express Paris's abduction of Helen through his brute physicality—he roughly restrains her while she falls to her knees, clinging to his waist.

The drawing of Venus (fig. 5) demonstrates the lyric beauty more typical of Burne-Jones's approach. The artist lightly sketched the figure's contour in pencil, reinforcing it in heavier strokes. He coaxed the musculature into three-dimensions with softly modulated shading, while firmly articulating the details of face, fingers, and toes. This study recalls Sandro Botticelli's serene, statuesque depictions of the goddess. Burne-Jones had first begun to admire the Florentine master during his first Italian journey, in 1859, and after his third trip he included him, with Michelangelo, among the painters "I care for most."[23] He felt a profound sympathy with Botticelli's aesthetic, and late in life he teasingly told Rooke, "Botticelli and I would get on together," but "Michelangelo would sniff contemptuously at me."[24]

The Art Institute's sketchbook also contains a number of drawings associated with *The Mirror of Venus*. These, which include ten studies directly linked to the later version of the painting (fig. 7), testify to the artist's pursuit of beauty through perfection, which manifested itself in a tendency to rework on both the level of individual elements and entire compositions. The subjects of the sketches—arms, feet, heads, and spills of drapery—record his intense attention to detail. Burne-Jones pursued his motif on sheet after sheet, seeking to transfer the elusive refinement of an image from his imagination onto paper. Other sketchbooks, filled with only a few repeated forms such as striding legs and fluttering banners, reveal that this was a regular aspect of his practice.[25] These drawings are

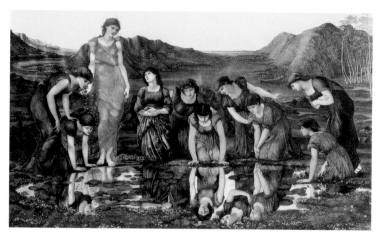

FIGURE 7. Edward Burne-Jones. *The Mirror of Venus*, 1873–76. Oil on canvas; 120 x 199.9 cm (47 ¼ x 78 ¹¹/₁₆ in.). Calouste Gulbenkian Foundation Museum, Lisbon.

lightly done in pencil, with fine hatched and looping lines that suggest a swift touch. Of such works, the art historian T. Martin Wood remarked, "Often these studies end abruptly . . . owing to a feeling that he had extracted what he was in search of, and the protraction of the minute study would no longer give him pleasure."[26]

Burne-Jones painted *The Mirror of Venus* twice between the years 1867 and 1877.[27] The subject is an invention upon several lines from "The Hill of Venus," a poem written by William Morris as part of *The Earthly Paradise*, an epic, twenty-four-part cycle published from 1868 to 1870. As early as 1865, Morris proposed that Burne-Jones draw designs to be reproduced as woodcut illustrations for a deluxe folio edition of the work. The artist made more than one hundred sketches for the project, including twenty for "The Hill of Venus."[28] Morris abandoned the project, but Burne-Jones developed several of these subjects into paintings.[29] One was *The Mirror of Venus*, which portrays nine young women gathered around the edge of a glassy pond, gazing at their comely reflections. Without disturbing them, Venus appears, awakening them to their own beauty. Burne-Jones may have begun the first canvas as early as 1867; it was incomplete when he started the second, larger variant in 1873. It was in the 1870s that he began to indulge fully his compulsion to create another rendition of a work even while the first was still in progress, enlarging the scale, refining the details, and

adjusting nuances of tonality without significantly altering the composition. The later version of *The Mirror of Venus* captures this practice perfectly. While the composition is the same, the tonal harmonies are warmer and more varied, and the figures are fuller bodied and more sensuous, echoing the voluptuous proportions Burne-Jones adopted after his third trip to Italy. Water lilies glide over the surface of the pond, and the landscape—barren in the initial painting—offers a promise of lush spring growth.

It is the voluminous folds of the drapery, more than any other feature, that link the studies in the Art Institute sketchbook to the second version of *The Mirror of Venus*. The garments in the earlier painting are

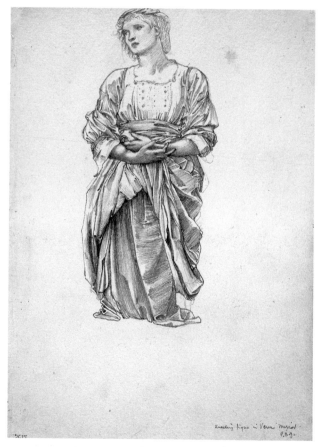

Figure 8. Edward Burne-Jones. *Study of a Kneeling Figure for "The Mirror of Venus,"* 1873. Graphite on ivory wove paper; 25.3 x 17.8 cm (9 ¹⁵/₁₆ x 7 in.). Ida E. S. Noyes Fund, 1920.1147.

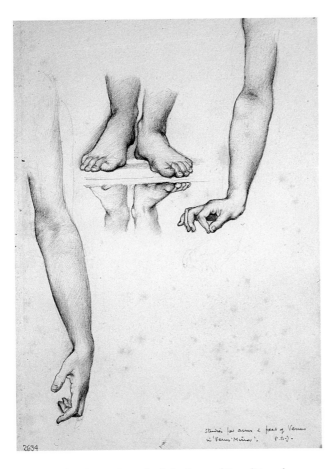

Figure 9. Edward Burne-Jones. *Study for Arms and Feet of Venus for "The Mirror of Venus,"* 1873. Graphite on ivory wove paper; 25.3 x 17.8 cm (9 ¹⁵/₁₆ x 7 in.). Ida E. S. Noyes Fund, 1920.1164.

articulated by narrow, vertical pleats and slide smoothly over the women's slender bodies. In the second version, the fabric is more abundant and free, flowing over the figures' rounder limbs and fuller forms. One drawing in the museum's sketchbook (fig. 8), for example, depicts a kneeling woman who gathers the folds of her overskirt in her hands, causing the excess fabric to undulate over her hips.[30] Burne-Jones's precise rendering of the hand gestures and the costume contours reveals that this figure is well resolved; she appears in the second variant of the painting on Venus's left.

Another study of Venus's arms and feet (fig. 9) calls attention to the similar treatment in the sketch of the goddess for *The Story of Troy* (fig. 5) and suggests the extent to which Burne-Jones re-employed design approaches that he particularly favored.[31] On the left side, the place-

ment of the arm is nearly identical—Burne-Jones repeated even the complicated play of thumb and fingers. The handling of the right arm displays the same soft gradations that the artist used to model form in the *Troy* studies. The feet, too, echo the stance of the *Troy Venus*—the body's weight is centered on the left foot, allowing the right to rise slightly on its ball. But it is the presence of the reflection, however, that allows us to identify this unmistakably as a preliminary study for *The Mirror of Venus*, not *The Story of Troy*. In fact, the firm contours and deft, light lines of these sketches seem more assured than those of the *Troy* drawings, indicating that the artist had already decided where to place the figures and was now working out the fine points. It seems reasonable to speculate that he made these sketches after the *Troy* studies, most likely in 1873, when he began the second version of *The Mirror of Venus*.[32]

Two of the sketchbook's other studies (figs. 10–11), representing the standing figure of Saint Mark, offer a glimpse into another area of Burne-Jones's activity in the 1870s—his work designing stained glass. While he conceived his first set of stained-glass panels in 1856, he worked closely with Morris in the years that followed, creating ensembles to decorate private homes and public spaces, most notably churches. The years of his withdrawal from the art world were the most active for this type of work; more than 270 designs can be dated between the years 1872 and 1878.[33] Burne-Jones drew these cartoons with ease, typically working freehand to scale in charcoal. His wife recalled that he found the work relaxing, fondly remembering the "soft scraping sound of the charcoal" in the evenings after dinner, when he would draw among family and friends.[34]

Burne-Jones executed these drawings of Saint Mark as part of a large undertaking for Morris's firm, an eleven-part program for the nave and transepts of the chapel at Jesus College, Cambridge. Between 1872 and 1876, he made more than fifty-five designs for this project. The sketchbook studies reveal that, prior to his rapid execution of the cartoons, the artist prepared his hand and eye with deliberate, attentive studies of the figure in pencil, drawn from a model in the studio.[35] The draped study (fig. 10) is very close to the final design for the window: the

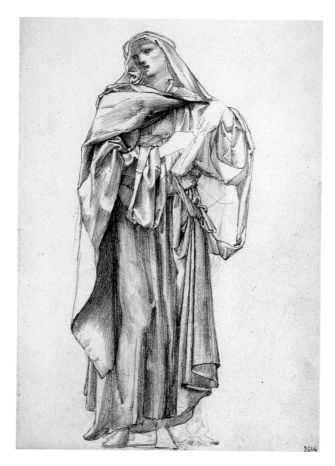

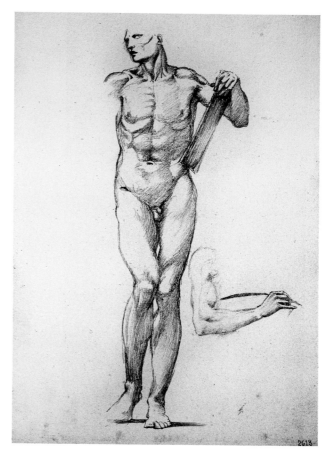

FIGURE 10. Edward Burne-Jones. *Draped Study of Saint Mark*, 1873/74. Graphite on ivory wove paper; 25.4 x 17.8 cm (10 x 7 in.). Ida E. S. Noyes Fund, 1920.1144.

FIGURE 11. Edward Burne-Jones. *Nude Study of Saint Mark*, 1873/74. Graphite on ivory wove paper; 25.3 x 17.8 cm (9 ¹⁵⁄₁₆ x 7 in.). Ida E. S. Noyes Fund, 1920.1143.

heavy garments are nearly identical in their twists and folds, as is the angle at which the saint steadies a book on his hip. But in the drawing, the head is slightly less turned, the neck shorter, and the hands and feet simply roughed in. In this particular sketch, it is the clothing, rather than the details of the body, that captured Burne-Jones's attention.

The nude study (fig. 11), however, suggests that he had resolved the nuances of the position before clothing his figure. In this sheet, he established the head's sharp incline and rendered the exaggerated tendons of the twisting neck. Although he ultimately swathed the figure in robes, Burne-Jones carefully delineated the muscular torque of its broad torso and the strain of the shifting weight on its powerful legs. He evidently was uncertain about the position of the right arm and hand, since the drawing stops abruptly at the turn of the right shoulder,

and a rough sketch of the arm, clumsily handled, appears in the lower right. In September 1873, in his account book for his work with Morris, Burne-Jones wrote that he had finished the cartoon for the related Saint Matthew window, writing: "hastily executed I admit but altogether a bold conception."[36] The finished Saint Mark window was installed in the Jesus College chapel in 1874, which suggests that the Art Institute's drawings were likely made during the winter of 1873–74.

A delicately rendered male nude in the sketchbook (fig. 1) suggests the ways in which Burne-Jones regularly translated motifs from his Morris designs into his paintings. With his soft, fine hair, which curls around a fillet of leaves, and the twisted length of fabric crossing his hips, the figure is linked to a series of sketches that Burne-Jones produced for an embroidered "tapestry frieze" entitled

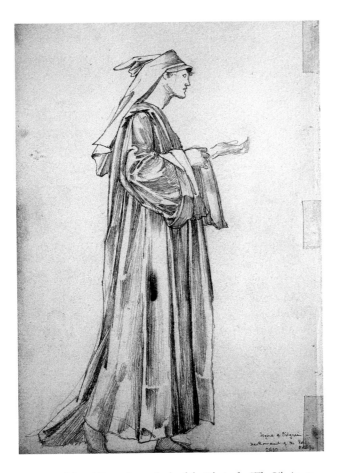

FIGURE 12. Edward Burne-Jones. *Study of the Pilgrim for "The Pilgrim at the Gate of Idleness,"* 1874/77. Graphite on ivory wove paper; 25.3 x 17.8 cm (9 ¹⁵/₁₆ x 7 in.). Ida E. S. Noyes Fund, 1920.1140.

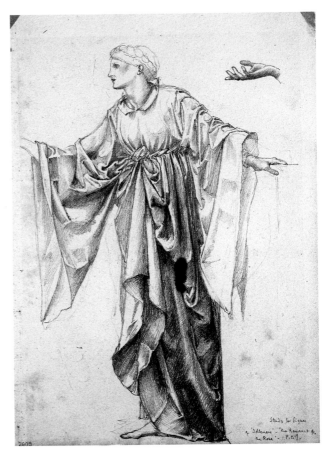

FIGURE 13. Edward Burne-Jones. *Study of Idleness for "The Pilgrim at the Gate of Idleness,"* 1874/77. Graphite on ivory wove paper; 25.3 x 17.8 cm (9 ¹⁵/₁₆ x 7 in.). Ida E. S. Noyes Fund, 1920.1139.

The Pilgrim in the Garden of Idleness. That work was based on an episode in Chaucer's *Romaunt de Rose* in which a pilgrim, searching for his heart's desire, encounters the incarnations of life's falsehoods and miseries just before the personifications of Love and Beauty lead him to the object of his quest. Burne-Jones created the ensemble for Routon Grange, a house built for the Yorkshire industrialist Isaac Lowthian Bell and decorated by Morris's firm.[37] Although the male nude does not appear in any finished decorative design or painting, the sketchbook also contains a set of four drawings for a canvas completed nearly a decade later, *The Pilgrim at the Gate of Idleness* (fig. 14), which depicts the stately figure of Idleness welcoming the weary Pilgrim into her garden on the penultimate stop on his journey. These include a study for the Pilgrim (fig. 12) and another of Idleness (fig. 13),

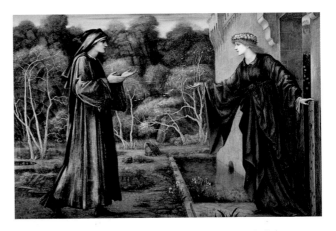

FIGURE 14. Edward Burne-Jones. *The Pilgrim at the Gate of Idleness*, 1884. Oil on canvas; 96.5 x 130.8 cm (38 x 51 ½ in.). Dallas Museum of Art, Foundation for the Arts Collection, Mrs. John B. O'Hara Fund.

which anticipate very closely the positions and gestures of the figures in the finished painting; like those in the sketches created for the earlier tapestry frieze, however, they are more attenuated and wear sweeter expressions.[38]

An unfinished figure (fig. 15) in the Art Institute sketchbook may mark the first appearance of Cupid drawing his bow, a motif that Burne-Jones employed both in his decorative designs and his paintings for the duration of his career. The artist included an image of Cupid as a handsome young archer in the predella of *The Story of Troy*; after that, he used the figure repeatedly, with subtle variations. For example, he depicted Cupid with his head tilted downward and his bow pointed toward the earth, in the central panel of the triptych *Pyramus and Thisbe* (1872–76; Williamson Art Gallery and Museum,

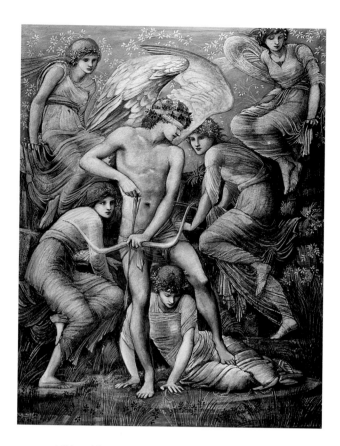

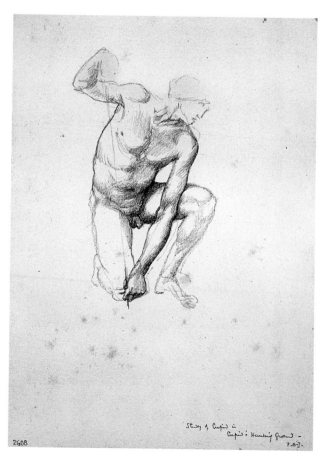

Birkenhead).[39] He also used the figure as the key image in *Cupid's Hunting Fields*, which he painted three times between 1880 and 1885. The last of these is a stunningly finished watercolor heightened with gold, now in the Art Institute's collection (fig. 16).[40] In the sketchbook drawing, Cupid's position varies slightly from these later depictions; his left arm, which holds the bow, pushes forward and away from his body, and the left knee is raised and bent at an acute angle. But the figure itself is fragmentary and lightly rendered, as if the artist intended to capture a fleeting idea, more suggestive than descriptive, so as not to lose it.

While it chronicles seven years of work, the Art Institute's sketchbook represents the creative process and aesthetic ideals that Burne-Jones followed to the end of his career. In 1877 the artist emerged from this period of

isolation, earning resounding acclaim for eight works in the premier exhibition at the Grosvenor Gallery, London. His critical reputation was transformed: as his wife observed, "he belonged to the world in a sense that he had never done before, for his existence became widely known and his name famous."[41] But his studio practice did not change, and he continued to start more works than he could ever finish. Of all Burne-Jones's "unpainted masterpieces," the one that troubled him most was the grand-scale oil *The Sleep of Arthur in Avalon* (1881–98; Museo de Arte de Ponce, Puerto Rico).[42] He began the canvas in 1881, on commission from George Howard for his library in Naworth Castle, Cumberland, but the project grew so large and complex that by 1885 Burne-Jones asked Howard if he would accept a simpler composition. A longtime friend, Howard realized the significance of the work to Burne-Jones and released him from his obligation.[43] The artist never regarded the painting as finished; he was working on it the day before he died.

One element of the plan that he did ultimately abandon was a pair of panels intended to flank the central composition, which were painted but never used.[44] These depicted hill fairies, mystical sprites that climbed the cliffs above Arthur's citadel. Burne-Jones executed preparatory drawings for the panels in 1885, after he had come to his agreement with Howard.[45] An undated, half-length pencil study of a male nude, now in the Art Institute (fig. 17), can be firmly identified as one of them. While the sketch itself is heavily worked and rubbed, as if the desired effect eluded Burne-Jones, the figure's flying hair and wild gaze capture the otherworldly atmosphere he hoped that the panels would evoke. Burne-Jones disliked it when a drawing appeared labored; this one must have displeased him, but he used the figure at the top of the right panel nevertheless. Looking back at his work, he told Rooke, "There's no drawing that I consider perfect."[46] But the *Hill Fairy* drawing—like the others we have examined—bears witness to his relentless struggle to find that perfection, sketching in pencil before taking up his brush.

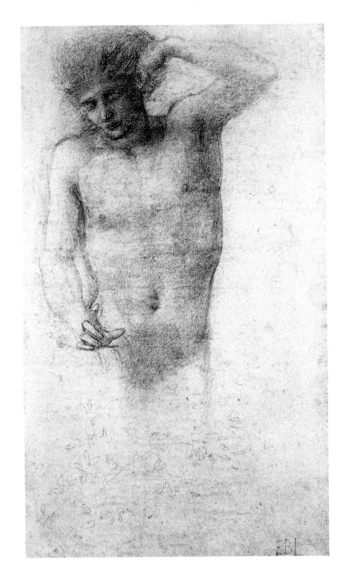

FIGURE 17. Edward Burne-Jones. *Study of a Male Nude for "Hill Fairies,"* c. 1885. Graphite on ivory wove paper; 22 x 12.3 cm (8 5/8 x 4 7/8 in.). Charles C. Cunningham Bequest, 1980.412.

From the Manor House to the Asylum:
The George Cowper Album

Douglas R. Nickel

Director, Center for Creative Photography, University of Arizona

A century after the curtain descended on the Victorian period, historians still struggle to define its import. While nineteenth-century Britain gave birth to most of the ideas, institutions, and technologies that define our own time, it was also the era of the top hat and crinoline, of spiritualism and phrenology, of the *horror vacui* and pinches of snuff—things that suggest how remote Victorian culture often seems from our own. The early twentieth century encouraged this sense of historical distance: writers such as Lytton Strachey caricatured the eminent Victorians as maudlin, overly pious, and sexually repressed, the better to establish their own generation's credentials as modern, rational, and liberated.[1] The historiography that undergirds our own understanding of the Victorians, therefore, is itself a filter or screen, imparting its own values in its struggle to describe those of its subject.

The Art Institute of Chicago retains a unique album of early photographs that offers us a more transparent window onto the elite world of Victorian England. Known as the George Cowper Album, this well-preserved compendium holds nearly one hundred original images dating from 1849 to 1860, bound in red morocco with fancy, gilt tooling (fig. 2). Within its pages, the feature that strikes contemporary viewers most immediately is the jumble of seemingly disparate genres of photography—from reportage of a shipwreck in the resort town of Brighton (fig. 3) to amateur family portraits. The contents incorporate examples of some of the earliest paper photographs ever conceived, as well as copies of drawings and paintings, commercial studio pictures, landscape studies, sweeping images of manor houses, a view of Jerusalem in 1856, and a formal portrait of Napoleon III, Emperor of France. To our eyes, such an arrangement is foreign: while neither purely random nor straightforwardly systematic or narrative, it evidently conforms to some Victorian organizational logic that would have been legible to its original makers and users. The central intellectual problem the album poses, then, is accounting for the cultural conventions—the aesthetic, biographical, political, or sociological programs—that brought these polyglot images together.

The first place to turn to is the collection's reputed maker, George Augustus Frederick, the 6th Earl Cowper. The volume was sold to the museum as the George Cowper Album, the monogram "G.C." is embossed prominently on its cover, and many of the unattributed photographs inside are family portraits thought to have been taken by Cowper himself.[2]

FIGURE 1. *Broadlands*, 1859 (detail). Albumen print; 14.4 x 19.3 cm (5 5/8 x 7 5/8 in.). Second from left is William Francis Cowper-Temple, George Cowper's brother and Lord Palmerston's stepson, who inherited the Broadlands estate in 1865.

FIGURE 2. The George Cowper Album (1960.815) is bound in fine red leather and embossed with gilt fleurs-de-lis and, at center, the monogram "G.C."

However, the evidence for the album as a repository for the efforts of a sole aristocratic, amateur practitioner appears not so simple or straightforward. Standard reference works list no George Cowper as a photographer in the 1850s, nor does his name appear in any period exhibition catalogues or in the minutes of any photographic society meeting. Nonetheless, his firsthand association with several prominent individuals who *were* centrally involved with the burgeoning world of photography—William Henry Fox Talbot, Henry White, and Dr. Hugh Welch Diamond, to name just three—seems plausible, based on original examples of their work collected in the album. This was an elite, well-educated group of Britain's finest, which comprised gentlemen wealthy enough to practice photography as an art and not a trade, and who enjoyed a leisured lifestyle much like that depicted in several of the photographs ascribed to Cowper. One such image (fig. 4), labeled "Mr. and Mrs. G. C., 1849," likely portrays Cowper with his wife and two companions, visiting the recently landscaped gardens of Dunrobin Castle in Scotland.

Indeed, it is this preponderance of evidence—albeit circumstantial—that ties the album's inception to Cowper. Born in London in 1806, he served as a lieutenant in the Royal Horse Guards as a young man and was later elected to Parliament, representing Canterbury as a member of the Whig Party from 1830 to 1834. In 1833 he married Anne Florence de Grey, daughter of Thomas Philip, Earl de Grey, and a year later was named Undersecretary of State for Foreign Affairs.[3] The family's Hertfordshire estate, Panshanger (see fig. 5), was built in the eighteenth century and had hanging on its walls at least two Raphael Madonnas, acquired by the 3rd Earl Cowper while serving as ambassador to Florence in the 1780s.[4] The only obstacle to attaching the album securely to George Augustus Cowper is the fact that he died suddenly in 1856 from what were described as "spasms of the heart."[5] Since several of the photographs in the scrapbook are inscribed with dates as late as 1859, it is likely that someone continued to add prints, writing the captions that postdate the earl's death.

The Cowpers' eldest son, Francis Thomas, was twenty-two when his father died, studying law and modern medicine at Christ Church College, Oxford. The album includes a portrait of a fellow Oxonian, Augustus Vernon Harcourt of Balliol College, dated 1857. Harcourt was exactly the same age as Francis and was already on his way to becoming a famous scientist.[6] Since this image was made a year after George Cowper's death, we might surmise that Francis Thomas, now the 7th Earl Cowper, inherited the album and supplemented it with photographs related to his own interests and social circle. If this was so, the scrapbook is perhaps best understood as a testament of patriarchy, reflecting the fortunes of the Cowper family over a ten-year period.

The Cowpers' creation and expansion of the album is perfectly in keeping with their social station and with a particular moment in the history of British photography. While Henry Talbot introduced the medium in 1839, the years 1849 to 1860—when this collection was assembled—witnessed photography's transition from what was essentially a gentleman's pastime into a professional enterprise. Making albums and exchanging prints were an integral part of the exclusive, private photographic societies that sprang up in the early years of the technology. Victorians were already accustomed to assembling various specimens or mementos—calling

FIGURE 3. *The Wreck, Brighton, Oct. 8, 1857.* Salted paper print; 14.9 x 19.7 cm (5 7/8 x 7 3/4 in.). A crowd gathers around a foundered ship on the beach of this famous resort town, located on England's southern coast. Bathing machines, quintessential emblems of Victorian propriety, sit unused in the foreground.

cards, locks of hair, newspaper clippings, ribbons—into contemporary *Wunderkammern* and to giving these objects added significance through their own stories about them. Photographs appealed to them as similar, particularly potent emblems of actuality, as artifacts that could point to a wide variety of meanings.

Pictures of England's upper crust, and the great houses they owned and visited, comprise a considerable proportion of images in the Cowper album.[7] Photography was a gentleman's hobby, and Talbot, who invented the positive-negative process, was, like George Cowper, one of the landed gentry. Cambridge educated, he was a polymath who excelled in subjects ranging from Assyriology to optics. Secure in his social standing and independent income, Talbot could pursue his scholarly interests as an *amateur*, a term that in the 1830s was understood in its original sense, as one who engages in an activity out of love, not for money. (The word comes from the Latin *amare*, to love.) Talbot inherited his estate, Lacock Abbey in Wiltshire, as a young man, and his earliest experiments with photography took place on its grounds, with its ancient buildings often a subject.

In the first half of the nineteenth century, the situation of the countryside became more complex, as the rising middle class of the industrial cities grew dissatisfied with a parliamentary system that, by law, vested much of its power in agriculture and in aristocratic landowners. To some, grand manor houses symbolized an outmoded, self-serving tradition of nepotism in which titles were passed down by birth, not earned by talent and hard work. Talbot, who served in Parliament from 1832 to 1834, belonged to the Whig, or Reform, party; he called for his fellow peers to treat their workers and tenants more progressively, modeling this behavior at Lacock. In this light, it is interesting to learn that he orchestrated photographic tableaux featuring his estate workers posed as if interrupted in their activities of sawing, chopping, and storing wood. The copy of a print pasted into the Cowper Album (fig. 6) bears the inscription *labor omnia vincit*, Latin for "work overcomes all." Although not included in Talbot's publication *The Pencil of Nature* (1844–46), the first publicly available book to be illustrated with photographs, the scene relates to other views that characterize Lacock Abbey as a working estate.[8]

FIGURE 4. *Dunrobin*, 1849. Thinly albumenized silver print; 15.7 x 18.6 cm (6 3/16 x 7 5/16 in.). Anne Florence de Grey and George Augustus Cowper are visible at right.

A second, more familiar Talbot image, *The Open Door* (fig. 7), is also present in the Art Institute's album. It shows a scene near Lacock's stables, identifiable by the bridle hanging over the door. Emulating the moral symbolism of seventeenth-century genre paintings, Talbot artfully obliged a broom to lean across the doorway.[9] This photograph features prominently in *The Pencil of Nature*, where Talbot explained it as an example of a new art, still in its infancy, which allows for the aesthetic contemplation of "scenes of daily and familiar occurrence."[10] In the Cowper Album, however, its art function is suppressed; appearing without its title, it carries the inscription "one of the earliest impressions by H. Talbot, inventor of Talbotype." It is, in other words, presented as a specimen of the technology and its history, associated directly with Talbot as an innovator. The conceptual nexus of antiquity, art, morality, and rural labor remains latent, as it does so often in the scrapbook as a whole.[11]

The presence of Talbot's images in the album also suggests the way in which the scrapbook itself arose out of a peculiarly transitional moment in the history of English photography—a point when the technology found itself caught up in wider debates over the institution of the peerage, international competition in the realm of industry, and which class of men would ultimately lead the country into the future. The nation's first photographic organizations were established by already wealthy experimenters like Talbot, who were by no means oblivious to the useful (and possibly gainful) applications to which the new medium might be put. The Calotype Club, also known as the Photographic Club, was formed in London in 1847 and served to formalize discussions that were already taking place within a small network of gentleman-amateurs.[12] Most of these men knew each other through other learned groups, such as the science-oriented Royal and Linnaean societies, but their conversations at the Calotype Club centered specifically on photographic technique, with occasional forays into topics such as aesthetics.[13]

In response to rising popular interest, however, the group was invited to participate in a large-scale, international exhibition of camera images held at the Society of

FIGURE 5. Attrib. George Augustus Cowper (English, 1805–1856). *Panshanger*, 1858. Albumen print; 14.6 x 18.1 cm (5 ¾ x 7 ⅛ in.).

Arts galleries in London in late 1852. This was the first public showing of photographs in England, and all the polite world turned out to examine the many works on display (see fig. 8). The keynote lecture was presented by an upstart lawyer-turned-photographer named Roger Fenton, who spoke "On the Present Position and Future Prospects of the Art of Photography—Technical, Esthetic and Commercial Progress." Scion of a family of bankers and mill-owners, Fenton epitomized the bourgeois entrepreneur, and he used his address to call for the founding of a new organization devoted to promoting photography as an industry and encouraging its growth as a popular art.[14] His model was the Great Exhibition of 1851 (better known as the Crystal Palace exhibition), which brought together manufactured goods from the leading industrial nations in open competition. The Photographic Society of London was formed two months after Fenton read his paper; it secured its triumph in 1855, when a professional portraitist named Silvester Laroche prevailed in his suit against Talbot and his patent restrictions on the new collodion positive-

negative process. The tide had turned: photography soon spread from its formerly exclusive circles to the more enterprising classes.

The new Photographic Society retained most of the Calotype Club's members but was more expansive in character, aiming to open up photography to larger audiences and a greater number of practitioners. The April 1853 *Journal of the Photographic Society* proposed that every member take part in an exchange system, generating prints of their best work, trading them, and then assembling their own unique albums of their colleagues' photographs. This was a common practice in other learned societies, where botanical specimens, for instance, were exchanged for mutual benefit. An autonomous Photographic Exchange Club existed by 1855, and the yearly albums it produced are now the best existing means of understanding the photographic world of the 1850s.

The Cowper scrapbook was not one of these exchange albums, but it bears a family resemblance to them in its organizational logic and in the broad range of

FIGURE 6. William Henry Fox Talbot (English, 1800–1877). *Labor Omnia Vincit*, c. 1845. Salted paper print; 15.4 x 21.2 cm (6 $\frac{1}{16}$ x 8 $\frac{3}{8}$ in.).

FIGURE 7. William Henry Fox Talbot. *The Open Door*, 1844. Coated salted paper print; 14.3 x 19.2 cm (5 $\frac{5}{8}$ x 7 $\frac{9}{16}$ in.).

works it includes. In fact, George Cowper seems to have been acquainted with a number of the Photographic Society's members. One of these men was Henry White. A solicitor by profession, White was also an accomplished amateur photographer who specialized in pastoral compositions such as *The Thames near Weybridge* (fig. 9), which found its way into Cowper's album.[15] White's career exemplifies the fluidity of photographers' identities in this period: he began his work in association with fellow devotees like Talbot and Diamond but by 1856 was publishing and selling his photographs on the open market. While it is unlikely that Cowper and his family would have resorted to such commercial activity themselves, their apparent associations with those who did attest to the state of social flux in which mid-century Victorians often found themselves.

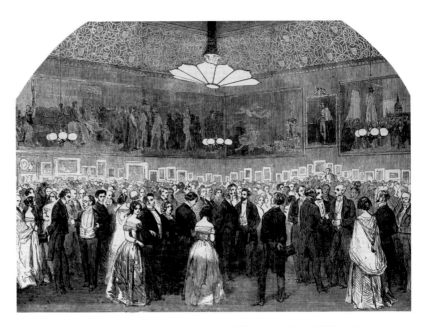

FIGURE 8. *Soirée of Photographers in the Great Room of the Society of Arts*. Published in the *Illustrated London News,* Jan. 1, 1853, p. 12.

Albums from the 1850s and 1860s include a variety of images, commonplace to the Victorians, that seem rather alien to our modern understanding of photography. The Cowper scrapbook in particular contains photographs of drawings, paintings, and sculptures. Facsimile drawings showing famous figures such as Charlotte Brontë or Florence Nightingale, for example, appear opposite copies of religious paintings and direct photographic portraits and scenic views. The Cowpers must have been conventionally pious, as the general tenor of these inclusions is devout and sentimental. One image reproduces an unidentified painting of children reading from scripture and is inscribed "We Praise Thee, O Lord"; another depicts a beaming boy and girl (fig. 10) interpreted by a caption reading "The heart of childhood is all mirth; / we frolic to and fro; / As free and blithe as if on earth was no such thing as woe."[16]

FIGURE 9. Henry White (English, 1819–1903). *The Thames near Weybridge*, c. 1856. Albumen print; diam. 19 cm (7 ½ in.).

One particularly interesting page pairs two original photographs (figs. 11–12). At the top is the seated figure of a young woman, taking a break from her reading. The caption declares, "Her Eyes are Homes of Silent Prayer," a line taken from Alfred Tennyson's poem *In Memoriam*, published in 1850. Tennyson's subject is the question of faith and the possibility of an afterlife; the "her" of the quotation is Mary, the sister of Lazarus, who confronts her brother, whom Jesus has just raised from the dead: "Her eyes are homes of silent prayer, / No other thought her mind admits / But, he was dead, and there he sits / And He that brought him back is there."[17] In the biblical story, Mary's sister Martha storms outside to behold Jesus, while Mary stays back in the house; in the Christian tradition Mary came to symbolize modesty and contemplation, feminine qualities conveyed in the photograph through the subject's posture and open book.

Below, we find the same sitter in another scenario, captioned by an inscription reading: "Her quiet eyelids closed; she has another Morn than ours." This quotation is from another, more obscure source, Thomas Hood's 1846 poem "The Death Bed," which describes the untimely demise of a devout young woman. The original lines read, "Her quiet eyelids closed—she had Another dawn than ours" and refer to the spiritual rebirth awaiting the girl in heaven. Through literary allusions such as these, Victorian viewers removed photographs from the sphere of the material and the particular, imbuing them with a sense of the universal. Within the Art Institute's album, this theme of evangelical Christian sentiment overrides other taxonomies: while direct, modern photographs and copies of traditional artworks may appear alongside one another, they are each tethered to a more powerful, religious interpretive framework through the use of associative texts.

In the most general sense, it is a confluence of family relations, social privilege, Christian charity, and progressive politics that inform the Cowpers' logic of selection more than anything else. The very first item in the scrapbook is an unassuming portrait of a gentleman signing a document, captioned "The president of the board of health, 1856, indicting a sewer" (fig. 13). No issue con-

FIGURE 10. Copy photograph of an unidentified painting, c. 1855. Albumen print; 21.2 x 15.3 cm (8 5/16 x 6 in.).

cerned the English more in the 1850s than public health. London's population exploded in the first half of the nineteenth century: crime, disease, and social unrest were the result, and poor sanitation became a major problem that affected every city dweller, from paupers to members of Parliament.[18] Before then, London was served by a primitive network of street-level sewers, essentially covered ditches that drained into the Thames. The poor would simply empty their chamber pots in the street, while the wealthy had water closets connected to cesspits installed under the floors of their homes, which would pour into the sewers when they reached a certain level. The stench was unimaginable.

A sizeable portion of residents continued to get drinking water from the Thames, despite its fetid condi-

tion. The result was epidemics of typhoid and cholera; over 14,000 Londoners died of cholera in 1849, and another 10,000 followed in 1853. Sir Edwin Chadwick, the subject of this photograph, was a barrister and assistant to the economist Jeremy Bentham, who in 1832 became involved in a campaign to overhaul Britain's Poor Laws. This led him to take up the question of sanitation, and in 1842 he drafted a report that for the first time identified the source of the epidemics as contaminated drinking water. While the Metropolitan Commission for Sewers was set up in 1847, the government dragged its feet about funding the system—that is, until the summer of 1858, when unusually warm weather conspired with the backed-up Thames to occasion the "Great Stink," during which members of Parliament were forced to drape curtains soaked in chloride of lime over windows in order to continue their work. A major engineering project was passed into law shortly thereafter, but in 1856, when the Cowper photograph was composed, this triumph of hygiene was still a work in progress.[19] The act of "indicting a sewer" would be readily recognized as part of the liberal campaign to improve the living conditions of London's innumerable slum dwellers.

Only two groups could be considered lower on the social ladder than the urban poor in Victorian times: criminals and the insane. Without doubt the most startling inclusion in the Cowper album is a set of portraits, inexplicably interleaved with images of country houses and society types, showing an unnamed psychiatric patient at the Surrey County Lunatic Asylum (fig. 14). This is an example of the scientific work of Dr. Hugh Welch Diamond, one of the original Calotype Club members and a founding member of the Photographic Society. While an amateur, Diamond was also the first medical photographer, and the best-known practitioner of psychiatric photography, in nineteenth-century Britain.[20] His decision to accept his appointment in Surrey came about partly because the medical treatment of mental conditions had become a cutting-edge specialization, offering someone with his experimentalist bent the opportunity to distinguish himself while also performing a public service.[21]

Diamond believed that portraits of his patients could be useful in two ways. First, photography allowed highly accurate, objective records of his subjects' outward demeanor to be catalogued, so that their movement from

FIGURE 11. *Her Eyes Are Homes of Silent Prayer*, c. 1850s. Albumen print; 11.2 x 9.8 cm (4 3/8 x 3 7/8 in.).

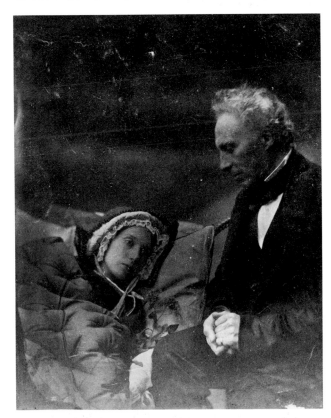

FIGURE 12. *Her Quiet Eyelids Closed*, c. 1850s. Albumen print; 12.5 x 9.7 cm (4 15/16 x 3 13/16 in.).

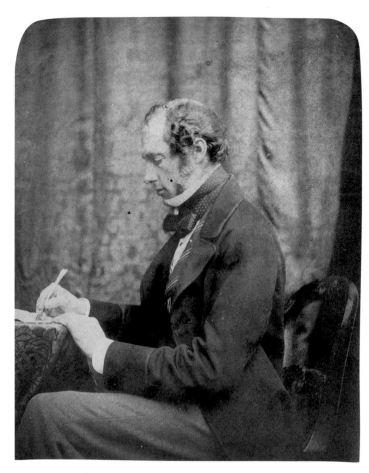

FIGURE 13. *The President of the Board of Health, 1856, Indicting a Sewer,* 1856. Thinly albumenized silver print; 18.8 x 14.6 cm (7 3/8 x 5 13/16 in.).

one state of their condition to another could be documented. Diamond preferred visual descriptions to verbal ones, writing, "The photographer . . . needs in many cases no aid from any language of his own, but prefers rather to listen, with the picture before him, to the silent but telling language of nature."[22] Second, because Diamond made his portraits with his sitters' help, he felt that the photographic sessions themselves had a beneficial effect and that the images allowed patients to reflect on and better understand their individual maladies.

The set of four studies featured in the Cowper album was especially important to Diamond: it shows a woman suffering from puerperal mania—what we would today call postpartum syndrome. John Conolly, Diamond's partner, chose the series to illustrate an article published in the *Medical Times and Gazette* in 1858, where they appeared as lithographs.[23] Explaining the first photo-

graph, Conolly described how the woman was abandoned by her jobless husband just before giving birth and how her condition followed immediately upon delivery. The second photo was taken eight days after the first and shows the patient regaining liveliness and beginning to eat again. The third image depicts her in full recovery, six weeks later, standing up and neatly dressed. Her discharge from the asylum was marked with a final study two months later, her features restored to a condition of tranquility and normal animation. Diamond did not confine such studies to medical circles: he put them on display in general photographic exhibitions, including the 1852 Society of Arts exhibition at which Fenton first called for the creation of the Photographic Society. For Diamond, these photographs seemed to collapse distinctions between art and science, applied method and public demonstration. He regarded them simultaneously as working diagnostic tools and as emblems of photography's ability to penetrate hitherto invisible aspects of reality, making them observable to the modern public.

But what are Diamond's asylum pictures doing in the Cowper Album in the first place? We have two clues. First, the scrapbook contains an extensive suite of photographs made in and around a Palladian country house known as Broadlands.[24] This was the home and birthplace of Henry John Temple, 3rd Viscount Palmerston, England's prime minister from 1855 to 1858 and again from 1859 until his death in 1865. Queen Victoria hated Palmerston, and his position was worsened when he seduced one of her ladies-in-waiting, but he was an effective politician and a pillar of the Whig Party. The Cowpers were intimately connected with Palmerston, who served as secretary of state for foreign affairs in 1834, while George Cowper assumed the office of undersecretary. More intriguingly, Cowper's younger brother William Francis Cowper-Temple became Palmerston's stepson after his widowed mother married Palmerston. William, who appears in an 1859 photograph from the album (fig. 1), inherited Broadlands upon the prime minister's death.[25] Thus, the scrapbook's collection of images related to the liberal platform—the reform of Parliament, the dignity of rural labor, the construction of sewers, and the campaign for

more humane treatment of the mentally ill—turns out to tied to a family connection with the head of the Whig Party in Victorian England: the prime minister himself.

Second, it is also possible that George Cowper knew Diamond through social circles and collected examples of his nonscientific photographs as illustrations of the art, and that his elder son, Thomas Francis, maintained this relationship, adding pictures like these to reflect his own interest in medicine. There is much evidence to suggest that George Cowper—who served in parliament with Talbot and worked under Palmerston—bequeathed his own political and social connections to his younger son, William, who carried on the family tradition by serving in government and supporting reform issues. The Surrey County Asylum was a jewel in the crown of progressive reform in the 1850s, so specimens of the innovative work being performed there would have been perfectly in keeping with the politics of the scrapbook as a whole.

In the end, however, the Cowper Album holds traces of an essentially private family story that can be meaningfully—if only partially—reconstructed today. For the scholar, it exists as something like a time machine, all the more compelling because its images and inscriptions document lives, lifestyles, and sensibilities that rarely make their way into official history in such an immediate way.

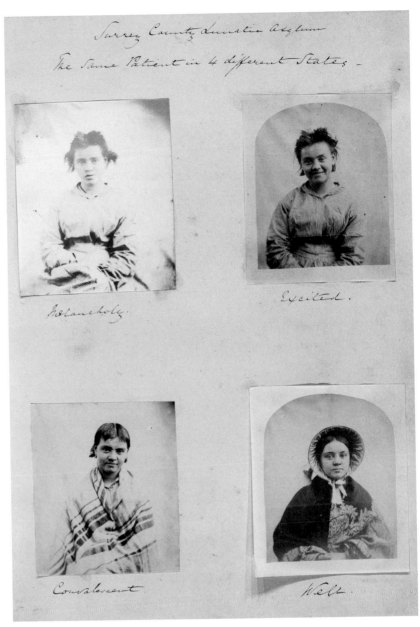

FIGURE 14. Hugh Welch Diamond (English, 1808–1886). *Patient in Four States*, c. 1850. Albumen prints; sheet: 28.4 x 22.7 cm (11 3/16 x 9 in.).

1. *Design for a Gothic Arch*, 1853

John Everett Millais (English, 1829–1896)

>Graphite with touches of pen and brown ink on ivory wove
>paper; 23 x 10.75 cm (9 x 4 ½ in.)
>
>Margaret Day Blake and Sarah R. Shorey Endowments, 1996.318

These two spontaneous, innovative drawings emerged from the close relationship between John Everett Millais, founding member of the Pre-Raphaelite Brotherhood, and the influential art critic John Ruskin, and tell the story of Millais's increasing infatuation with his friend's wife, Euphemia (Effie) Chalmers Gray.

In June 1853 Ruskin invited Millais and his brother William to join him and Effie on an extended holiday in the Scottish Trossachs, where the party lived together in cramped quarters.[1] Ruskin was preoccupied, working on the index for *The Stones of Venice* and preparing four lectures planned for November. Millais and Effie spent a lot of time together, walking through the Highland landscape each evening. It was during one of these outings that Effie admitted the truth: her marriage was unconsummated, and she was deeply unhappy. She and Millais were strongly attracted to each another, but their love appeared hopeless, as divorce was virtually unheard of.

The verso drawing (at left), a preliminary sketch for *Design for a Gothic Window* (1853; Andrew Lloyd Webber Collection, England), was done under Ruskin's encouragement and close guidance.[2] Both angels are images of Effie, her figure bending to accentuate the shape of the arch. Demure and saintly, she appears frozen in her "innocent attractions" and embodies the piety that characterized the "prescribed femininity of the period."[3] According to Millais, his design represented "eternal happiness and the struggle for life."[4] Is it then any surprise that he elevated Effie's image as an object of worship, while adding, below, a ring signifying his eternal love for her?

In direct contrast, the recto (at right) holds a sexually charged sketch of an intimate embrace in which Effie's angelic traits have been replaced by those of a lover. This is an image of acknowledged desire and romantic love in which the devoted couple has overcome their obstacles to be together in a dreamlike state.[5] The staccato pencil work along the figures' edges highlights the tension and excitement of the moment. The drawing breaks rigid social constraints, giving expression to sexual feelings that were meant to be repressed.

Both drawings are representations of what was thought to be an impossible love. However, Effie's marriage to Ruskin was annulled in 1854, and twelve months later she married Millais.[6] While she kept the sheet for most of her life, she may have covered up the recto drawing, preferring to conceal its potentially embarrassing secret.[7] L.L.

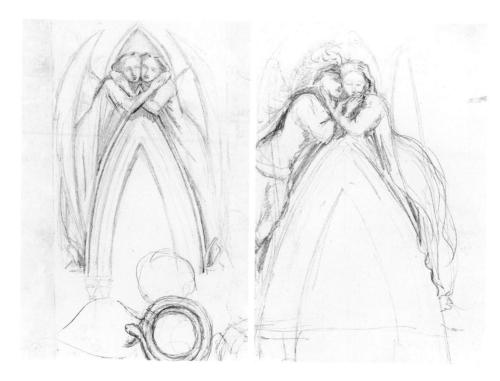

2. *Whitby Abbey*, 1852/54

Benjamin Brecknell Turner (English, 1815–1894)

> Albumen print from a calotype negative; 28.4 x 39 cm
> (11 3/16 x 15 3/8 in.)
> Restricted gift of Edward Byron Smith, 1983.322

Whitby Abbey, situated on the coastal headland in the northern county of Yorkshire, was founded in the seventh century as a shrine to Saint Hild. A ruin by the Victorian era, its skeletal remains were a popular tourist destination, despite the 199 steps that visitors were required to ascend to reach them. The abbey's appeal lay as a nostalgic, picturesque ruin that revealed the presence of the past even as nature reclaimed it.

Benjamin Brecknell Turner, like other painters and early photographers, found himself attracted to the romantic forces of growth and change apparent in Whitby's ivy-covered stones.[1] He made several images of the site, ultimately publishing six of them in *Photographic Views from Nature* (1854/55), an album that included sixty views made between 1852 and 1854; he also displayed five pictures of the ruin at the Photographic Society of London exhibition of 1854. These methods of circulation—the album and the exhibition—were typical for gentleman-amateurs of the day. The scion of a successful manufacturing family, Turner had taken up photography as a hobby in 1849, following the calotype process invented by William Henry Fox Talbot (see Nickel essay, figs. 6–7) a decade earlier. His wife's family had purchased a small estate in the west of England, and Turner eventually spent many of his summers making pastoral landscapes with this new technique.

Making a calotype image involved exposing sensitized paper to sunlight in a large camera and using the resulting negative to produce positive prints. One drawback of the process, which required half-hour exposures on even the brightest days, was the risk of overexposing very light areas while underexposing darker ones. The photographer Gustave Le Gray, who was making contemporaneous seascapes, addressed this problem by printing from two negatives, one for sea and one for sky; Turner solved it by presenting the sky as interesting white shapes, framed here by the bones of the old church. The properties of the calotype medium are ideally suited to subjects such as this: the paper negative's subtle texture lends the print a perfect combination of accuracy and atmospheric quality, allowing it to evoke more effectively the character and tactile qualities of stone. Ironically enough, it was the interest of artists such as Turner that ultimately led to the preservation of decaying ruins like Whitby. In that sense, this image of the abbey can be seen to have stalled the inevitable march of time in its path, both in art and life. E.S.

3. *Lovers*, 1855

William Powell Frith (English, 1819–1909)

Oil on canvas; 38 x 31 cm (14 ¹¹/₁₆ x 12 in.)

Restricted gifts of Irving Lauf and Irene McNear, Mrs. P. Kelley Armour through the Old Masters Society, Mr. and Mrs. Donald Patterson; through prior acquisition of Mrs. Dellora A. Norris, 2003.47

William Powell Frith possessed a keen eye for the details of ordinary life. The son of former domestic servants who ran a hotel in the northern spa town of Harrogate, he wanted to become an auctioneer, but his parents sent him to study art in Dover, where he honed his skills by copying paintings in the local museum. He entered the Royal Academy Schools in London in 1837 and studied with William Mulready, the leading practitioner of contemporary painting. Three years he later made his debut at the Royal Academy. After more than a decade of solid but undistinguished reception, Frith enjoyed resounding success in 1854 when he exhibited *Life at the Seaside (Ramsgate Sands)* (1854; Royal Collection, London).[1] Stripped of sentimentality but rich in anecdotal observations, *Ramsgate Sands* displays a panorama of middle-class life at a popular coastal resort. Queen Victoria purchased the painting and granted the rights to have the image engraved. Overwhelmed by his newfound fame, Frith lamented that for nearly a year he was "abominably idle" and painted only small studies. These included *Lovers*, which he singled out as "among the best."[2]

Simple yet suggestive, *Lovers* presents an intimate glimpse of Victorian courtship and, as a critic for the *Art Journal* observed, "the story is at once seen."[3] With hat in hand, the man leans forward, gazing at his companion as if waiting her response to his question. But the woman glances downward, fixing her attention on the pink rose she holds in her ungloved hands. Just as the absence of a chaperone indicates that he has proposed marriage, the pink rose, a symbol of first love, signals her acceptance. While elements of this painting—the country setting, the man's position, and the tender tension—recall Mulready's *The Sonnet* (1839; Victoria and Albert Museum, London), and while Frith maintained a deep respect for his former teacher, the work is hardly an homage.[4] With its restrained palette and fashionable, emotionally guarded subjects, *Lovers* reinterpreted the subject for a new generation. The *Athenaeum* hailed the picture as "a charming bit of modern life poetry," and it was engraved as an illustration for the 1866 edition of *Moore's Irish Melodies*, a popular collection of sheet music.[5] Although later, ambitious works such as *Derby Day* (1858; Tate Britain, London) and *Railway Station* (1862; Royal Holloway College, Surrey) confirm Frith as the chronicler of Victorian times, *Lovers* reveals his perfect accord with the Victorian temperament.[6]　D.M.N.

4. *Study of a Young Man's Head with Right Arm Outstretched*, 1860

Edward John Poynter (English, 1836–1919)

> Black chalk and watercolor heightened with white gouache on
> light blue paper; 19.6 x 23.1 cm (7 ¾ x 9 ⅛ in.)
> Inscription: at lower left, *Paris EJP 1860*
> Marjorie and Brookes Hubachek Memorial Fund, 1997.304

At the age of nineteen, Edward John Poynter visited the 1855 Exposition universelle in Paris. The experience convinced him that French art and instruction were immensely superior to anything available in England, and a year later he enrolled at the Parisian atelier of Charles Gleyre. A classicist, Gleyre taught his students to revere the traditions of European art and adhere completely to strict academic principles, which included making numerous studies and drawing from live models.

During three bohemian years in France, Poynter became familiar with the work of William Bouguereau, Alexandre Cabanel, Jean-Auguste-Dominique Ingres, and the "Neo-Grecs," including Jean-Léon Gérôme.[1] The example of these artists, along with that of his friend and mentor Frederic Leighton, encouraged the young artist to develop his own style of academic classicism.

This drawing shows the influence not only of Gleyre but also of the academic French art. The confident use of hatching and blending emphasizes the texture of the model's skin as well as the tension of his outstretched arm, demonstrating Poynter's excellence as a draftsman. Poynter designed the complex composition to give a feeling of forward movement, yet the drawing exhibits a friezelike quality reminiscent of the classical art that he saw while in Rome during 1853 and 1854.

Throughout his life, Poynter pursued "a continuous and determined study of the figure" so that he could return art to the high standards of the Renaissance.[2] Indeed, it was his great admiration for Michelangelo, and his insistence that the "constant study from the life-model is the only means . . . of arriving at a comprehension of the beauty in nature and of avoiding its ugliness and deformity," that prompted an aesthetic dispute with John Ruskin during the late 1860s and 1870s.[3]

Poynter left Paris in 1859, a year before he executed this sheet. While the work's inscription has been interpreted as evidence that the artist began it while still in France, the word *Paris* more likely relates to the subject matter and identifies the figure as Paris of Troy, from Homer's *Iliad*. The Victorians had a huge passion for Homer, and a painting of Paris would have been very saleable, earning the struggling Poynter some much-needed income. Whatever the drawing's origins, the figure's pose clearly appealed to the artist, who used it in paintings throughout his career, including *The Cave of the Storm Nymphs* (1903; Andrew Lloyd Webber Collection, England) and *Israel in Egypt* (1867; Guildhall Art Gallery, London).[4] L.L.

5. *Untitled (Margaret Frances Langton Clarke)*, 1864

Charles Lutwidge Dodgson, known as Lewis Carroll
(English, 1832–1898)

Albumen print; 15.2 x 12.6 cm (6 x 5 in.)

Gift of Mrs. John W. Taylor, Mrs. Winthrop M. Robinson, Jr., and Mrs. Fred D. Sauter, from the Estate of Frances Hooper, 1987.211.3

Rev. Charles Lutwidge Dodgson, more commonly known today by his pen name, Lewis Carroll, was a noted mathematician and logician, and the beloved author of the children's books *Alice's Adventures in Wonderland* and *Through the Looking-Glass.* He also produced some three thousand photographs over a period of twenty-four years. Dodgson first took up the camera in 1856 and began assembling portraits into display albums shortly thereafter. By 1860 he had compiled

a four-page list of photographs for sale, which included portraits (many of fellow Oxford professors), architectural studies, and pictures of sculpture and natural-history subjects. He later expanded his output to include images of important writers and painters of the day. At the same time, however, he had begun work on what would become his most personal and cherished images: his photographs of children.

Dodgson made this picture of four-year-old Margaret Frances Langton Clarke during a September 1864 visit to Whitburn, in the north of England. In his diary entry for those days, he mentioned, "During my stay, I took a good many photographs—of the Wilcoxes, the Langton Clarkes, Mrs. Balfour and children, etc.—these occupied the mornings, and the afternoons went in croquet, walking, etc."[1] The eldest daughter of Rev. James Langton Clarke, curate of Whitburn and sometime inventor, Margaret must have attracted Dodgson with her sweet but slightly melancholy expression.

Little Miss Clarke was only one of numerous children that Dodgson photographed during this period (one of his favorites was Alice Liddell, the inspiration for the Alice of his books). In many of his works, he cast his sitters in allegorical or mythological tableaux, having them dramatize heroic rescues of damsels in distress or act out scenes from popular poems. In other photographs—as in his *Alice* books—the motifs of sleep and dreaming feature prominently, with children feigning sleep, reclining in drowsy contemplation, or appearing ghostlike in a dream. Both of these strategies served to elevate his subjects beyond the materially grounded, merely accurate kind of images that the photographic medium so excelled at producing. This portrait of the young Margaret shows her engulfed by an adult-sized chair, feet barely reaching the edge, lost in thought or perhaps captivated by something outside the frame of the photograph. She is charming but sad, childish but dignified, awake but absorbed—occupying an in-between state that Dodgson's images of children repeatedly explore. E.S.

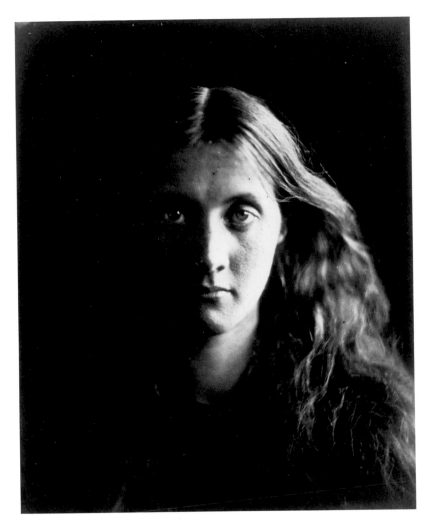

6. *Julia Jackson*, 1867

Julia Margaret Cameron (English, 1815–1879)
 Albumen silver print from wet collodion negative,
 27.6 x 22 cm (17 3/4 x 13 7/8 in.)
 Harriott A. Fox Endowment, 1968.227

Julia Margaret Cameron's photograph of her beloved niece Julia Jackson flouts the conventions of Victorian portrait photography. A typical example would present an entire figure for the viewer's scrutiny, sharply focused and evenly lit. By contrast, Cameron concentrated on the head, controlling the focal range to show only limited planes of Jackson's face clearly, leaving fully half of it shrouded in shadow. In this arresting image, the young woman stares directly and almost defiantly at the camera as if to impress the sheer force of her personality upon the photographic plate.

Cameron began photographing at age forty-eight, when her daughter and son-in-law gave her a camera as an amusement. She soon became obsessed with the medium, reveling in its messy magic, subsuming technical perfection to the overall effect. "I longed to arrest all beauty that came before me, and at length the longing has been satisfied," she wrote in her autobiography.[1] After converting her henhouse into a glasshouse and her coal shed into a darkroom, she began transforming maids into Madonnas and children into cherubim in highly allegorical and literary pictures. While she made portraits of some of the most important men of her day, including Thomas Carlyle, John Herschel, and Alfred Tennyson, female subjects allowed Cameron to explore the realm of mythology and imagination. She delighted in dressing and posing friends, relatives, and servants as the compassionate Virgin Mary, proud Queen Esther, or Shakespeare's faithful Cordelia.

Jackson was a notable exception. Known as a great beauty throughout her life, she was a favorite subject for Cameron. "Julia's beauty was conspicuous from her childhood and . . . as she grew up she was admired by all who had eyes to see," recalled her second husband, Leslie Stephen.[2] Cameron took dozens of photographs of her niece over the course of ten years; she was one of the few women who posed as herself. In April 1867, a month before Jackson's wedding to her first husband, Herbert Duckworth, Cameron made a series of portraits of the young bride-to-be. These pictures alternately reveal Jackson as noble, strong, tender, and vulnerable. With her hair down and her eyes wide, she is unsentimental, looking forward with equanimity and purpose to her own personal and social transformation. E.S.

7. *Study for "A Garden,"* c. 1869

Albert Joseph Moore (English, 1841–1893)

Black and white chalk on tan wove paper;
35.1 x 19.9 cm (13 ¾ x 7 ¾ in.)

Restricted gift of Marjorie H. Watkins in memory of Marjorie and Frank Brookes Hubachek, Sr., 2003.251

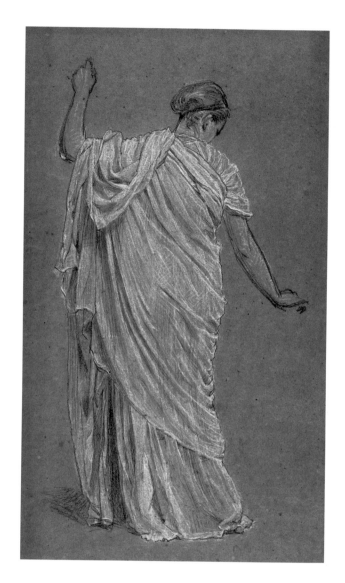

Writing of Albert Joseph Moore, the art historian Robyn Asleson remarked that "perfected beauty was the sole subject of his pictures."[1] To achieve this end, the artist developed a creative process that was methodical and extremely time consuming. When beginning a painting, Moore would undertake numerous sketches of each figure, working from a model who first posed nude and then clothed in the classical style. *Study for "A Garden"* is one example of such sheets, which Moore drew in order to determine a figure's exact proportions and physical characteristics. He then enlarged his designs into a number of full-scale cartoons. At this stage, using his "theoretical principles for ideal combinations of colour, line and form," which he developed through his substantial knowledge of architecture, geometry, mathematics, and the classical idiom, Moore made many refinements to his design so that it would fit his abstract ideal.[2]

This drawing, done in preparation for *A Garden* (1869; Tate Britain, London), shows Moore's brand of rigorous fine-tuning. In the sheet, the woman's arm is bent at an acute angle while the outer layer of drapery covers most of her lower-left shoulder. In the later *Cartoon for "A Garden"* (c. 1869; Victoria and Albert Museum, London), the artist moved the arm so that it forms an almost perfect right angle and lowered the drapery so that the cross-straps across the figure's back are clearly visible.[3] Moore used these revisions in the final painting.

Reflecting the contemporary trend toward classicism, *Study for "A Garden"* was influenced by a Roman wall painting, *Spring* (c. A.D. 79; Museo Nazionale, Naples).[4] The drawing's simplicity and two-dimensional linearity are also indebted to Moore's decorative work of the 1860s.[5] He was interested in movement, designing the figure's complicated pose to suggest spontaneity. The folds of drapery elegantly articulate the woman's body while also providing a decorative effect that draws the viewer away from the figure itself.

In line with his belief in the progressive Aesthetic Movement theory of art for art's sake, Moore wanted his work to be evaluated solely on visual terms.[6] He felt that art should transcend all narrative or moralistic meanings and should not reflect any sociopolitical period. In *Study for "A Garden,"* the artist intended his anonymous, perfect figure to be timeless; she can also be understood, however, as the product of a patriarchal Victorian society that was preoccupied with ideal feminine beauty. L.L.

8. *Photo Collage*, c. 1870s

Artist unknown (English, 19th century)

Collage of albumen prints and watercolor on paper; image
24 x 31 cm (9 7/16 x 12 3/16 in.), page 34.6 x 44 cm (13 5/8 x 17 3/8 in.)
Henry Foundation Fund, 1992.221

Sixty years ahead of the avant-garde, Victorian women were turning the rather serious conventions of studio photography on their heads with whimsical, often surreal collages. They may have made such images during the slow summers in the country; while the gentlemen were out on a hunt, the ladies would have amused themselves with needlework, painting, and playing cards—or with constructing their albums, for which most of these collages were produced.

A common motif in these pictures was the domestic interior, specifically the well-appointed drawing room. The most public space in the Victorian home, the drawing room was often used by the upper levels of society for formal gatherings. These included the ritual of visiting, which provided an opportunity to confirm one's social status and cement connections, and was governed by elaborate conventions that determined the appointed hours a lady was "at home," the etiquette of calling cards, and the appropriate duration of an encounter. In this scene, two women, two men, and a dog—probably cut out from studio cabinet card photographs, available from the late 1860s on—are arrayed rather stiffly within a room, which was sketched in watercolor by the album-maker. There is no place to sit, so the ladies stand while one gentleman leans jauntily against the wall and the other perches upon the window ledge. The central figure pursues a pastime appropriate to her age and sex, perhaps showing off her skill to the men by painting a portrait in their presence. Although the relationships among these photographic characters are unclear, the maker of this collage might have taken some sly pleasure in the story she could tell and the social power she could wield by manipulating them—which would have been far easier on paper than in real life.

The tableau moves from plausible to fanciful, however, with the addition of two important photographs: the man being painted on the easel and the woman whose picture hangs on the wall. These figures are intended to represent painted portraits rather than actual visitors, although their inclusion in the drawing room links them socially with the other guests. Photographs included in such collages, then, simultaneously refer to the real (or potentially real) and the invented, shifting and suspending the notion of a consistent photographic truth.[1] When combined with the fictions of drawing, they result in images that, like this one, hover between surrogate realities and fantasy worlds. E.S.

9–10. *The Golden Age*, 1875
The Festival, 1875

Edward John Poynter (English, 1836–1919)

Oil on canvas; each 137.2 x 53.4 cm (54 x 21 in.)

Bequest of Suzette Morton Davidson, 2002.379–80

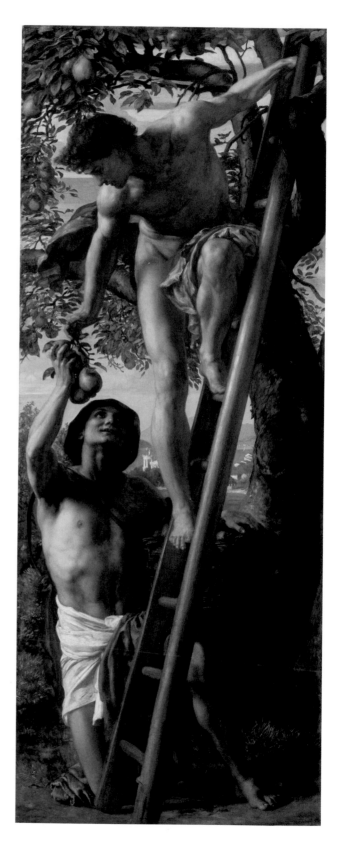

In 1875, when the preeminent critic John Ruskin compared the figures in Edward Poynter's painted panels *The Golden Age* and *The Festival* to those of Michelangelo, his purpose was to criticize rather than to praise. Just four years earlier, in his inaugural lecture as the newly appointed Slade Professor of Fine Art at Oxford, he delivered an excoriating indictment of the Renaissance master, savagely attacking his expressive rendering of the human body as unnatural and ugly. Ruskin now discerned similar flaws in Poynter's work, complaining that "Mr. Poynter's object . . . is to show us, like Michael Angelo, the adaptability of limbs to awkward positions," and that only "surgical spectators" would admire such contortions.[1] The complex postures of Poynter's subjects—with their twisted torsos and raised, extended arms—may well have been inspired by Michelangelo's figures of prophets and sibyls in the Sistine Chapel frescoes (1509–12). The artist had studied that ensemble firsthand in Rome, and he remained a fervent admirer of Michelangelo's ability to capture the human body in motion.[2] But this pair of panels, more lyric than dramatic, reveals that Poynter, widely respected for his austere and accurate classicism, was equally skilled in the decorative mode.

Born into a family of artists—his father, Ambrose, was an architect and watercolor painter and his grandfather Thomas Banks a highly regarded sculptor—Poynter seemed destined for success. Trained in Paris, he remained a lifelong advocate of the French academic approach and debuted at the Royal Academy in 1861 as a painter of classical vignettes. The artist established his signature style, which features archeological accuracy and rigorously rendered male nudes, in the epic paintings *Israel in Egypt* (1867; Guildhall Art Gallery, London) and *The Catapult* (1868; Laing Art Gallery, Newcastle on Tyne) to wide acclaim.[3] In addition to his distinguished career as a

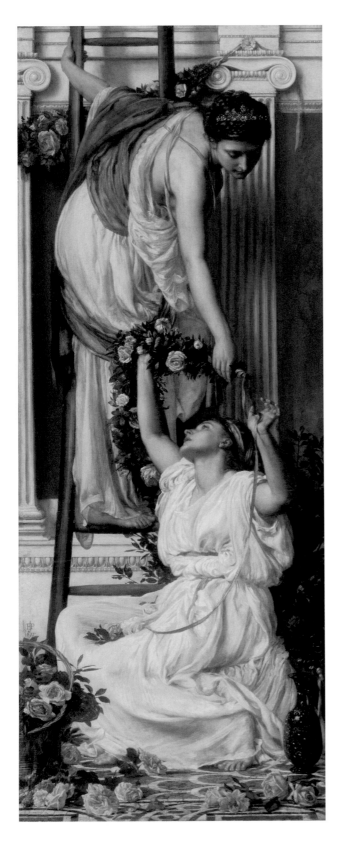

painter, Poynter won recognition for teaching and service; his positions included the first Slade Professor of Fine Art at University College, London, director of the National Gallery, and president of the Royal Academy. He also created decorative designs, most notably his figurative tile ensemble for the Grill Room in the South Kensington Museum, now the Victoria and Albert (1866).[4]

Along with his renowned mastery of human form, *The Festival* and *The Golden Age* display Poynter's harmonious sense of decorative design.[5] The narrow, vertical format of the canvases conforms to the dimensions of panels conceived as part of a room ensemble, such as the allegorical figures of the seasons he designed for the Grill Room. While there is no evidence that Poynter intended these two paintings as part of a broader scheme, small-scale watercolors of the same subject painted in 1870 reveal that such a format was part of an earlier plan.[6] The Arcadian themes further suggest the decorative mode; the supple figures stretch and turn in rhythmic motion, embodying youth and beauty rather than a high-minded message.

Ruskin found fault in this as well. Despite Poynter's meticulous rendering of architectural details and costume, the critic chided the painter for his use of round-runged ladders in both compositions, further asserting that a "sensible Greek girl" would never perch barefoot on a ladder. He argued that, had Poynter consulted "the best authorities," he would have understood that the men would not have to climb to gather fruit at a time when people lived "chiefly on corn and strawberries, both growing wild," and also realized that the bounty of the fruit trees was so abundant that "doubtless the loaded fruit branches drooped to their reach."[7] But in 1879 Poynter defended his position in his own lecture on Michelangelo, defining a difference between the historicist demands of classical painting and the aesthetic freedom of decorative art. Even in the Renaissance master's work, Poynter observed, "in some forms of composition intended to be decorative, a certain license may be allowed."[8] D.M.N.

11. *Sutherland*

Designed 1870/71 by Owen Jones (English, 1809–1874)

Manufactured c. 1872 by Warner, Sillett and Ramm,

London

> Silk, warp-float faced satin weave with twill interlacings of
> secondary binding warps and supplementary patterning wefts,
> left selvage present; 39 x 53.7 cm (15 ⅜ x 21 ⅛ in.)
> Royalties from the Minasian Corporation, 1995.386

The lack of quality British goods at the Great Exhibition of 1851 highlighted the need for radical changes in native design and manufacture. Five years later, the architect and designer Owen Jones wrote his enormously influential *Grammar of Ornament* as means of bringing them about.[1] In the book he outlined thirty-seven principles of good design; these lessons, all accompanied by numerous illustrations, were based on his study of historical ornament and Islamic design in particular.[2]

It was from these principles that Jones developed the visual elements of *Sutherland*, which was among his last textile designs. This was one of sixteen made during the early 1870s by Warner, Sillett and Ramm, one of the few silk manufacturers to weather the huge decline of the English silk industry during the nineteenth century.[3] The firm's survival was partially due to its use of the Jacquard attachment, which allowed the production of elaborate and intricate woven patterns such as this one through the manipulation of individual warp threads.

Sutherland is a very formal design that combines distinctive elements of geometric and floral ornamentation. Jones maintained that "all ornament should be based upon a geometrical construction," a belief that demonstrated the influence of the patterns of Augustus Welby Northmore Pugin, a pioneering Gothic revivalist.[4] *Sutherland* was inspired in part by the English perpendicular architectural style, but in its use of rich colors it also displays a very Eastern feel that reflects Victorian Britain's imperialistic interest in near and far eastern cultures. Nevertheless, the textile is a highly original and innovative creation that illustrates Jones's belief in using historical styles to create something utterly new. As he remarked in *Grammar of Ornament*, "The principles discoverable in the works of the past belong to us; not so the results."[5]

Jones was also very interested in color, studying the findings of the color theorists George Field and Michel-Eugène Chevreul and incorporating them into his own principles. He remarked that color should be "used to assist in the development of form, and to distinguish objects or parts of objects from another"; this is clearly so in *Sutherland*, where the bright blue petals and leaves clearly stand apart from the other rich ornamentation.[6] The designer also valued harmony and distribution within a pattern, stating that "Every ornament, however distant, should be traced to its branch and root."[7] Such is the case in this textile, which displays a highly organized repeat that centers on the gold circle at the bottom of the ornamentation's stem. L.L.

12. *Stove Front*, c. 1875

Designed by Thomas Jeckyll (English, 1827–1881)

Made by Barnard, Bishop, and Barnards,

Norfolk, England

> Cast iron; 97 x 92 cm (38 ⅛ x 36 ¼ in.)
>
> Major Acquisitions Fund, 2003.320

Although little remembered today, Thomas Jeckyll was an architect and designer of some renown in his own time. His most famous commission was the 1876 interior of the London home of the British industrialist and shipping magnate Frederick Richards Leyland. He conceived the Peacock Room (now at the Freer Gallery of Art in Washington, D.C.) as a cabinet to showcase Leyland's collection of blue-and-white Chinese porcelain. But this most vibrant and enduring of Jeckyll's creations was shortly to be identified as the work of James McNeill Whistler, whose redecoration of the room in the following year included painting the tooled leather wall hangings blue and stenciling them with peacocks and abstract, Japanese-inspired designs.[1]

Jeckyll was the exact contemporary of William Burges (see Zelleke essay).[2] For a time, he too fell under the spell of the Gothic Revival and built or renovated churches, rectories, and a number of houses and cottages. He was also interested in the architecture of industry, sketching bridges, railway stations, and other fixtures of modern life. After practicing in Norfolk and Cambridge, he relocated in 1857 to London, where he opened an office in 1862. In the capitol, he moved in the circles of such artists as Whistler and the Pre-Raphaelite painter Dante Gabriel Rossetti.

Jeckyll's work in metals—especially in cast and wrought iron in the Anglo-Japanese style—is his greatest legacy. On commission from the iron foundry of Barnard, Bishop, and Barnards, he designed park gates that were shown at the London International Exhibition of 1862.[3] For the firm's display at the 1876 Centennial exhibition in Philadelphia, Jeckyll created a two-story, Japanese-inspired pavilion in which the sunflower was one of the principal structural and decorative motifs.[4]

In contrast to these one-of-a-kind exhibition pieces, Jeckyll and Barnards also collaborated in creating something truly progressive in conception and design: a slow combustion stove. Industrially produced and affordably priced, it was fitted into the fireplace and burned coal efficiently, projecting heat into the room rather than up through the chimney. When surrounded by an elegant frame such as this one, it added an exotic touch to the Victorian interior. In this particular example, Jeckyll adapted Japanese *mon*, or heraldic emblems, which he arranged as circular, low-relief reserves filled with abstract patterns and images of chrysanthemum, iris, and prunus. Jeckyll and his partners even adopted decorative, Japanese-style marks to sign their work: the designer's consisted of two confronting moths while Barnards's was a rebus of four bees—one for each of the firm's principals—within a circle. G.Z.

13. *Cabinet*, 1878/80

Herter Brothers, New York, New York

> Rosewood with ebonized cherry, maple, walnut, satinwood,
> marquetry of various woods, brass, gilding, and paint;
> 134.6 x 180.3 x 40.6 cm (53 x 71 x 16 in.)
> Gift of the Antiquarian Society through the Capital
> Campaign, 1986.26

Aestheticism, the doctrine of art for art's sake, began in England in the 1860s and was characterized by an interest in visual beauty as opposed to narrative content. It reached its height in the United States after the 1876 Philadelphia Centennial exhibition, where the British displays exposed many Americans to the movement for the first time.[1] The still-life genre was thought to lend itself well to Aestheticism because it was free of the verbal resonances of history painting, genre, and portraiture, and could be used for more purely formal exercises in pictorial beauty. On this cabinet, for instance, carefully arranged butterflies, flowers, and foliage create a sense of overall harmony.

The cabinet was made by the New York firm Herter Brothers, a leading designer of furniture and interiors for the nouveaux riches of the Gilded Age. A German immigrant, Gustave Herter founded the business by 1858 and was joined by his younger brother Christian seven years later. In Europe from 1868 to 1869, Christian was exposed to Aestheticism and the related design reform movement, which was led by theorists such as the English critic John Ruskin, who derided the poor quality of mass-produced furnishings. Influenced by Aestheticism, they advocated bringing art into the realm of functional objects through tasteful design. In 1870 Christian assumed control of the firm and went on to create some of the first American Aesthetic Movement furniture.

In the late 1870s, Herter began to find inspiration in Japanese art. In 1854, after over two centuries of self-imposed isolation, Japan was forced to resume trade with the West by the American Commodore Matthew Perry. The unfamiliar forms of Japanese objects fascinated Western consumers, and a craze for things Japanese began. Like Aestheticism, japanism peaked in the United States after the 1876 Centennial exhibition, and American furniture designers responded by incorporating Japanese motifs and design strategies into their works.[2] They were influenced not only by Japanese art but also by japanesque work from Europe, where the movement had been widely influential for a decade or more.

This cabinet's overall form has the simplicity and lightness characteristic of English japanesque furniture, particularly the work of Edward Godwin.[3] In this piece, however, as in many of his japanesque designs, Herter also used rich materials and effects including gilding, marquetry, and rosewood. Plum blossoms, a common Japanese motif, appear in the arch spandrels, and the horizontal strips of abstracted flowers are derived from

Japanese family crests.[4] At center, the drawer and two doors are decorated with marquetry of golden maple on ebonized cherry, suggesting gold inlay on black Japanese lacquer. Herter divided each door into three sections, making the facade resemble a six-panel painted Japanese screen.[5] Such screens, like these doors, typically feature natural motifs arranged decoratively, so that each panel can stand by itself as a cropped, yet balanced, design. Gilded medallions adorn both side doors, each with a different scene of flowers and butterflies. In their illusionistic rendering, these roundels relate to contemporary American china painting.[6] They also recall Japanese paintings, which often feature natural motifs, especially flowers, executed in colors on gold.

Despite these elements, the cabinet's overall design is Western. Although both central door designs are asymmetrical in a japanesque way, they are symmetrical to each other, just as the two sides of the drawer are. Similarly, the side medallions vary slightly but are basically in mirror relation. Moreover, the overall cabinet form, while simplified in a japanesque manner, is symmetrical and includes distinctly un-Japanese elements such as Egyptian revival paw feet. Aesthetic Movement designers such as Herter readily combined such eclectic motifs as long as they achieved a sense of visual unity. Japanese art was a particularly useful model for them, though, since it offered a way to treat natural forms in a decorative manner, creating true art furniture. E.E.R.

14. *Plaque*, 1879

John Bennett (American, 1840–1907)
　　Ceramic; diam. 46.7 cm (18 ⅜ in.)
　　Through prior acquisitions of the George F. Harding Collection, an anonymous donor, Bessie Bennett, Mrs. William Blood, Emily Crane Chadbourne, Milton Straus, Elizabeth R. Vaughan, Behrend/Sanford Auction and Thorne Rooms Exhibition funds, 1998.317

In the late nineteenth century, John Bennett, an English immigrant, became one of the leading art potters in the United States.[1] He worked first for the London firm

Doulton and Company, decorating ceramics using a new method he had invented that involved painting his designs in slip, or liquid clay, and then covering them with clear glaze. This "Bennett ware" was exhibited to great acclaim at the 1876 Centennial exhibition in Philadelphia, and its commercial success in America prompted Bennett to relocate to New York in 1877.

Although Bennett's early pottery displays an Islamic influence, this plaque's decoration is more indebted to contemporary English Aesthetic Movement design. Like the Art Institute's Herter cabinet (cat. 13), it features a still life—in this case, white and pink flowers in a vase. Bennett positioned the vessel to one side of his composition, creating an asymmetrical, yet balanced, design modeled after similar effects in Japanese lacquer, paintings, and prints. While the cropping of the flowers around the edge also emulates Japanese art, japanism is by no means the dominant influence. In the plaque's decoration, flowers extend into the composition from beyond the pictorial space, yielding a design that resembles the intricate textiles of the English Aesthetic Movement designer William Morris, which also feature stylized flowers and foliage (see cat. 17). The muted colors—shades of olive highlighted by white and pink—are also characteristic of Morris's work.

Bennett initially enjoyed great success in the United

States. His ceramics sold well, were exhibited widely, and garnered praise in art journals.[2] A critic for the *Art Amateur*, for instance, wrote: "Successful as Mr. Bennett certainly has been in this country, we doubt whether the value of his work is sufficiently appreciated. No one in the United States has yet approached him in underglaze decoration; and . . . there is probably no factory in Europe which could rival in body, glaze, and decoration this very handsome vase."[3] In 1883 Bennett moved to West Orange, New Jersey, where he fell into obscurity. Nevertheless, he was integral to the development of American art pottery and the spread of English Aesthetic Movement ideas in the United States. E.E.R.

15. *Pitcher*, 1878

Tiffany and Company, New York, New York

> Silver, gold, and copper; 22.2 x 14 cm (8 ¾ x 5 ½ in.).
> Restricted gift of Mrs. Frank Sulzberger, 1984.240

During the Aesthetic Movement, still-life motifs also appeared on silver objects such as this Tiffany and Company pitcher. The firm, founded by Charles Lewis Tiffany and John Young in 1837, became known for japanesque silver in the late nineteenth century because of the work of its chief designer, Edward Moore.[1] In the 1870s, Moore formed one of the earliest major Japanese art collections in America, acquiring ceramics, ivories, lacquer, metalwork, prints, and textiles. Emulating Japanese mixed metal decoration, he experimented with soldering electrotype ornament onto silver; he also created decorative motifs influenced by Japanese metalwork and prints.

Like other early japanists, Moore especially admired the graphic strength and balanced designs of Katsushika Hokusai's woodblock prints, and the irises and dragonfly on this pitcher closely relate to forms found in Hokusai's work.[2] By 1878 Moore had a standardized set of such motifs that he arranged in different combinations. In his design for this pitcher, for instance, he noted each japanesque electrotype ele-

ment with its corresponding number.[3] He arranged these motifs asymmetrically while achieving a balanced design overall, again demonstrating his debt to Japanese artists such as Hokusai.

Moore exhibited an identical pitcher at the 1878 Exposition universelle in Paris.[4] That display was his first opportunity to showcase his japanesque mixed metalwork, and it was an overwhelming success. His silver won first prize and was praised by Europeans and Americans alike. The English designer Christopher Dresser, for instance, wrote to Tiffany and Company: "No silversmith, that I know, has made the progress in art as applied to their industry in the last few years, that you have—indeed, the rapidity of your advancement has astonished many of my art friends . . . you occupy the proud position of being the first silversmith of the world."[5] E.E.R.

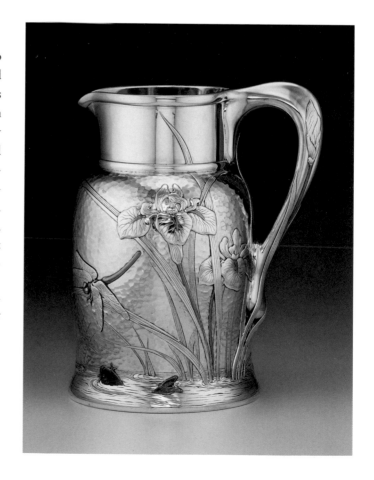

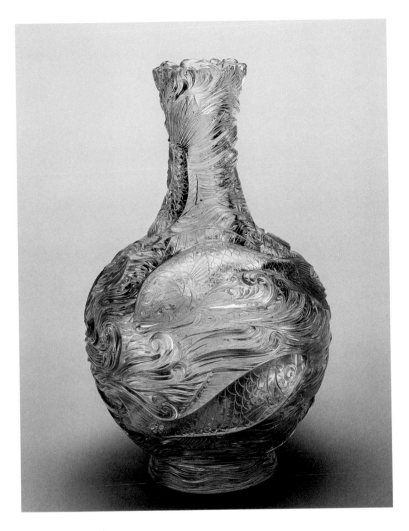

16. *"Rock Crystal" Vase*, 1889

Thomas Webb and Sons, Stourbridge, England

Carved glass; h. 30.5 cm (12 in.)

Harry and Maribel G. Blum, Richard T. Crane, Jr.,
Memorial, and Rosenwald Glass endowments, 2001.115

With its deeply carved walls and brilliantly polished surfaces, this vase expresses both the technical accomplishments and aesthetic refinements of which the English glass-making firm Thomas Webb and Sons was capable in the last decades of the nineteenth century. In 1878 the company perfected the manufacture of English glass to simulate the appearance of rock crystal, a transparent gemstone quartz that had been prized for centuries for its translucent and luminous qualities. Webb's thick-walled

vase, one of two made to this pattern, is animated with carp swimming vigorously against roiling waters whose spiraling currents sparkle as if seen in brilliant sunlight.[1]

The development of "rock crystal" glass with high relief decoration was described by George Woodall, one of Webb's principal designers and a partner in the invention, who recalled years later that "Mr. Webb brought . . . a specimen of real rock crystal and we found out a method of polishing the glass by acid in such a way as to resemble exactly the natural product. . . . A new era commenced, the rock crystal glass quite superseding the old dull-coloured engraving."[2] In contrast to the thin-walled vessels more commonly made at Webb's and other glass manufacturers, rock crystal glass was blown with deliberately thick sides so that it might be engraved in high relief, giving up as much as fifty percent of its original weight by the time it was finished.

The heyday of English rock crystal glass was the 1880s, when motifs drawn from Asian art, especially that of China and Japan, were particularly popular. It was only in the second half of the nineteenth century that the English public became increasingly aware of Japanese art and craft through international exhibitions and a growing number of publications.[3] Among these was architect Thomas W. Cutler's *Grammar of Japanese Ornament and Design* of 1880, which features photolithographic plates of motifs drawn from lacquer, textiles, and other crafts. Carp appeared repeatedly in such compendiums; one, from 1882, describes the fish depicted "with wonderful spirit, swimming or swerving in the water or dashing up a waterfall."[4] Webb's achievement here was in making fish and waves appear as if they had been crystallized out of the molten glass, forever frozen amidst the turbulent waves. G.Z.

17. *Cray*, 1885

Designed by William Morris (English, 1834 – 1896)

Manufactured by Morris and Company, London

Cotton, plain weave, block printed, four selvages present; a:
277 x 97.2 cm (109 x 38 7/8 in.); b: 278.9 x 97.8 cm (109 7/8 x 38 1/2 in.)
Inscription: on selvage, *Rec.D. Morris & Company, 449
Oxford Street, W.*

Gift of Mrs. Charles F. Batchelder, 1974.419a–b

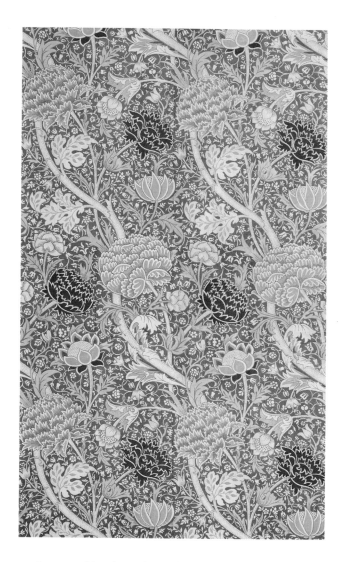

High-quality domestic decoration was extremely important to William Morris, who once remarked, "If I were asked to say what is at once the most important production of Art and the thing most to be longed for, I should answer, a beautiful House."[1] It was this belief, together with his hatred of contemporary textile design, manufacturing techniques, and working conditions—not to mention his greater desire to vigorously reform contemporary arts and crafts—that led him to create his own textiles.

Morris's earliest printed textiles date from 1868. Unable to print these himself, he relied on independent firms to produce them. He ultimately grew unhappy with the arrangement, becoming convinced that in order to make textiles of the quality and consistency he desired he would have to do it himself.[2] In June 1881 Morris and Company moved into Merton Abbey, a disused printworks near Wimbledon. Morris designed *Cray* three years later, printing it at Merton Abbey with the natural dyes that he had revived so that he could produce textiles with colors reminiscent of the historical patterns that he so admired.[3] Made with thirty-four woodblocks, *Cray* was the firm's most expensive printed textile and was available in both cotton and linen in a number of different colors. The textile is unusual in that it was not printed using the indigo discharge technique that Morris had perfected at Merton Abbey.

Cray is one of Morris's most complex designs, demonstrating his immense, self-taught knowledge of printed textile techniques.[4] Here, he combined balanced colors with a superbly observed naturalistic composition. Indeed, Morris's horticultural and botanical knowledge were major factors in *Cray*'s success. Floral designs such as this were inspired by Morris's nostalgia for a rural countryside unthreatened by the Industrial Revolution, a reaction that was anti-industrial and anti-urban in character.

The textile has a bold, meandering motif, forming a strong diagonal emphasis that Morris called "the branch." Common in his work of the 1880s, it was influenced by seventeenth-century Italian silks and velvets that he had seen in London's South Kensington Museum (now the Victoria and Albert).[5] The design has a large repeat, a decision explained in part by Morris's own advice: "Do not be afraid of large patterns. . . . Very small rooms, as well as very large ones, look better ornamented with large patterns."[6]
L.L.

18. *Purple Bird*, c. 1899

Designed by Charles Francis Annesley Voysey

(English, 1857–1941)

Manufactured by Alexander Morton and Company,

Darvel, Scotland, and Carlisle, England

Wild silk and cotton, three-color complementary weft plain
weave double cloth; 297.1 x 116.5 cm (117 x 45 ⅞ in.)

Louise Lutz Endowment, 1989.561

Charles Francis Annesley Voysey, a trained architect, was
encouraged and taught by Arthur Mackmurdo, his men-
tor, to design repeating patterns for fabrics and wallpapers
as a way to earn income while waiting for commissions.[1]
In 1897 he signed a contract with the textile firm Alexander
Morton and Company, agreeing to produce a
minimum of twelve designs per year. One of these
was *Purple Bird*.

Purple Bird is a double cloth, a fabric pro-
duced by weaving two layers, one above the other,
on the same loom.[2] The Art Institute's example is
unusual in that it was made using wild silk and
cotton; most versions, including one shown at the
1899 Arts and Crafts Exhibition in London, were
produced in silk and wool. Voysey himself was
not concerned with the inherent qualities of cloth
and would sell the same patterns to various man-
ufacturers, who produced them using different
techniques. It was the Morton firm that made the
expert decision to execute *Purple Bird* in double
cloth, adding a glossy, undulating texture that
enhances the design immeasurably.

Voysey wanted to bring color into dark, clut-
tered Victorian interiors and endowed *Purple
Bird* with an unusual palette of burgundy, green,
and orange. The textile is sophisticated, yet the
pose of the swallow is whimsical, with its down-
cast, aloof look. The design's two-dimensional
quality is rooted in Voysey's desire for flatness,
which he explained thus: "An attempt at realism
provokes comparison with nature, which is dis-
tressing in proportion to the beholder's apprecia-
tion of the subtle beauties of real life."[3]

This pattern combines two of Voysey's most charac-
teristic design elements, the silhouette and the bird. He
used silhouettes to simplify his work, stating, "Simplicity
in decoration is one of the essential qualities without
which no true richness is possible."[4] For Voysey, nature
rather than earlier styles of pattern making was the source
of inspiration for his highly original textiles. Throughout
his career, he incorporated many different varieties of
birds into his designs, developing a highly personal alle-
gorical system in which different species were given dis-
tinct meanings. He believed that such symbols would
allow "Objects of daily use [to] assume a significance they
had not before . . . these things would sing to them songs
of joy, and carry them up into the clear blue sky of celes-
tial thought and feeling."[5] L.L.

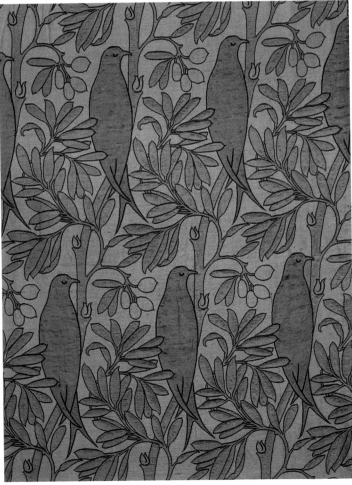

19. *Armchair*, 1897

Designed by Charles Rennie Mackintosh
(Scottish, 1868–1928)

Oak, stained dark, with (modern) horsehair
upholstery; 96.4 x 57.2 x 45.8 cm (38 x 22 ½ x 18 in.)
Gift of Neville F. Bryan, 2000.464

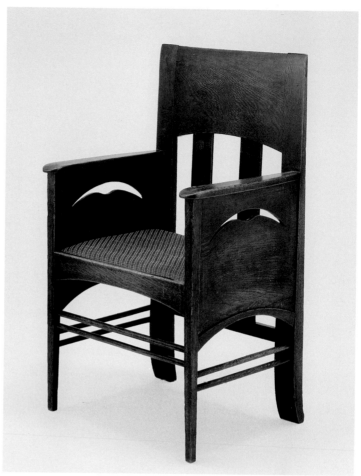

This armchair is one of several forms of seating furniture that the architect-designer Charles Rennie Mackintosh created in 1897 for one of Glasgow's most fashionable tearooms. He designed the Argyle Street Tea Rooms, among others, for Catherine Cranston, a woman who combined an entrepreneurial spirit with a clarity of moral purpose.[1] In the second half of the nineteenth century, Glasgow was a city full of pubs and was often made uncivil by the drunk and disorderly behavior of many of their patrons. The new tearooms offered women a place to lunch, take tea, and meet family and friends in a non threatening, cultivated environment. For men, they were alternatives to pubs and clubs; although alcohol-free, they provided such male-centered spaces as billiard and smoking rooms in addition to those for dining and drinking tea in mixed company.

At Argyle Street, Mackintosh was responsible for every component of the interior, from the wall decoration to the furnishings. In keeping with the other furniture, this chair—made for the Luncheon Room—is crafted of dark-stained oak. Sturdy in construction and somewhat rustic in appearance, it is enlivened with a series of shallow arcs that define the front seat rail, the crest of the back, and the lower edges of the two side panels. More dramatic are the curved lines that form the pierced crescent of each arm, just below the arm rests. This motif, reminiscent of a bird with wings outstretched in flight, is seen most spectacularly in an iconic, high-backed chair with a pierced oval back rail, produced for the same establishment.[2]

Mackintosh's career as an architect and designer lasted from 1896, when he won the design competition for the Glasgow School of Art's new building, until the years just before World War I. He was able to realize his vision through the patronage of a handful of clients in and around Glasgow; further afield he and his artist wife Margaret Macdonald were acclaimed at the 1900 Secession Exhibition in Vienna, where they caught the attention of progressive architects such as Josef Hoffmann.[3] The postwar years, however, found few clients interested in Mackintosh's increasingly bold, graphic architectural conceptions. He turned his hand instead to watercolors, in which he combined a luminous palette with a bold massing of forms, producing works that equaled in originality the stark harmony he had attained in his earlier, three-dimensional designs. G.Z.

20. *Work Cabinet*, c. 1901

Designed by Mackay Hugh Baillie Scott (English, 1865–1945)

Made by John P. White, the Pyghtle Works, Bedford

Mahogany, holly, pewter, bone, cellulose nitrate (semi-synthetic plastic), ebony, and mother-of-pearl; wrought iron and glass handles; 121.8 x 66.4 x 42.4 cm (48 x 26 ½ x 16 ¾ in.) Restricted gifts of Mrs. T. Stanton Armour, Bowen Blair, Quinn Delaney, Mr. and Mrs. Robert Hixon Glore, and Adelaide H. Ryerson; Mr. and Mrs. Henry M. Buchbinder and Richard T. Crane, Jr., endowments; through prior acquisitions of Kate Buckingham, H. M. Gillen, George F. Harding Collection, Hibbard Memorial Fund, Katharine Kuh, and Russell Tyson, 1998.516

The chief contribution of Mackay Hugh Baillie Scott, one of the most poetic Arts and Crafts practitioners, was the artistic reform of the small house. Believing that every facet of its exterior and interior, from ceiling, floor, and wall treatments to lighting fixtures, furniture, and textiles, was the proper domain of the architect, he sought to integrate each element into a unified whole through color and ornament. His furniture was often boxy in form and simply constructed; it achieved its warmth and elegance through the color and grain of its wood and from the use of inlaid ornament in which birds, flowers, and blossoming trees provided the principal decoration.

This cabinet's two doors are embellished with inlaid designs depicting a bird in flight, silhouetted against the full moon; these were made with pewter, an early form of plastic, and several varieties of wood.[1] The piece itself corresponds to one illustrated in a 1901 catalogue that advertised a wide range of high-quality items "made by skilled workmen under the personal supervision of the designer."[2] This furniture could be customized to a certain extent—here the client chose to add loop handles made of wrought iron and glass beads, giving the cabinet a rustic accent.

While the concept of the completely designed interior remained the ideal for Baillie Scott, such opportunities were the exception rather than the rule in his career. By aligning himself with firms such as the Pyghtle Works, located in Bedford, where he

practiced between 1901 and 1919, Baillie Scott made his aesthetic available to buyers of a single piece, as well as to more prosperous or enlightened consumers seeking an all-encompassing effect. In the latter case, he offered, through Pyghtle's, a complete line of decorative treatments including paneling and other woodwork; stenciled patterns for walls; modeled plaster and gesso work; and metalwork of various kinds—everything, in short, "required for the complete furnishing and decoration of the house."[3]

Baillie Scott's designs helped spread the ideals of the English Arts and Crafts movement beyond the British Isles. Beginning in 1895, his endeavors were extensively documented in the London art periodical the *Studio*, not only in critical reviews but also through articles he himself contributed. Baillie Scott also authored *Houses and Gardens* (1906), which was a summation of his design philosophy and a chronicle of some of his most important commissions. G.Z.

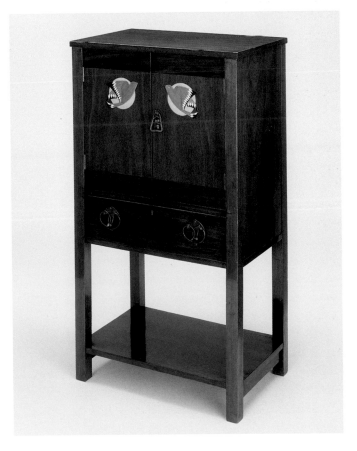

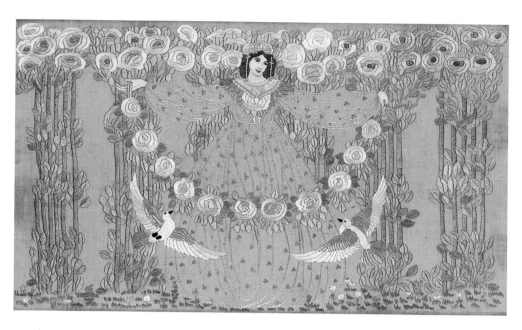

21. *Panel*, 1905

Designed and executed by Ann Macbeth (Scottish, 1875–1948)

Linen, plain weave, underdrawing in graphite; painted;
embroidered with silk in detached chain, satin, single satin,
and stem stitches; French knots; embellished with pearls;
43.8 x 76.2 cm (17 ¼ x 30 in.)
Grace R. Smith Textile Endowment, 1993.309

At the Glasgow School of Art, students seeking a diploma in decorative design were encouraged to develop their studio skills. This revolutionary curriculum dissolved the traditional division between the fine and applied arts. When Ann Macbeth enrolled in 1897 to study in the needlework department, she demonstrated an extraordinary aptitude for drawing. In 1901 she was appointed assistant instructor in the program, becoming head of the department seven years later. Throughout her long and distinguished career, which included teaching, publishing, and designing for prominent firms such as Liberty and Company, Macbeth regarded artistic excellence as essential to the mastery of her craft.[1]

Macbeth's matriculation occurred at a time when Glasgow was emerging as a vital center of modern design. Like his friend Francis H. Newbery, the Glasgow School's director, Charles Rennie Mackintosh advocated the unity of art and craft, and his wife, Margaret Macdonald, and sister-in-law Frances Macdonald applied this belief to embroidery. While not a close member of Mackintosh and Macdonald's circle, Macbeth embraced the ideals of the Glasgow style, creating needlework that earned a silver medal at the city's first International Exhibition in 1901.[2] She also designed a needlework lunette for one of Miss Cranston's Tea Rooms (see cat. 19).[3]

This linen panel, embroidered with silk, is a tour de force of Macbeth's mature style. The neutral, tan fabric, fully exposed in the body of the dress and the background, is integral to the piece's composition and color harmonies. The figure strikes a graceful pose, her arms outstretched to support a garland of full-blown roses; this gesture is repeated in the wingspan of the birds that flutter near the hem of her skirt. Macbeth employed simple techniques that complement the modest linen support, including shimmering satin stitches for the roses and feathers, and lines of pink stem stitches that articulate the folds of the garment, which is decorated with a powdering of blue French knots. Painting the figure's hands and face in ivory, she delineated the facial features in graphite, ornamenting the headdress of roses with strings of tiny pearls. Macbeth preferred naturalistic figures over the elongated, stylized forms more typical of the Glasgow style, but her muted palette of ivory, pink, rose, and sage displays the ethereal tonality characteristic of that subtle aesthetic. D.N.M.

Notes

Tedeschi, *"Where the Picture Cannot Go, the Engravings Penetrate": Prints and the Victorian Art Market*, pp. 8–19.

1. J. S. Hodson, "Fifty Years' Development of the Graphic Arts," *Art Journal* n.s. (June 1887), p. 210.
2. Anthony Dyson did the important work of compiling the statistics that qualify this vastly expanded trade in prints as a "boom market." See Anthony Dyson, *Pictures to Print: The Nineteenth-Century Engraving Trade* (London: Farrand Press, 1984).
3. The broad social and economic consequences of the Industrial Revolution and the Reform Bill of 1832 are examined in E. J. Hobsbawm, *Industry and Empire: An Economic History of Britain Since 1750* (Weidenfeld and Nicolson, 1968); Harold Perkin, *The Origins of Modern English Society, 1780–1880* (Routledge and Kegan Paul, 1969); and Eric J. Evans, *The Forging of the Modern State: Early Industrial Britain, 1783–1870* (Longman, 1983).
4. An account of the problem of fraudulent Old Master paintings was published in the *Quarterly Review* for 1854 and is reproduced in its entirety in Bernard Denvir, ed., *The Late Victorians: Art, Design, and Society, 1852–1910* (Longman, 1986), pp. 121–27. The author reported that many of the fakes were given a darkened, cracked look of authenticity in secret ovens in Richmond. While forgeries clearly posed a problem for elite as well as middle-class patrons, accounts such as this one were particularly unnerving to new collectors who lacked experience and trusted advisors.
5. Charles Robert Leslie to Miss [Anne] Leslie, May 18, 1851, in Tom Taylor, ed., *Autobiographical Recollections by the Late Charles Robert Leslie, R. A.* (London: Ticknor and Fields, 1860), vol. 2, pp. 302–303. The market for Old Master paintings had provided serious competition to modern English artists in the eighteenth and early nineteenth centuries; this is discussed in Paula Gillett, *The Victorian Painter's World* (Gloucester: Sutton, 1990), p. 70.
6. Hobsbawm (note 3), pp. 93–94.
7. *Art Journal* n.s. 5 (Nov. 1853), p. 308.
8. J. A. Manson, *Sir Edwin Landseer, R.A.* (London/New York: W. Scott/C. Scribner's Sons, 1902), p. 104.
9. *Art Union* 9 (July 1847), p. 261. After its 1848 volume, the periodical was renamed *Art Journal* but continued to promote contemporary works and the dissemination of art to all classes.
10. See Gillett (note 5), pp. 43–53, for more on artists' attempts to maintain their professionalism in the face of market pressures.
11. Dianne Sachko Macleod, "Patronage and Power: The Construction of Victorian Culture," in *Papers of the Sixth Annual Colloquium of Interdisciplinary Nineteenth-Century Studies* (Yale Center for British Art, 1991), p. 6.
12. *Parliamentary Papers: Report of the Select Committee on Art Unions* 612 (London, 1845), quoted in Gillett (note 5), p. 48.
13. Quoted in Jeremy Maas, *Gambart: Prince of the Victorian Art World* (London: Barrie and Jenkins, 1975), p. 122; and Brenda D. Rix, *Pictures for the Parlour: The English Reproductive Print from 1775 to 1900*, exh. cat. (Art Gallery of Ontario, 1983), p. 55
14. For more on *Chatterton*, see Malcolm Warner, *The Victorians: British Painting, 1837–1901*, exh. cat. (Washington, D.C.: National Gallery of Art, 1996). pp. 101–102, pl. 20
15. The London Etching Club, which operated between 1838 and 1885, offered artists the opportunity to try their hand at printmaking. On the practice and revival of original etching in the nineteenth century, and on the activities of the London Etching Club in particular, see Martha Tedeschi, "How Prints Work: Reproductions, Originals, and Their Markets in England, 1840–1900" (Ph.D. diss., Northwestern University, 1994), pp. 167–258; and Emma Chambers, *An Indolent and Blundering Art?: The Etching Revival and the Redefinition of Etching in England, 1838–1892* (Brookfield, Vt.: Ashgate, 1999).
16. The painting *The Shadow of Death* is reproduced in *Pre-Raphaelite and Other Masters: The Andrew Lloyd Webber Collection*, exh. cat. (Royal Academy of Arts, 2003), p. 101, cat. 64.
17. See Wyse's speech, delivered to a gathering of artists on Dec. 12, 1842, reproduced in its entirety in the important work by the engraver John Pye, *Patronage of British Art* (1845; repr. London: Cornmarket Press, 1970), pp. 176–85.
18. This situation changed when the Copyright Commission of 1897 ruled that the owner of a work of art also owned its copyright.
19. Rix (note 13), p. 61.
20. Millais wrote about this himself in 1858; see Gerald Reitlinger, *The Economics of Taste*, vol. 2, *The Rise and Fall of Picture Prices, 1760–1960* (London: Barrie and Rockliff, 1961), pp. 144–45. On the changes in Millais's strategy and style as a result of the pressures of the reproduction market, see Malcolm Warner, "The Professional Career of John Everett Millais to 1863, with a Catalogue of Works to the Same Date" (Ph.D. diss., Courtauld Institute, University of London, 1985).
21. The engravings were issued as follows: *The Order of Release* (1856), *The Huguenot* (1857), *The Proscribed Royalist* (1858), and *The Black Brunswicker* (1864); the series is reproduced in Hilary Guise, *Great Victorian Engravings: A Collector's Guide* (London: Astragal Books, 1980), pp. 49–52, figs. 51–52. The original painting is illustrated in *Pre-Raphaelite and Other Masters* (note 16), p. 54, cat. 24.
22. This particular comment was made by the reviewer of a new engraving after Bartolomé Estéban Murillo by Charles Cousen; see *Art Journal* 11 (Feb. 1849), p. 66.
23. Guise (note 21), p. 5; see also W. J. Stannard, *Art Exemplar* (London: Stannard and Rae, 1859).
24. The usual method for transferring the composition of an oil painting to a copperplate was to square down the canvas with watercolor (this would later be sponged off the painting); using the squaring as a guideline the engraver or his expert copyist would scale down the subject in a drawing made on smooth paper. This drawing was then damped and placed face down on the plate, which had been prepared with a wax ground, and run through a press, which would cause the subject to appear in reverse in fine, silvery lines. When no reduction in size was needed, squaring down was unnecessary and a simple tracing could be made. In either case, the engraving was rarely based on the original but rather on an intermediary drawing. For a detailed description of all available techniques, see T. H. Fielding, *The Art of Engraving* (London: Ackermann and Company, 1841).
25. A coincidental change in shoe fashions seems to have been responsible for an influx of unemployed workmen into London from Birmingham. According to the engraver William Sharpe, when buckles decorated with punch work went out of favor, the suddenly redundant buckle punchers were drafted to create the backgrounds for stipple engravings; see Guise (note 21), p. 4.
26. The richness of mezzotint tones depended on the crisp quality of the burr left by the mezzotint rocker; a copperplate mezzotint could yield no more than 500 impressions before the burr completely deteriorated. The practice and function of the mezzotint medium is thoroughly chronicled in Carol Wax, *The Mezzotint: History and Technique* (Harry N. Abrams, 1990), esp. pp. 97–137.

27. "On Applications of Science to the Fine and Useful Arts: The Curiosities of Steel Manufacture," *Art Journal* 12 (July 1850), p. 230.

28. This struggle is thoroughly chronicled in Celina Fox, "The Engravers' Battle for Professional Recognition in Early Nineteenth-Century London," *London Journal* 2, 1 (May 1976), pp. 3–32.

29. John Ruskin, *Edinburgh Lectures II* (London: Smith, Elder, 1854), pp. 46–47. While Ruskin characterized his engraver as a man, and men indeed dominated the profession, there is some evidence of female practitioners. As early as 1812, Marie-Ann Bourlier was one of thirteen engravers who produced the plates for Hans Holbein the Elder's *Portraits of Illustrious Personages of the Court of Henry VIII*. In 1851 the official catalogue of the Great Exhibition stated that engraving was a profession currently practiced by both sexes; see Robert Ellis, *Great Exhibition: Official Descriptive and Illustrated Catalogue* (London: Spicer Brothers, 1851). Women seem to have been more frequently employed in wood engraving for illustration than in intaglio engraving.

30. Review of *The Fight in the Larder* by C. W. Wass after J. Bateman, *Art Union* 9 (Nov. 1847), p. 392.

31. William Holman Hunt to Thomas Combe, July 29, 1854, quoted in Maas (note 13), p. 67.

32. Pye (note 17), p. 210.

33. Guise (note 21), p. 9.

34. Rix (note 13), p. 60.

35. Quoted in Richard T. Godfrey, *Printmaking in Britain: A General History from Its Beginnings to the Present Day* (New York University Press, 1978), p. 100.

36. "Plan of the Art Union of London," from *Annual Report of the Art Union of London* (London, 1840).

37. Ibid. The founding of the Art Union of London was the direct consequence of a recommendation made by the Select Committee on the State of the Arts and Manufactures, convened in 1835 to investigate the perceived inferiority of British art education, manufactures, and taste. For more on this process, see Lyndel Saunders King, *The Industrialization of Taste: Victorian England and the Art Union of London*, Studies in the Fine Arts, Art Patronage 4 (UMI Research Press, 1985), esp. pp. 5–33.

38. For more on the steelfacing and electrotype processes, see Antony Griffiths, *Prints and Printmaking: An Introduction to the History and Techniques* (Knopf, 1980), pp. 136, 149.

Zelleke, *Telling Stories in the Gothic Vein: William Burges and the Art of Painted Furniture*, pp. 20–28.

I am most indebted to Tracey Albainy, Caroline Bacon, Frances Collard, Vivian Davies, Martin Levy, and Matthew Williams for sharing their enthusiasm for William Burges with me. At the Victoria and Albert Museum, London, the staffs of the Prints and Drawings Study Room and the Royal Institute of British Architects (RIBA) Drawing and Archives collections were generous in allowing me access to their holdings; the same is true of the staff of the RIBA Library at Portland Place. Emily Heye's patience and skill in conserving the Art Institute's Sideboard and Wine Cabinet has allowed us to see it as Burges intended.

1. Quoted in J. Mordaunt Crook, *William Burges and the High Victorian Dream* (London: John Murray, 1981), p. 36.

2. The Great Exhibition of the Works of Industry of All Nations, held in London's Hyde Park, was a watershed event in which Britain's technological and industrial preeminence were contrasted with the sorry state of its manufactured goods. This realization led to a movement for design reform and the founding of schools and museums to encourage better design in the applied arts.

3. The competition to build a new cathedral at Lille was the dream commission for every architect enamored of the Gothic style. In 1856 Clutton and Burges were announced winners of the contest; their designs were soon replaced by those of a committee for reasons, it appears, of national chauvinism.

4. William Burges, *Abstract of Diaries, 1853–1881*, photocopy, National Art Library, Manuscript Collection, Victoria and Albert Museum.

5. For more on Burges's work at Cardiff Castle and in general, see Crook (note 1); J. Mordaunt Crook, ed., *The Strange Genius of William Burges, "Art-Architect," 1827–1888*, exh. cat. (National Museum of Wales, 1981);

and Matthew Williams, "William Burges' Furniture for Cardiff Castle," *Journal of the Decorative Arts Society 1850–the Present* 16 (1992), pp. 14–19.

6. William Burges, *Art Applied to Industry* (Oxford: John Henry and James Parker, 1865), p. 69.

7. Ibid., p. 71.

8. William Burges, "Why We Have So Little Art in Our Churches," *Ecclesiologist* 28, n.s. 25 (June 1867), p. 153.

9. These publications included Ludovic Vitet, *Monographie de l'eglise de Notre-Dame de Noyon* (Paris: Imprimerie royale, 1845); the serial *Annales archéologiques*, ed. Adolphe-Napoléon Didron and Édouard Didron; the serial *Revue générale de l'architecture*, ed. César Daly, esp. vol. 10 (1852); and Eugène-Emmanuel Viollet-le-Duc, *Dictionnaire raisonné du mobilier français*, vol. 1 (Paris: B. Bance, 1858).

10. William Burges, "Our Future Architecture," *Builder* 25, 1269 (June 1, 1867), p. 386, quoted in Crook (note 1), p. 118.

11. J. B. Waring, *Masterpieces of Industrial Art and Sculpture at the International Exhibition 1862* (London: Day and Son, 1863), vol. 2, text with pl. 155.

12. The Bayeaux Cabinet is illustrated in Viollet-le-Duc (note 9), pp. 6–8.

13. See William Burges, *Abstract of Diaries* (note 4). A Burges drawing of one of the figures on the Noyon Cabinet is now in the collection of drawings by British architects at the Victoria and Albert Museum.

14. Crook (note 1), p. 120.

15. See, for example, William Burges, "The Late Exhibition of Renaissance and Medieval Antiquities at Florence," *Gentleman's Magazine and Historical Review* 212, n.s. 12 (Jan. 1862), p. 10.

16. See Giorgio Vasari, *Lives of the Most Eminent Painters, Sculptors, and Architects*, trans. Mrs. Jonathan Foster (London: Henry G. Bohn, 1850), vol. 1, pp. 327–32.

17. Ibid., p. 328.

18. Burges (note 6), p. 107.

19. For the original reception history of the Art Institute's cabinet, see *The Ninth Architectural Exhibition*, exh. cat. (London: J. King, 1859), p. 32, cat. 19; and "Review of the Architectural Exhibition—Opening of the Galleries," *Builder* 17, 841 (Mar. 19, 1859), pp. 197–98. Valued at £120, the piece was reported as being "from the designs of Mr. W. BURGES, Architect," with "The Paintings designed and executed by Mr. N. H. J. WESTLAKE."

20. Three of these panels are initialed and dated "N. H. J. W. 1858." That same year, upon Burges's recommendation, Westlake became the principal designer in Lavers and Barraud, a firm of stained-glass makers.

21. For the full text of the poem, see "Le martyre de saint Baccus," in *Nouveau recueil de contes, dits, fabliaux, et autres pièces inédites des 13, 14, 15me siècles*, ed. Achille Jubinal (Paris: É. Pannier, 1839), pp. 250–65. For an excerpt, see *The Ninth Architectural Exhibition* (note 19), p. 32.

22. *The Ninth Architectural Exhibition* (note 19), p. 32.

23. Ibid.

24. "Architecture at the Royal Academy and Architectural Exhibition, 1859," *Ecclesiologist* 20, n.s. 17 (June 1859), p. 194, quoted in Matthew Williams, "A Buffet Made for Bacchus," *Country Life* 193, 12 (Mar. 25, 1999), p. 117.

25. Portraits of Burges and the painter Edward John Poynter were featured on the interior of two doors of the Yatman Cabinet (fig. 8), while the head of the painter James McNeill Whistler appeared on the exterior of Burges's Wines and Beers Sideboard (fig. 11). For an illustration of the painted profile of Burges, see Crook, ed. (note 5), p. 4. For more on Whistler's portrait, inscribed as the cocktail Gin Sling, see Deanna Marohn Bendix, *Diabolical Designs: Paintings, Interiors, and Exhibitions of James McNeill Whistler* (Smithsonian Institution Press, 1995), p. 57.

26. *The Ninth Architectural Exhibition* (note 19), cat. 120. For more on the drawings, see "Review of the Architectural Exhibition" (note 19), p. 190.

27. The Yatman Cabinet was given to the Victoria and Albert Museum in 1961 by Yatman's grandson, Lt. Col. P. H. W. Russell, who suggested that it was originally made for Yatman's London home, located at 41 Welbeck Street.

28. "Fine-Art Gossip," *Athenaeum* 1617 (Oct. 23, 1858), p. 527; I am grateful to Vivian Davies for kindly sharing this reference with me. For more on this cabinet, now in the Detroit Institute of Arts, see Sarah Towne Hufford, "The 'St. Bacchus Sideboard': A New Piece of Furniture by William

Burges," *Burlington Magazine* 128, 999 (June 1986), pp. 407–13.

29. Like the Yatman Cabinet and Detroit sideboard, the Sun Cabinet was also represented by a drawing at the 1859 exhibition; for more, see *The Ninth Architectural Exhibition* (note 19), cat. 120. Burges's drawing of the Sun Cabinet is now in the collection of the Victoria and Albert Museum (93 E 8).

30. The Ecclesiological Society was founded as the Cambridge Camden Society in 1839 with the aim of reviving historically authentic Anglican worship through architecture.

31. For the 1859 entry, see *The Ninth Architectural Exhibition* (note 19), p. 32, cat. 19.

32. William Burges, "The International Exhibition—Second Article," *Gentleman's Magazine and Historical Review* 213, n.s. 13 (July 1862), p. 5. Morris, Burne-Jones, and Rossetti had begun painting furniture for their own use around 1857. For a cabinet exhibited by Morris, Marshall, Faulkner and Company at the London International Exhibition of 1862, see Christopher Wilk, ed., *Western Furniture: 1350 to the Present Day in the Victoria and Albert Museum* (London: Philip Wilson, 1996), pp. 158–59.

33. The Great Bookcase is now in the collection of the Ashmolean Museum, Oxford, and is currently on loan to Knightshayes, Devon, England. For an illustration of this piece, see Crook (note 1), pl. 8.

34. Charles Boutell, "The Medieval Court," *Art Journal Illustrated Catalogue of the International Exhibition, 1862* (1863; repr., Wakefield, England: EP Publishing, 1973), p. 206.

35. "The Medieval Court at the International Exhibition," *Parthenon* 23 (Oct. 4, 1862), p. 724.

Heye, *Conserving the Art Institute's "Sideboard and Wine Cabinet,"* pp. 29–31.

I wish to thank Inge Fiedler and Francesca Casadio for coordinating, executing, and interpreting the analytical work for this project. Thanks are also due to Dr. Christopher Maines of the National Gallery of Art, Washington, D.C., for the pyrolysis gas-chromatography analysis of the varnish; to Suzanne Schnepp for capturing the infrared images; to Kirk Vuillemot for solving the problem of the swollen doors; and to Earl Locke, who manufactured the new lock according to our design. I especially wish to thank Frank Zuccari, who offered guidance on the thorny issues of cleaning what is essentially a painting on a piece of furniture.

1. A drying oil is any vegetable oil that will form a solid, non-tacky film when spread into a thin layer and exposed to air for a few days. Drying oils are widely used as the medium in artists' oil paints and varnishes.

2. Amber varnishes were always characterized by their deep colors, which ranged from dark yellow to red to brown, depending on the initial color of the amber, the type of oil, and on how carefully the mixture was heated. Some varnish makers stated that amber's deep color did not affect the colors to which it was added as a paint medium, but commented that "the amber should be employed over gold or over colours of a somber hue." L. Carlyle, *The Artist's Assistant: Oil Painting Instruction Manuals and Handbooks in Britain 1800–1900 with Reference to Selected Eighteenth-Century Sources* (London: Archetype, 2001), p. 362.

3. For a complete description of the evolving interest in amber as a varnish and oil color medium during the nineteenth century, see ibid., esp. pp. 129–31, 371–73.

4. See Mary P. Merrifield, *Original Treatises on the Arts of Painting* (1849; repr. Dover, 1967), pp. 254–57, 267–75.

5. One late-nineteenth-century recipe vividly describes the fusing process in which amber is melted in a red-hot crucible; an offensively pungent oil is driven off, leaving a dark brown residue called amber-colophony, which can be dissolved in hot linseed oil. See W. T. Brannt, *Varnishes, Lacquers, Printing Inks, and Sealing-Waxes: Their Raw Materials and Their Manufacture* (Philadelphia: Henry Carey Baird, 1893), pp. 44–46, 154–55.

6. Carlyle (note 2), p. 130.

7. In this type of cleaning, an effective solvent is mixed with a cellulose derivative to form a very thick, colorless gel, which keeps the solvent confined to the surface of the object and allows exact control of the cleaning rate.

Barter, *True to the Senses and False in Its Essence: Still-Life and Trompe l'Oeil Painting in Victorian America,* pp. 32–43.

1. Philadelphians enjoyed a thriving literature on the cultivation of plants in a hothouse climate, including such local publications as Bernard McMahon, *The American Gardener's Calendar* (Philadelphia: B. Graves, 1806); and Abraham Rees, *The Cyclopaedia; or Universal Dictionary of Arts, Sciences, and Literature* (Philadelphia: Samuel F. Bradford and Murray, Fairman, and Company, 1805–25).

2. See Phoebe Lloyd, "Philadelphia Story," in *Art in America* 76, 11 (Nov. 1988), pp. 154–71, 195–202. Peale also traveled to Mexico in 1793 and could have seen Spanish still-life paintings there. For more on this journey and Peale's life more generally, see Lillian B. Miller, "Father and Son: The Relationship of Charles Willson Peale and Raphaelle Peale," *American Art Journal* 25, 1/2 (1993) pp. 5–61. For more on Cotán's paintings, see William B. Jordan, *La imitación de la naturaleza: Los bodegones de Sánchez Cotán*, exh. cat. (Museo del Prado, 1992).

3. The maritime imagery on the sugar bowl also suggests the power of commerce; Peale may have owned this object, which first appears in *Still-life with Stawberries and Ostrich Egg Cup* (1814; Roy Nutt Family Trust), which is discussed and illustrated in Lloyd (note 2), p. 159.

4. For more on this painting, see Annie V. F. Storr, "Raphaelle Peale's *Strawberries, Nuts, &c.*: A Riddle of Enlightened Science," *Art Institute of Chicago Museum Studies* 21, 1 (1995), pp. 24–35.

5. The first alcohol prohibition laws in the United States were enacted in Maine between 1846 and 1851, while temperance laws were hotly debated and passed in Massachusetts, Rhode Island, and Vermont. In 1854 New York's governor vetoed a prohibition law and Pennsylvania defeated a similar initiative through a voters' referendum.

6. John F. Francis, will dated Nov. 11, 1886, Orphans Court of Montgomery County, Penn., O.C. 5839, bk. 18, p. 286.

7. For more on Francis's life and work, see Alfred Frankenstein, "J. F. Francis," *Antiques* 59, 5 (May 1951), pp. 374–77; and Bruce Weber, *Who Was John F. Francis?* (New York: Berry-Hill Galleries, 1990). Francis painted the portraits of three Pennsylvania governors, all temperance supporters, including James Pollock, elected in 1854 by temperance advocates. See Pennsylvania Historical and Museum Commission, "Governors of Pennsylvania," http://www.phmc.state.pa.us/bah/dam/governors/overview.asp; and George L. Hersey, *A Catalogue of Paintings by John F. Francis*, exh. cat., Bibliotheca Bucnellensis 14, 1 (Lewisburg, Penn.: Bucknell University, 1958). I am grateful to Alice DeBoer for searching the Historical Society of Pennsylvania records for biographical statistics on Francis's religious affiliation, heirs, and portrait sitters.

8. For more on gendered spaces, see Kenneth Ames, *Death in the Dining Room and Other Tales of Victorian Culture* (Temple University Press, 1992).

9. Sugar cubes were not available until the 1870s. The inventor of the machine that could cut loaves into uniform cubes was Sir Henry Tate, a collector of modern British art for whom the Tate Gallery (now Tate Britain) was named.

10. For more on Snyders's work, see Susan Koslow, *Frans Snyders: The Noble Estate; Seventeenth-Century Still-Life and Animal Painting in the Southern Netherlands* (Antwerp. Fonds Mercator Paribas, 1995).

11. Ames (note 8), pp. 71–72.

12. See, for example, Charles Willson Peale, *Staircase Group (Portrait of Raphaelle Peale and Titian Ramsay Peale)* (1795; Philadelphia Museum of Art) and Raphaelle Peale, *Venus Rising from the Sea—A Deception* (c. 1822; Nelson-Atkins Museum of Art); these are reproduced in Lillian B. Miller, ed., *The Peale Family: Creating a Legacy, 1770–1870*, exh. cat. (Abbeville Press, 1996), p. 50, pl. 23 and p. 90, pl. 56, respectively. For an illustration of *The Artist's Letter Rack*, see Doreen Bolger, Marc Simpson, and John Wilmerding, eds., *William M. Harnett*, exh. cat. (Amon Carter Museum/Metropolitan Museum of Art/Harry N. Abrams, 1992), p. 96, fig. 3.

13. See Nicolai Cikovsky, Jr., "Sordid Mechanics" and "Monkey Talents': The Illusionistic Tradition," in Bolger et al. (note 12), p. 23.

14. Irish nationalist leader Charles Steward Parnell brought attention to the Irish plight, speaking at Madison Square Garden in 1880. For more on the Irish in America, see "Editor's Easy Chair," *Harper's New Monthly Magazine* 62 (Dec. 1880), pp. 148–49; and David R. Roediger, "Irish-

American Workers and White Racial Formation in the Antebellum United States," chap. 7 in *The Wages of Whiteness: Race and the Making of the American Working Class*, rev. ed. (Verso, 1999).

15. For more on Evans and his career, see Nannette Maciejunes, *A New Variety, Try One: De Scott Evans or S. S. David*, exh. cat. (Columbus Museum of Art, 1985).

16. For a full discussion of *My Passport* and the impact of federal laws on trompe l'oeil artists who painted currency, see Bruce W. Chambers, *Old Money: American Trompe l'Oeil Images of Currency*, exh. cat. (New York: Berry-Hill Galleries, 1988).

17. Paul Staiti, "Illusionism, Trompe l'Oeil, and the Perils of Viewership," in Bolger et al. (note 12), p. 32.

18. See *Daily Local News*, West Chester, Penn., Oct. 24, 1887.

19. David Lubin, "Permanent Objects in a Fast-Changing World: Harnett's Still Lifes as a Hold on the Past," in Bolger et al. (note 12), pp. 52–53. Not until 1890 was a memorial or decoration day recognized by all the northern states, and not by the former Confederate states until after World War I. Memorial Day did not become a federal holiday until 1971.

20. A fascination with the past also marked mid-century literature. In "Young Goodman Brown" (1846) and *The Scarlet Letter* (1850), Nathaniel Hawthorne explored the Puritan roots of American culture, and Henry Wadsworth Longfellow's poem "The Old Clock on the Stairs" (1860) took as its subject the pendulum of eternity.

21. For more on *The Old Violin* (1886; National Gallery of Art, Washington, D.C.), see Bolger et al. (note 12), esp. p. 196, pl. 3.

22. Nathaniel Hawthorne, "Rappaccini's Daughter," in *Nathaniel Hawthorne's Tales: Authoritative Texts, Backgrounds, Criticism*, ed. James McIntosh (W. W. Norton, 1987), p. 199.

Mancoff, *Unpainted Masterpieces: The Drawings of Edward Burne-Jones*, pp. 44–55.

I would like to thank my research assistant Elizabeth Shingleton for her kind help.

1. Charles Eliot Norton to G. W. Curtis, June 20, 1869, in *Letters of Charles Eliot Norton*, ed. Sara Norton and M. A. De Wolfe Howe (London: Constable, 1913), vol. 1, p. 346. Norton, Professor of Fine Arts at Harvard University and one of the earliest American advocates of Pre-Raphaelite art, was originally introduced to Burne-Jones in 1856 by Dante Gabriel Rossetti. The two men maintained their friendship through correspondence for the rest of Burne-Jones's lifetime.

2. Conversation between Edward Burne-Jones and his studio assistant T. M. Rooke, June 13, 1896; see T. M. Rooke, "Notes of Conversations Among the Pre-Raphaelite Brotherhood," National Art Library Manuscript Collection, Victoria and Albert Museum, London, vol. 2, p. 237.

3. Norton and Howe (note 1), p. 346.

4. Undated letter, as quoted in Georgiana Burne-Jones, *Memorials of Edward Burne-Jones* (Macmillan, 1904), vol. 2, p. 107. For more on *Unpainted Masterpieces*, see Stephen Wildman and John Christian, *Edward Burne-Jones: Victorian Artist-Dreamer*, exh. cat. (Metropolitan Museum of Art/Harry N. Abrams, 1998), p. 332, cat. 169.

5. W. Graham Robertson, *Letters to Katie* (Macmillan, 1925), pp. viii–ix. Georgiana Burne-Jones offered a similar recollection from one of her husband's schoolmates, revealing that this was a lifelong habit; Burne-Jones (note 4), vol. 1, p. 38.

6. As told to Rooke on Nov. 28, 1895; Rooke (note 2), vol. 1, p. 60.

7. While Philip Burne-Jones's original letter of authenticity has been lost, a transcription resides in the Art Institute's Department of Prints and Drawings. The sketchbook remained in the Burne-Jones family until Brooks purchased it along with another, which the Minneapolis Institute of Arts acquired in 1915. The Art Institute's sketchbook has been long neglected by scholars, but two studies exist: George S. Hellman, "From a Burne-Jones Sketchbook," *Harper's Monthly Magazine* 141 (Nov. 1920), pp. 769–74; and Kathleen Elizabeth Alexander, "A Sketchbook by Sir Edward Burne-Jones" (M.A. thesis, Northwestern University, 1980).

8. Burne-Jones, as quoted in *Exhibition of Drawings and Studies by Sir Edward Burne-Jones*, exh. cat. (London: Burlington Fine Arts Club, 1899), p. vii.

9. As quoted in Burne-Jones (note 4), vol. 1, p. 8.

10. *The Fairy Family* (Longmans, 1857) was compiled and edited by Archibald Maclaren; for examples of Burne-Jones's work on the publication, see *Pre-Raphaelite and Other Masters: The Andrew Lloyd Webber Collection*, exh. cat. (Royal Academy of Arts, 2003), p. 64, cats. 30 a–g; and Wildman and Christian (note 4), pp. 55–56, cats. 1–3.

11. *The Letters of Dante Gabriel Rossetti*, ed. Oswald Doughty and John Robert Wahl (Clarendon Press, 1965), vol. 1, p. 319. Examples of this decorative style in pen and ink on vellum include *Going to Battle* (1858; Fitzwilliam Museum, Cambridge) and *Sir Galahad* (1859; Fogg Art Museum, Cambridge, Mass.); for illustrations of these works, see Debra N. Mancoff, *Burne-Jones* (Pomegranate, 1998), p. 23, fig. 9; p. 27, fig. 10.

12. This method was described by the artist's son, who asserted that his father "preferred to conquer his first difficulties" before he approached the canvas to avoid any "subsequent correction, which, however carefully erased, might possibly one day assert its presence." Philip Burne-Jones, "Notes on Some Unfinished Works of Sir Edward Burne-Jones, BT, by his Son," *Magazine of Art* 23 (1900/01), pp. 159–60.

13. Morris's firm was initially founded as Morris, Marshall, Faulkner, and Company in 1861. Morris bought out his partners and reorganized it as Morris and Company in 1875. Morris and Company remained in active business until 1940.

14. For an illustration of *Phyllis and Demophoön*, see Mancoff (note 11), p. 56, pl. 18.

15. Burne-Jones (note 4), vol. 1, p. 13.

16. His wife suggested that he began the project before 1872; see ibid., vol. 1, p. 308.

17. See Fiona MacCarthy, *William Morris: A Life for Our Time* (Knopf, 1995), pp. 147, 190. MacCarthy noted that Morris picked up and abandoned the planned twelve-part cycle several times and only finished six scenes, which were published by his daughter May in the last volume of his *Collected Works* (Longmans, Green, 1915).

18. Burne-Jones (note 4), vol. 2, p. 5.

19. The Venus panels flank a depiction of the Feast of Peleus and are separated by four small allegories on the theme *Amor Vincit Omnia*: *Fortune, Fame Over Throwing Fortune, Oblivion Conquering Fame*, and *Love Subduing Oblivion*.

20. For more on this, see Wildman and Christian (note 4), pp. 152–53. In 1873 Frank Lathrop, a young American painter, executed the central panel of the predella from a larger version by Burne-Jones; for an illustration of the latter (1872–81), now in the Birmingham Museums and Art Gallery, see Wildman and Christian (note 4), p. 153, cat. 51.

21. Burne-Jones (note 4), vol. 2, pp. 25–26.

22. As told to Rooke; see Rooke (note 2), vol. 1, p. 121. This entry is simply dated "two years back."

23. As quoted in Burne-Jones (note 4), vol. 1, p. 26.

24. As told to Rooke; see Rooke (note 2), vol. 1, p. 11.

25. For example one sketchbook (1943.1815.16) in the collection of the Fogg Art Museum, Harvard University, contains mostly banners and nude sketches, while another (1943.1815.15) is almost completely devoted to drapery.

26. T. Martin Wood, *The Drawings of Sir Edward Burne-Jones* (London: George Newnes, 1907), p. 2.

27. For an illustration of the first version (1867–77; Andrew Lloyd Webber Collection, England), see *Pre-Raphaelite and Other Masters* (note 10), p. 83, cat. 48.

28. Burne-Jones's interpretation of the subject is more an invention upon these lines than an imitative illustration: "Or in the stream the maids would stare, / nor know why they were made so fair; / Their yellow locks, their bosoms white, / Their limbs well wrought for all delight." William Morris, "The Hill of Venus," from *The Earthly Paradise* (Kelmscott Press, 1897), vol. 8, p. 31. For more on the project, see Joseph R. Dunlap, *The Book That Never Was* (New York: Oriole Editions, 1971).

29. These paintings include, among others, several versions of *Cupid Finding Psyche* (1865); Yale Center for British Art, New Haven, and Manchester City Art Galleries) and *Cupid Delivering Psyche* (1867; Cecil Higgins Art Gallery, Bedford). For illustrations of these works, see Wildman and

Christian (note 4), pp. 121–22, cats. 37–39.

30. The Art Institute sketchbook also holds another very similar study of the same figure (1920.1148); two other studies (1920.53–54) depict the spill of fabric around the knees of the figure fourth from the left and the resulting reflection on the water's surface. All of these works remain unpublished.

31. The sketchbook also holds another, similar study of the goddess's arms and feet (1920.1163) that has yet to be published.

32. The second version of *The Mirror of Venus* was featured in a group of eight works that Burne-Jones sent to the Grosvenor Gallery in 1877, marking his return to the Victorian art world. His works caused a sensation, prompting Henry James to call him "the lion of the exhibition." See Henry James, "The Galaxy" (1877), in *The Painter's Eye: Notes and Essays on the Pictorial Arts by Henry James*, ed. John L. Sweeny (University of Wisconsin Press, 1989), pp. 144.

33. Alan Crawford speculated that during this time Burne-Jones drew as many as one cartoon every eight and a half days. (By the end of his career, he had produced 650 designs for Morris's firm alone.) See Alan Crawford, "Burne-Jones as a Decorative Artist," in Wildman and Christian (note 4), p. 12. The Art Institute holds two cartoons from this period, *Timotheus Episcopus (Dabit Tibi)* (1912.1675) and *Samuel Propheta (Lequere Domini)* (1912.1676). For more on these, see A. C. Sewter, "Notes on Some Burne-Jones Designs for Stained Glass in American Collections," *Art Institute of Chicago Museum Studies* 5 (1970), p. 77–81.

34. Georgiana Burne-Jones noted that her husband worked on full-size cartoons on strainers while standing, even in the company of his family: "His drawing at home in the evening never separated him from us, for he heard everything that went on and talked also." See Burne-Jones (note 4), vol. 2, pp. 5–6.

35. A similar pair of drawings for the Saint Matthew window (Birmingham Museums and Art Gallery) suggests that Burne-Jones prepared for his swift production of cartoons by repeatedly drawing a figure until it was fully realized in his mind; these sketches are published in Wildman and Christian (note 4), p. 13, figs. 10–11. For illustrations of the cartoon of the Saint Mark window (Birmingham Museums and Art Gallery) and of the finished window itself, see A. C. Sewter, *The Stained Glass of William Morris and His Circle* (Yale University Press, 1974), vol. 1, pl. 435–36.

36. As quoted in Sewter (note 35), vol. 2, p. 43. Burne-Jones reported that he worked on the cartoons for the Saint Mark window between February and May 1874.

37. The painting is inscribed "EBJ 1874 1884"; see Wildman and Christian (note 4), p. 184.

38. See, for example, the highly finished pencil drawings for the figures of *Love and Beauty* (1874; Andrew Lloyd Webber Collection, England) and for *Largesse and Richesse* (1874; Collection Susan L. Burden), reproduced respectively in *Pre-Raphaelite and Other Masters* (note 10), p. 66, cat. 31; and Wildman and Christian (note 4), p. 181, cat. 73. For an illustration of the tapestry frieze (1874–82; William Morris Gallery, Walthamstow), see Wildman and Christian (note 4), pp. 180–81, cat. 72.

39. *Pyramus and Thisbe* is discussed in Wildman and Christian (note 4), p. 256. For illustrations of other works featuring the image of Cupid drawing his bow, all in ibid., see *Laus Veneris* (1873–78; Laing Art Gallery, Newcastle upon Tyne), p. 167, cat. 63; *The Passing of Venus: Painted Fan* (c. 1880; private collection), p. 234, cat. 99; *The Passing of Venus: Design for Tapestry* (1898; Metropolitan Museum of Art, New York), p. 234, cat. 100; and *The Passing of Venus Tapestry* (1922–26; Detroit Institute of Arts), pp. 234–35, cat. 101.

40. The other two versions of *Cupid's Hunting Fields* are a monochrome oil painting (1880; Victoria and Albert Museum, London), illustrated in Stephen Wildman, *Waking Dreams: The Art of the Pre-Raphaelites from the Delaware Art Museum* (Alexandria, Va.: Art Services International, 2004), p. 124, fig. 35; and a panel heightened with gold and gesso (c. 1882; Delaware Art Museum), reproduced in Jeanette M. Toohey, *Pre-Raphaelites: The Samuel and Mary Bancroft Collection of the Delaware Art Museum* (Delaware Art Museum, 1995), p. 35.

41. Burne-Jones (note 4) vol. 2, p. 75.

42. The painting is reproduced in Mancoff (note 11), pp. 120–24, pl. 54.

43. For a full account of the commission, see Debra N. Mancoff, "Infinite

Rest: Sleep, Death, and Awakening in the Late Works of Edward Burne-Jones," in Joe Law and Linda K. Hughes, *Biographical Passages: Essays in Victorian and Modernist Biography* (University of Missouri Press, 2000), pp. 116–21.

44. The *Hill Fairy* panels are unlocated. For an illustration of the panels, see Bill Waters, *Burne-Jones: A Quest for Love: Works by Sir Edward Burne-Jones BT and Related Works by Contemporary Artists* (London: Peter Nahum, 1993), p. 25, cat. 25.

45. Studies for the *Hill Fairies* include two unpublished drawings, both dated 1885, in the collection of the Fogg Art Museum, Cambridge, Mass. (1942.21, 1942.18); and a drawing in an unidentified private collection, illustrated in Mancoff (note 11), p. 119, fig. 36.

46. As told to Rooke; see Rooke (note 2), vol. 1, p. 187.

Nickel, *From the Manor House to the Asylum: The George Cowper Album,* pp. 56–67.

1. See Lytton Strachey, *Eminent Victorians: Cardinal Manning, Florence Nightingale, Dr. Arnold, General Gordon* (London: Chatto and Windus, 1918).

2. The album was one of three Victorian scrapbooks that the Art Institute acquired in December 1960 from the San Francisco bookseller David Magee; the total price was $95. No supporting documentation accompanied these items; Magee died in 1977, so tracing their provenance before San Francisco is difficult at best.

3. References to the Cowpers, and especially to Anne de Grey, show up regularly in the letters and diaries of prominent Victorians. The Countess Granville described her as "one of the most delightful girls I ever met with, a fine, open-hearted, unaffected creature, very clever and full of talents." Harriet, Countess Granville, Nov. 6, 1828, quoted in *Who Was Who in Britain*, pp. 486–87, Media Microfilm Collection, New York Public Library. See also Lady St. Helier, *Memories of Fifty Years*, 1909. pp. 91–92, quoted in ibid.

4. These works are still known as the Cowper Madonna and the Panshanger Madonna, respectively.

5. Harriet, Countess Granville (note 3).

6. He founded the field of reaction kinetics, which endeavors to describe the rate of change in a chemical reaction.

7. The larger significance of these structures, with their extensive encompassing land holdings, would not have been lost on an educated viewer in the mid-nineteenth century. The country house was then the hub of an economic system in which the relationship between the lord and the workers on his estate became increasingly critical, as estate tenants began to realize political clout for the first time. For more, see John Barrell, *The Dark Side of the Landscape* (Cambridge University Press, 1983).

8. See, for example, *The Haystack* and *The Ladder*, pls. 10 and 14 in William Henry Fox Talbot, *The Pencil of Nature* (1844–46; repr., Da Capo Press, 1969). Curiously, in his text for *The Ladder*, Talbot described photography's talent for making portraits of living individuals and groups—in particular, family groups—and remarked on its value at producing records of the English nobility, had it existed a century earlier.

9. In the Protestant tradition, cleanliness was next to godliness, and a well-swept threshold indicated the pious domesticity of the household within. The bridle symbolized restraint of the passions, and the lantern (to the right of the open door) represented truth. See Mike Weaver, "Diogenes with a Camera," in *Henry Fox Talbot: Selected Texts and Bibliography*, ed. Mike Weaver (Oxford: Clio Press, 1992), pp. 1–25.

10. Talbot (note 8), n.p.; *The Open Door* appears as pl. 6.

11. A third Talbot print, *St. Mary, Oxford*, is also to be found in the album.

12. The club's members included the photographers Frederick Scott Archer, Hugh Welch Diamond, Robert Hunt, and the painter Sir William Newton.

13. For more on these groups, see Grace Seiberling with Carolyn Bloore, *Amateurs, Photography, and the Mid-Victorian Imagination* (University of Chicago Press, 1986).

14. In an effort to keep photography within the bounds of educated amateurs like himself, Talbot had patented his positive-negative process, extending it to include newer versions such as the calotype. Fenton was part of increasingly vocal sect of calotypists who came to feel Talbot's patent restrictions were interfering with the medium's natural development. For more on

Fenton's lecture, see Sarah Greenough, "'A New Starting Point': Roger Fenton's Life," in Gordon Baldwin, Malcolm Daniel, and Sarah Greenough, *All the Mighty World: The Photographs of Roger Fenton* (Yale University Press, 2004), pp. 10–11.

15. White's pictures of nature and rural idylls can be seen as expressions of "old Englishness" in a tradition that includes the work of John Constable. These representations won White a medal at the 1855 Exposition universelle in Paris, but it was primarily his participation in the Photographic Society's exchanges of 1855 and 1857 that have transmitted his artistic interests down to the present day. See Seiberling (note 13), p. 148.

16. The stanza comes from John Keble's 1827 poem "The Christian Year." Based on the Book of Common Prayer, the work went through 150 editions in the nineteenth century, so its appearance in the Cowper Album is hardly startling. Another page in the album, which features a cathedral view, includes other lines from the poem.

17. Alfred Tennyson, *In Memoriam* (1850; repr., W. W. Norton, 1973), p. 22.

18. In the first half of the nineteenth century, the populations of major industrial cities such as Birmingham, Liverpool, London, and Manchester swelled dramatically. London was already the largest single city on the planet in 1800, with just about 800,000 residents, but by 1850 this number had increased to 2,360,000, many of whom were crowded into the world's worst slums.

19. The project was based on the modern principle that running water could be used to keep wide, underground, brick-and-tile tunnels constantly flushed and away from drinking supplies.

20. Diamond was essentially born into the mental health profession. His father, William Batchelor Diamond, was a general practitioner who opened his own private asylum in London in 1820, and the young Hugh grew up caring for his father's inmates. For more on Diamond's early career and gravitation toward photography, see Seiberling (note 13), pp. 128–29.

21. The Surrey County Lunatic Asylum was a state-of-the-art facility, constructed in 1841 expressly to house 350 destitute patients and care for them using the most modern of methods. It was to be a showcase for that aspect of liberal reform in the government that wished to institute progressive, humane programs for the custody of society's most vulnerable populations.

22. Hugh Welch Diamond, "Photography Applied to the Phenomena of Insanity," *Journal of the Photographic Society* 4 (July 21, 1856), pp. 88–89.

23. See John Conolly, "The Physiognomy of Insanity," in *Medical Times and Gazette* 16 (June 19, 1858), pp. 623–25. For more on Diamond, see Adrienne Burrows, *Portraits of the Insane: The Case of Dr. Diamond* (New York: Quartet Books, 1990); and Carolyn Bloore, *Hugh Welch Diamond: Doctor, Antiquarian, Photographer* (Twickenham, England: Orleans House, 1980), esp. pp. 8–11, 24. These are dated variously December 1858, 1859, and January 1860, implying they were the result of at least two visits, probably three.

25. William Cowper-Temple, also an M.P., was instrumental in building the Thames Embankment, championed the cause of animal protection, and was responsible in 1870 for a piece of legislation known as the Cowper-Temple Clause, which says that no catechisms or denominational readings be allowed in the religious instruction of public schools.

Catalogue, pp. 68–88.

1. John Everett Millais, *Design for a Gothic Arch*, p. 68.

1. For more on this trip, see Mary Lutyens and Malcolm Warner, eds., *Rainy Days at Brig O'Turk—The Highland Sketches of John Everett Millais, 1853* (Westerham, Kent: Dalrymple Press, 1983).

2. Two of Ruskin's Edinburgh lectures were meant to promote the use of Gothic in Scottish buildings, and he employed Millais to produce large-scale illustrations for them. The two men worked very closely together on this project; Ruskin drew the arches and frames that Millais used as the basis of his designs. *Design for a Gothic Window* was thought to have been used in one of Ruskin's lectures, but it was not mentioned in any contemporary reports and it was not included in the published version of the lectures. However, Ruskin did write to his father telling him that "Millais has done me a beautiful design of angels." See ibid., p. 82. For more on Millais's and Ruskin's collaboration see Mary Lutyens, *Millais and the Ruskins* (London: Murray, 1967). *Design for a Gothic Window* is published in *Pre-Raphaelite and Other Masters: The Andrew Lloyd Webber Collection*, exh. cat. (Royal Academy of Arts, 2003), p. 48, cat. 19.

3. Jan Marsh, *Pre-Raphaelite Women: Images of Femininity in Pre-Raphaelite Art* (London: Artus Books, 1994), p. 26

4. Lutyens and Warner (note 1), p. 74

5. The triumph of romantic love was a frequent theme in contemporary music, painting, and poetry.

6. Effie's annulment made her a social outcast. She was not welcomed into London society during the early years of her marriage to Millais, and Queen Victoria refused to receive her.

7. Ruskin thought that his wife was divorcing him for a reason other than the nonconsumption of their marriage and could have used the drawing as evidence of an affair between Millais and Effie.

2. Benjamin Brecknell Turner, *Whitby Abbey*, p. 69

1. For more on Turner's interest in Whitby and his career more generally, see Martin Barnes, *Benjamin Brecknell Turner: Rural England through a Victorian Lens* (V&A Publications, 2001).

3. William Powell Frith, *Lovers*, p. 70

1. For an illustration of this work, see Lionel Lambourne, *Victorian Painting* (Phaidon, 1999), p. 258, pl. 317.

2. William Powell Frith, *My Autobiography and Reminiscences* (London: Bentley, 1887), vol. 1, pp. 262, 263–64.

3. *Art Journal* n.s. 1 (June 1855), p. 172.

4. For an illustration of *The Sonnet*, see Lambourne (note 1), p. 368, pl. 451. Frith may also have felt defensive about a comment that Mulready made during a studio visit to see *Ramsgate Sands*. His former teacher, whom Frith considered "the greatest of them all," criticized the overall gray tonality and other weaknesses in color—characteristics Frith described as "as all my old faults"—putting the younger artist in "bad spirits" about his work. Frith's friend and contemporary Augustus Leopold Egg reassured him, observing that Mulready "had come from his own brilliantly-coloured picture—his eye accustomed to strong colours—to yours, in which bright reds and greens could not be used." Taking up a subject similar to *The Sonnet* after winning critical acclaim for *Ramsgate Sands* may have been motivated in part by a desire to challenge Mulready's assessments and declare his independence from his teacher, although Frith claimed that "the idea of jealously was too absurd to be named." See Frith (note 2), pp. 253–54.

5. *Atheaneum* 1437 (May 1855), p. 558. *Moore's Irish Melodies* (London: Longman's Green, 1866) featured steel engravings of works (both newly commissioned and reproduced) by popular painters such as Frith and Daniel Maclise.

6. For illustrations of these paintings, see Lambourne (note 1), pp. 262–63; and p. 265, pl. 321.

4. Edward John Poynter, *Study of a Young Man's Head*, p. 71.

1. In Paris, Poynter initially shared rooms with James McNeill Whistler and later with a group of young men including George du Maurier, who immortalized their bohemian lifestyle in his 1894 novel *Trilby*. The Neo-Grecs were a group of artists, consisting largely of Gleyre's pupils, who painted intimate, almost photographically realistic scenes of everyday life in classical Greece.

2. Malcolm Bell, *Drawings of Sir E. J. Poynter Bart P.R.A.—Modern Draughtsman* (London: G. Newness, 1905), p. 6. In its focus on the male nude, a traditional challenge for classical artists, this drawing anticipates the preoccupation with the subject that took hold during the later part of the nineteenth century.

3. Ibid. For more on Poynter and Ruskin's conflict about the aesthetic versus moral in art, which was in many ways a debate over the propriety of the nude, see Caroline Arscott, "Poynter and the Arty," in *After the Pre-Raphaelites—Art and Aestheticism in Victorian England*, ed. Elizabeth Prettejohn (Manchester University Press, 1999), pp. 135–51.

4. *The Cave of the Storm* Nymphs is published *Pre-Raphaelite and Other Masters: The Andrew Lloyd Webber Collection*, exh. cat. (Royal Academy of Arts, 2003), p. 193, cat. 142. For an illustration of *Israel in Egypt*, see Jeremy Maas, *Victorian Painting* (Abbeville Press, 1984), p. 186. Other works in which Poynter used a similar pose include *The Catapult* (1868; Laing Art

Gallery, Newcastle on Tyne) and *Perseus and Andromeda* (1872; destroyed); see Christopher Wood, *Olympian Dreamers: Victorian Classical Painters, 1860–1914* (London: Constable, 1983), p. 136, fig. 3; p. 140–41, fig. 5.

5. Lewis Carroll, *Untitled (Margaret Frances Langton Clarke)*, p. 72.
1. Charles Lutwidge Dodgson, diary entry for Oct. 2, 1864, *The Diaries of Lewis Carroll*, ed. and suppl. Roger Lancelyn Green (London: Cassell and Company, 1953), vol. 1, p. 222.

6. Julia Margaret Cameron, *Julia Jackson*, p. 73.
1. Julia Margaret Cameron, "The Annals of My Glass House" (1874), in *Photography: Essays and Images; Illustrated Readings in the History of Photography*, ed. Beaumont Newhall (Museum of Modern Art, 1980), p. 135.
2. Leslie Stephen, *Mausoleum Book* (Clarendon Press, 1977), p. 28, quoted in Sylvia Wolf, *Julia Margaret Cameron's Women* (Art Institute of Chicago/Yale University Press, 1998), p. 66.

7. Albert Joseph Moore, *Study for "A Garden,"* p. 74.
1. Robyn Asleson, *Albert Moore* (Phaidon, 2000) p. 7.
2. Ibid. Moore's refinements would continue even after he had finished the cartoons. He transferred the designs from the cartoons to a number of oil sketches that he used to perfect his overall composition and determine the ideal arrangements of color.
3. For further information on the sketches, cartoons, and influences on *A Garden*, see ibid., pp. 84–85. The finished painting is published in ibid., p. 109, fig. 103.
4. *Spring* is reproduced in ibid., p. 108, fig. 99. The Art Institute's drawing was also influenced by the ukiyo-e woodblock prints collected by Moore's close friend James McNeill Whistler, which showed beautiful women occupied in everyday activities.
5. These efforts included painting one of the panels on William Burges's Great Bookcase (1859–62; Ashmolean Museum, Oxford) and furnishing stained-glass window designs to the recently formed firm of Morris, Marshall, Faulkner and Company.
6. Moore deliberately used allusive titles to stop any narrative meanings being given to his work. In his determination to do this he was moving away from the narrative and moralistic art of the Pre-Raphaelite Brotherhood.

8. Artist Unknown, *Photo Collage*, p. 75.
1. For more on this, see Robert Sobieszek, "Composite Imagery and the Origins of Photomontage, Part 1: The Naturalistic Strain," *Artforum* 17, 1 (September 1978), pp. 58–65.

9–10. Edward John Poynter, *The Golden Age* and *The Festival*, pp. 76–77.
1. John Ruskin, "Academy Notes" (1875), in *The Works of John Ruskin*, ed. E. T. Cook and Alexander Wedderburn (London: G. Allen, 1904), vol. 14, p. 273.
2. The artist devoted his ninth Slade Lecture to considering Michelangelo's style, in part as a response to Ruskin's harsh analysis. See Edward John Poynter, *Ten Lectures on Art* (London: Chapman and Hall, 1879), as cited in *Great Victorian Pictures: Their Paths to Fame*, exh. cat. (London: Arts Council of Great Britain, 1978), p. 70.
3. For illustrations of these works, see, respectively, Jeremy Maas, *Victorian Painting* (Abbeville Press, 1984), p. 186; and Christopher Wood, *Olympian Dreamers: Victorian Classical Painters, 1860–1914* (London: Constable, 1983), p. 136, fig. 3.
4. For an illustration of the Grill Room ensemble, see Michael Snodin and John Styles, *Design and the Decorative Arts: Britain, 1500–1900* (V&A Publications, 2001), p. 382, fig. 33.
5. The critic James Dafforne praised the panels for revealing the full scope of Poynter's abilities, writing, "It is in compositions such as these that Mr. Poynter shows his skill as a most graceful designer and masterly draughtsman." James Dafforne, "The Works of Edward J. Poynter, R.A.," *Art Journal* 29 (1877), p. 19. In this publication, *The Festival* and *The Golden Age* are reproduced in steel engravings by J. and G. P. Nicholls on pp. 18 and 19, respectively.
6. These watercolors were last located as part of the Handley-Read collec-

tion. See Fine Art Society, *Paintings, Water-Colours, and Drawings from the Handley-Read Collection* (London: Fine Art Society, 1974), lot 63. Aside from scale, the main differences between the watercolor paintings and the oil panels include a refinement of the architectural details and minor changes in costume.
7. Ruskin (note 1), p. 273.
8. Poynter, as quoted in *Great Victorian Pictures* (note 2), p. 70.

11. Owen Jones, *Sutherland*, p. 78.
1. *The Grammar of Ornament* became indispensable to those involved in the manufacture of patterns, who used it as a source of primary material. Its influence spread across multiple generations—both William Morris and Frank Lloyd Wright were very familiar with it. Jones was a prolific writer who also produced the extremely influential *Plans, Schemes, and the Elevation of the Alhambra*, published in 1842.
2. Jones explained the need for principles, stating "No improvement can take place in the Art of the present generation until . . . the existence of general principles is more fully recognized"; see Owen Jones, *The Grammar of Ornament* (1856; repr., Doring Kindersley, 2002), p. 14 .
3. The firm bought designs from contemporary designers such as Lindsey Butterfield, Arthur Mackmurdo, and Jones so that they could compete with foreign manufacturers.
4. Jones (note 2), p. 24. For more information on Pugin's influence, see Linda Parry, *The Victoria and Albert Museum's Textile Collection: British Textiles from 1850 to 1900* (New York: Canopy Books, 1993).
5. Jones (note 2), p. 28.
6. Ibid., p. 25.
7. Ibid., p. 24.

12. Thomas Jeckyll, *Stove Front*, p. 79.
1. For more on the Peacock Room, see Linda Merrill, *The Peacock Room: A Cultural Biography* (Freer Gallery of Art/Yale University Press, 1998).
2. For more on Jeckyll's life and work, see Susan Weber Soros and Catherine Arbuthnott, *Thomas Jeckyll: Architect and Designer, 1827–1881*, exh. cat. (Bard Graduate Center for Studies in the Decorative Arts/Yale University Press, 2003).
3. Originally designed in 1859, these gates were given in 1863 by the citizenry of Norfolk to the Prince of Wales on the occasion of his marriage.
4. For an illustration of this structure, see Soros and Arbuthnott (note 2), p. 200, fig. 6-1.

13. Herter Brothers, *Cabinet*, pp. 80–81.
1. For more on the Aesthetic Movement, see Doreen Bolger Burke et al., *In Pursuit of Beauty: Americans and the Aesthetic Movement*, exh. cat. (Metropolitan Museum of Art, 1986).
2. For more on American japanism, see William Hosley, *The Japan Idea: Art and Life in Victorian America*, exh. cat. (Hartford, Conn.: Wadsworth Atheneum, 1990).
3. For more on Godwin and his work, see Susan Weber Soros, ed., *E. W. Godwin: Aesthetic Movement Architect and Designer*, exh. cat. (Yale University Press, 1999).
4. Katherine S. Howe, "Cabinet," in Katherine S. Howe, Alice Cooney Frelinghuysen, and Catherine Hoover Voorsanger, *Herter Brothers: Furniture and Interiors for a Gilded Age*, exh. cat. (Museum of Fine Arts, Houston/Harry N. Abrams, 1994), p. 192, cat. 32.
5. Judith A. Barter, "Cabinet," in Judith A. Barter, Kimberly Rhodes, and Seth A. Thayer, *American Arts at the Art Institute of Chicago* (Art Institute of Chicago/Hudson Hills, 1998), p. 247, cat. 119.
6. Stephen Little first suggested this connection between the roundels and American china painting; see ibid., p. 248 n. 4. They had been mistakenly identified as Japanese lacquer box tops (see, for example, Milo M. Naeve and Lynn Springer Roberts, *A Decade of Decorative Arts: The Antiquarian Society of the Art Institute of Chicago*, exh. cat. [Art Institute of Chicago, 1986], p. 73).

14. John Bennett, *Plaque*, pp. 81–82.
1. For more on Bennett, see Catherine Hoover Voorsanger, "John Bennett," in Doreen Bolger Burke et al., *In Pursuit of Beauty: Americans and the Aesthetic Movement*, exh. cat. (Metropolitan Museum of Art, 1986), pp. 402–403; and Sarah Nichols, "John Bennett: From the Shadows to the Limelight," *Carnegie Magazine* 58, 2 (Mar./Apr. 1986), pp. 22–23.
2. For more on the popularity of Bennett's work in the United States, see "Among the Dealers," *Art Amateur* 2, 4 (Mar. 1880), p. 88.
3. "Ceramics," *Art Amateur* 6, 2 (Jan. 1882), p. 36.

15. Tiffany and Company, *Pitcher*, p. 82.
1. For more on Moore, see Charles H. Carpenter, Jr., and Janet Zapata, *The Silver of Tiffany & Co., 1850–1987*, exh. cat. (Museum of Fine Arts, Boston, 1987); and Catherine Hoover Voorsanger, "Tiffany and Company," in Doreen Bolger Burke et al., *In Pursuit of Beauty: Americans and the Aesthetic Movement*, exh. cat. (Metropolitan Museum of Art, 1986), pp. 472–74.
2. See, for example, Hokusai's woodblock prints *Iris and Grasshopper* and *Chinese Bell Flowers and a Dragonfly*, discussed in Judith A. Barter, "Pitcher," in Judith A. Barter, Kimberly Rhodes, and Seth A. Thayer, *American Arts at the Art Institute of Chicago* (Art Institute of Chicago/ Hudson Hills, 1998), p. 249, cat. 120.
3. For an illustration of this design, see ibid., p. 249, fig. 64.
4. Since it is not stamped with the French control mark, the Art Institute's pitcher was not exhibited at the 1878 Exposition. For more on a Tiffany and Company pitcher of this design with the French mark, see Christie's, New York, *Important American Furniture, Silver, Folk Art and Decorative Arts* (June 19, 1996), lot 50.
5. Christopher Dresser to "Messrs. Tiffany and Co.," July 25, 1878, Tiffany and Company Archives, Parsippany, N.J., quoted in David A. Hanks, "Metalwork: An Eclectic Aesthetic," in Burke et al. (note 1), p. 260.

16. Thomas Webb and Sons, *"Rock Crystal" Vase*, p. 83.
1. The design corresponds to the firm's pattern book number 17415. The second vase, with a recut foot, is in a private collection and is illustrated in H. W. Woodward, *"Art, Feat and Mystery": The Story of Thomas Webb and Sons, Glassmakers* (Stourbridge, England: Mark and Moody, 1978), p. 49.
2. *The Country Express*, Jan. 20, 1912, as quoted in Christopher Woodall Perry, *The Cameo Glass of Thomas and George Woodall* (London: Richard Dennis, 2000), p. 21, n. 22.
3. The collection of Rutherford Alcock, Britain's ambassador to Japan, was featured in the display of the Japanese Court at the London International Exhibition of 1862; for more on Alcock's appreciation of Japanese art, see his *Art and Art Industries in Japan* (1878; repr., Bristol: Ganesha Publishing, 1999).
4. George Ashdown Audsley, *The Ornamental Arts of Japan* (London: S. Low, Marston, Searle, and Rivington, 1882), vol. 1, pp. 6–7. For some designs featuring carp, see Thomas W. Cutler, *A Grammar of Japanese Ornament and Design* (London: B. T. Batsford, 1880), pls. 13–18.

17. William Morris, *Cray*, p. 84.
1. Quoted in Linda Parry, ed., *William Morris*, exh. cat. (Philip Wilson Publishers/Victoria and Albert Museum, 1996), p. 136
2. The firm of Morris, Marshall, Faulkner and Company had been reorganized under Morris's sole direction in 1875.
3. Morris was enormously proud of the colors that he had reestablished as a result of his dyeing experiments with Thomas Wardle, which involved the use of natural ingredients such as bark and berries.
4. Morris was unique among his contemporaries in following John Ruskin's ethos that designers should learn craft skills and acquire a working knowledge of the techniques and processes required to make an object.
5. It was thought at the time that these textiles were from the fifteenth century.
6. The repeat is 92 x 45 cm (36¹/₄ x 17¹/₄ in.); Morris is quoted in Parry (note 1), p. 47.

18. Charles Francis Annesley Voysey, *Purple Bird*, p. 85.
1. In 1882, the same year that Voysey set up his own architectural practice, Mackmurdo was involved in founding the Century Guild, a cooperative established "to render all branches of art the sphere no longer of the tradesman but of the artist." For more on Mackmurdo and the Century Guild, see S. E. Overal, *Catalogue of A. H. Mackmurdo and the Century Guild Collection*, exh. cat. (London: William Morris Gallery, 1967).
2. The advantage of a double cloth is that a heavier fabric can be produced in a single layer without spoiling the fineness and weave of the face ply. Alexander Morton and Company produced double cloths for Morris and Company.
3. Quoted in John Brandon-Jones, *C. F. A. Voysey: Architect and Designer, 1857–1941*, exh. cat. (London: Lund Humphries, 1978), p. 97.
4. Quoted in ibid., p. 96.
5. Quoted in Wendy Hitchmough, *C. F. A. Voysey* (Phaidon, 1995), p. 143.

19. Charles Rennie Mackintosh, *Armchair*, p. 86.
1. In addition to Cranston's commissions for her various tea houses, she also hired Mackintosh to renovate her home, Hous'hill. For more on her commissions, see Wendy Kaplan, ed., *Charles Rennie Mackintosh* (Abbeville Press, 1996).
2. For an illustration of this chair, see ibid., p. 233, cat. 160.
3. For more on Hoffmann and the Wiener Werkstätte, see *Art Institute of Museum Studies* 28, 2 (2002), pp. 70–73, 76–77, cats. 40–41, 45.

20. Mackay Hugh Baillie Scott, *Work Cabinet*, p. 87.
1. This cabinet is the second example of Baillie Scott's furniture to enter the Art Institute's collection, the first being the upright or "Manxman" piano of 1897. For more on that piece (1985.99), see Ghenete Zelleke, "Harmonizing Form and Function: Mackay Hugh Baillie Scott and the Transformation of the Upright Piano," *Art Institute of Chicago Museum Studies* 19, 2 (1993), pp. 160–73.
2. *Furniture Made at The Pyghtle Works, Bedford, by John P. White, Designed by M. H. Baillie Scott*, sale cat. (Bedford, England, 1901), p. 8. These items included beds, chairs, chests, clocks, cupboards, and tables. Baillie Scott's Work Cabinet is illustrated as fig. 47 and was available in oak at £10, or, as in this example, in mahogany for £11-11s. It was described as being "inlaid with pewter, ebony, holly, &c., in relief"; see ibid., p. 27.
3. Ibid., pp. 7–8.

21. Ann Macbeth, *Panel*, p. 88.
1. Macbeth also wrote several books on needlework, including *Educational Needlecraft*, with Margaret Swanson (Longmans, Green, 1911), which significantly reformed the way needlecraft was taught to schoolchildren. See Margaret Swain, "Ann Macbeth, 1875–1948," *Embroidery* 25 (1974), p. 9. For a firsthand account of Macbeth's classroom methods, see J. Taylor, "The Glasgow School of Embroidery," *Studio* 50 (1910), pp. 127–35.
2. This exhibition established Glasgow as a new center of innovative art and design. See Juliet Kinchin, "Glasgow: The Dark Daughter of the North," in *Art Nouveau: 1890–1914*, ed. Paul Greenhalgh (Harry N. Abrams, 2000), pp. 310–11.
3. The location of Macbeth's lunette does not seem to have been recorded.